A Personal Handwriting Program for Adults

# The Art Of Cursive Penmanship

*This Book Belongs To*

Hush! Hush! Now listen –
do you hear that tell-tale sound?
It's the music of writing on paper
from the days when penmen were found.
And if you look really hard, you'll see him
as he sits in that empty, worn chair;
he's looking inside a bound scrapbook
that also once was there.

His pen rests by a brass inkwell
as if poised and ready to write,
and you know the penman is happy
as he reads in the amber light.
Yes, close your eyes and listen
to the tales that once were told;
tales of a grand, old penman,
as time and the past unfold...

– Michael R. Sull, from Poems of a Penman

# The Art Of Cursive Penmanship

## A Personal Handwriting Program for Adults

by

### Michael R. Sull, Master Penman

Past president, International Association of Master Penmen, Engrossers, and Teachers of Handwriting

Founder and director, Spencerian Saga Workshop Program, 1987–2012

Personal calligrapher to former president Ronald Reagan, 1990–2003

Founder, The Spencerian Monument for American Handwriting

Lettering artist, Hallmark Cards, Kansas City, Missouri, 1981–1986

Corporate master penman, Zaner-Bloser Company

Author, *Spencerian Script and Ornamental Penmanship, Learning to Write Spencerian Script, Spencerian Script Practice Set, American Cursive Handwriting, Poems of a Penman*

Skyhorse Publishing

Skyhorse Publishing books may be purchased in bulk at special discounts for sales promotion, corporate gifts, fund-raising, or educational purposes. Special editions can also be created to specifications. For details, contact the Special Sales Department, Skyhorse Publishing, 307 West 36th Street, 11th Floor, New York, NY 10018 or info@skyhorsepublishing.com.

Skyhorse® and Skyhorse Publishing® are registered trademarks of Skyhorse Publishing, Inc.®, a Delaware corporation.

Visit our website at www.skyhorsepublishing.com.

10 9 8

Library of Congress Cataloging-in-Publication Data is available on file.

Cover design by Michael R. Sull

Cover illustration by Michael R. Sull

Print ISBN: 978-1-5107-3052-6

Printed in China

*This book is lovingly dedicated to my dear wife, Debra Sull.*
*I can never thank you enough for your affection, belief, and support.*

# The Value of Handwriting

In this 21st century, handwriting continues to be as important today as it has been in the past, for the instruction of penmanship at a primary grade-level remains a foundation of basic education. The efforts of teachers to nurture motor-skill development with the process of translating thoughts into written language will always be a vital step in the literacy training of our children. This necessary aspect of communication and expression is both spontaneous and individualistic. Conversely, it can never be as immediate or personal when interpreted through electronic means, since handwriting is inherently a human endeavor, without mechanization. The value of handwriting is, therefore, beyond any quantitative measure, as all human qualities are. It is a fundamental skill that provides inestimable service throughout a person's lifetime, and never fails to be as singular as a fingerprint of the writer, or as unique as their own voice.

- Michael Sull

# Table of Contents

# Appendices

# Illustrations

# Author's Note

Much of this book's content has appeared in my previous work, *American Cursive Handwriting*, which I wrote for primary-grade students. The content of this book is focused on the adult who seeks a traditional and effective guide for improving his or her own handwriting. If you follow the suggestions outlined in this book and dutifully practice each day, you surely will not fail. In this manner, I wish you much success on your penmanship journey.

*Michael Sull*

# Overview of this Curriculum

Welcome to *The Art of Cursive Penmanship*!

A great deal of information about American Cursive handwriting is contained in this publication: a discussion of the nature of handwriting, instructional techniques, and practice exercises. Appendices cover the use of fountain pens, accepted methods of writing a personal letter, a resource supply list, and more. My goal is to make this the most thorough single-volume instructional source on cursive handwriting currently available. To help the reader better understand my method of designing this book, I would like to take a moment to briefly explain its structure.

The book begins with a collection of handwriting samples that may be used for practice with the lesson plans, followed by handwritten model sheets of the letters and numbers.

Chapters 1 and 2 give preliminary information about the subject of handwriting and the purpose of this book. Chapter 3 presents information about Platt Rogers Spencer (the Father of American Handwriting) and the cursive handwriting style that followed. Chapter 4 is most important; it details the specific techniques used to write American Cursive, including such topics as posture, hand position, paper movement, the *writing zone*, and details about the letters and numbers.

The purpose of the information presented through Chapter 4 is to give the reader an overview of handwriting and specifically the particulars of American Cursive handwriting. All of this information is important for adults of all ages.

Chapter 5 begins the actual "doing" phase of this curriculum. The exercises in this chapter have been used by students of handwriting for over a century. They should be used by students of all ages—including adults—since their purpose is to help the student develop the muscle memory to move his or her hand and forearm in the graceful motion necessary to write effortlessly for any period of time. Recommendations for using these exercises are outlined in the lesson plans in Chapter 7.

Chapter 6 explains the different scales of writing presented in the Copybook Practice Sheets. As the student gains muscular control, he or she progresses from being able to write only at a large size to writing comfortably at the standard scale ($\frac{1}{8}$" small letter height), and eventually at the small scale suitable for everyday writing ($\frac{1}{16}$" small letter height). The practice sheets have been designed to enable students to proceed in a natural manner toward this goal.

Chapter 7 presents lesson plans and exercise sheets to help you practice your handwriting. The practice sheets (called *copybook practice sheets*) are presented in a sequential format. The first set of copybook practice sheets has large-size letters and words with model lines of writing as a guide to the proper letter size and slant. Each succeeding group of practice sheets refines the handwriting process by reducing the size of the writing down to approximately ¹⁄₁₆" for the small letters (considered the most efficient size for speed and legibility of handwriting) and gradually eliminating the extra printed guidelines for letter height and slant.

The goal is to write at the optimum size on a single baseline of writing, because throughout a person's lifetime he/she will normally be writing on a single line (such as on a tablet), without height or slant lines. The series of practice sheets in this course and their use as recommended in the lesson plans will systematically guide you to achieve this goal.

Chapter 8 is a collection of various quotations and excerpts from literature and poetry that you may use at your discretion for practice. As noted in the text and lesson plans, you should not feel limited to these examples and may choose any quotation, poetry, or literary text you desire for your practice.

The four appendices offer practice sheets to be used with the lesson plans and additional valuable information. Appendix 1 features blank copies of each of the practice sheets used in this curriculum. I suggest photocopying these to use at your discretion.

Appendices 2 and 3 offer information on the two subjects many handwriters find most enjoyable and useful when they wish to correspond with other people: how to use a fountain pen (along with sources and publications about pens) and the particulars of writing a personal letter.

**Summary**

This book has been designed to acquaint the reader with the history and function of handwriting, its value today as a personal means of communicating, and the techniques of practice recommended to acquire a high degree of proficiency in this art. The lesson plans are progressive in the skill level required of the student and will surely result in a high degree of handwriting ability if followed faithfully.

# Handwriting Samples

# A Special Place

Somehow the day seems to be more still, more quiet when I sit at my desk to write a letter. For me, the pace of the world slows down, and time is more of a concept than a realistic aspect of the moment. Minutes and hours do not exist, and neither distance nor speed have any meaning. I am alone, and yet I am in the reassuring company of the person in my thoughts; the person to whom I write. As the penpoint glides upon the paper, my thoughts become words, and I revel in the intimacy and silence of my private conversation. I am indeed in a special place — somewhere between daily activity and pure contemplation. It is as though I speak to the pen, and it speaks to my companion, and the paper surface listens to every word. There is a comfort in knowing that my writing will not change my thoughts nor alter my tone, and that faithfully, it will share this human being with another. For this duration, nothing else matters, and I long to be nowhere else, only here, in this very special place.

—Michael Sull

# Marvelous Anticipation

There is a marvelous anticipation I feel as I ready myself to write, for I know that in a moment I shall be on a journey of language and emotion that will take me anywhere I wish to go. It is an exciting adventure that I cannot wait to begin - to think of the privilege I have in choosing the most special words without cost, that, through the movement of my pen, I can speak to someone else in my own voice, and in my own way. The sheer joy of it overwhelms me. In this hectic world, handwriting affords me a sense of calm, allowing moments of privacy, personal expression and communication with another human soul. There is no machine between my thoughts and the paper upon which I write; the person whom I address will interpret thoughts formed by my own hand. They will see me and hear my own voice - my signature will be in every letter, every word, and on every line. They will know that no one else but me sent it; that only I said exactly what I wrote for no one else but them. And except for distance, we can look into each other's eyes, touch each other's hand, and not be apart.

-Michael R. Sull

The Land of Beyond - by Robert W. Service

Have ever you heard of the Land of Beyond
that dreams at the gates of day?
Alluring it lies at the skirts of the skies
and ever so far away.
Alluring it calls: "Oh, ye the yoke galls,
and ye of the trail overfond,
By saddle and pack, by paddle and track,
let's go to the Land of Beyond."

Have ever you stood where the silences brood
and vast the horizons begin
At the dawning of day to behold far away
the goal you would strive for, - and win?
Yet, ah! in the night when you gain to the height
of that vast pool of heaven, star-spawned,
afar and agleam, like a valley of dream,
still mocks you - a Land of Beyond?

Thank God! there is always a Land of Beyond
for us who are true to the trail;
A vision to seek, a beckoning peak,
a fairness that never will fail.
A pride in our soul that mocks at a goal,
a manhood that irks at a bond,
Yet, try how we will, unattainable still,
behold it - the Land of Beyond!

4

## Conjecture

Considering the stasis between Celestial Asterism and tectonic forces originating from Suboceanic regions, one must conclude that if portions of the earth's Xerothermic Ecosystems were infused with Hydrous Gelatin derived from photophosphorylation in the Spencerian process of Tertiary Fusion, surely the change in our planet's Physiognomy would dramatically be altered to the extent that Fish would ride bicycles and Monkeys could Sing!

— Dr. I. C. Ovals, from Scientific Spencerian

## The Old Scrapbook

'Twas an old scrapbook in the parlor there
where it lay in the amber light;
a token of time far past its prime
when forgotten hands would write.
Just there — on the desk by the briar pipe rest,
next to a dry inkwell,
where, like in a dream, it said, so it seemed:
"Come closer, I've stories to tell..."

— Michael R. Sull, from Poems of a Penman

784 Ashland Lane
Bitter Creek, Wyoming 82216
October 3, 2009

My dear sister Ruth,

The autumn leaves are full of color this year – they remind me of our childhood days in Ohio so long ago. The time has gone by so quickly. I hope this finds you, Dave, and Kathy healthy & well.

Everything is fine here. Mary continues to enjoy her new job, and my business is keeping me very busy with many client projects.

Mary and I were wondering what your plans are for Thanksgiving next month. We hope you can join us for the holiday – please fit us into your schedule and say "Yes!". It'll be great to see you, Dave, and Kathy again! We'll have a delicious turkey dinner with all the trimmings – yum! We'll keep our hopes up that you will come.

Not much else in the way of news. Please take care, I miss you very much. You're always in my thoughts. I look forward to hearing from you soon.

Your loving brother,
Cameron

- from *The Master's Pen*

It happened somewhere in the distance,
  so long ago in the past,
  the times that were set
  when the great penmen met
to see who could write well and fast.
They met at the Penmen's Convention;
  the thrill was to see who'd be there,
  and wagers were placed
  to see which Master's face
would be amongst those in each chair.
  Some, of course, were expected –
  the leaders and legends of fame,
  known well and by all
  as they walked down the hall
by their fondly-remembered nicknames.
"There goes the Dean of Engrossing!"
"See the Pen Wizard standing nearby!,"
  – then voices would ring:
  "Its the Flourishing King!,"
  as he winked a monocled eye...

  - Michael R. Sull, *Poems of a Penman*

7

Number 1263

There is no Frigate like a book
To take us Lands away
Nor any Coursers like a Page
Of prancing Poetry.
This Traverse may the poorest take
Without oppress of Toll —
How frugal is the Chariot
That bears the Human soul.
                    - Emily Dickinson

Observations on Space

     Space is very large. It is immense, very immense.
A great deal of immensity exists in Space. Space has
no top, no bottom. In fact, it is bottomless both at the bottom
and at the top. Space extends as far backwards as it does
forward, and vice versa. There is no compass of Space, nor
points of the compass, and no boxing of the compass. A
billion million miles traveled in Space won't bring a person
any nearer than one mile or one inch. Consequently, in Space
it's better to stay where you are, and let well enough alone.
                    - Bill Nye

# Model Letters

*In this section, arrows show the direction of movement as you write each letter.*

## Completed Letter

The top portion of some capitals extend ← into this space. →

## Steps in making the Letter

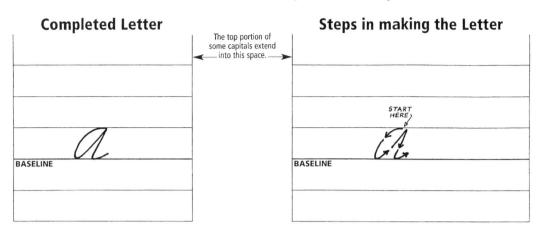

BASELINE

BASELINE

## Practice making the Letter Yourself

The top portion of some capitals extend ← into this space. →

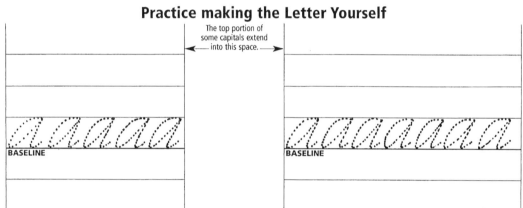

BASELINE

BASELINE

## Sample Letters / Words for Study
DOTTED DIAGONAL LINES SHOW PROPER LETTER SLANT

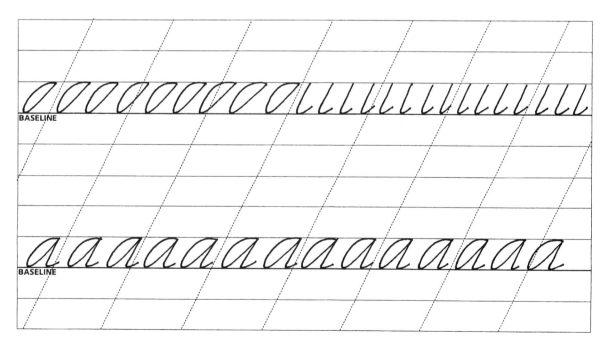

BASELINE

BASELINE

## Completed Letter

The top portion of some capitals extend into this space.

BASELINE

## Steps in making the Letter

The top portion of some capitals extend into this space.

BASELINE

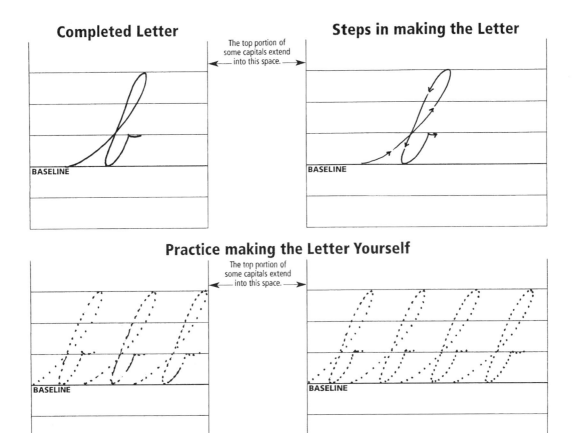

## Practice making the Letter Yourself

The top portion of some capitals extend into this space.

BASELINE

BASELINE

## Sample Letters / Words for Study

DOTTED DIAGONAL LINES SHOW PROPER LETTER SLANT

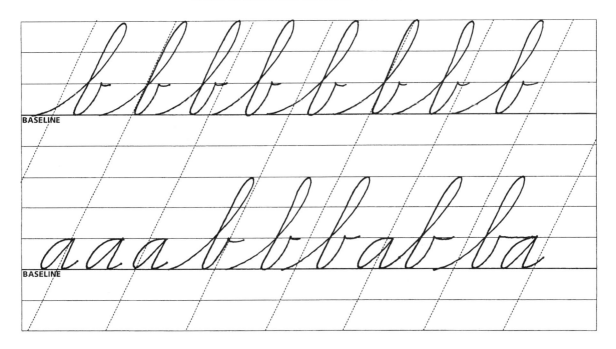

BASELINE

BASELINE

12

## Completed Letter

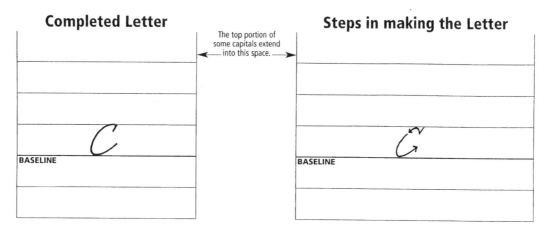

BASELINE

The top portion of some capitals extend into this space.

## Steps in making the Letter

BASELINE

## Practice making the Letter Yourself

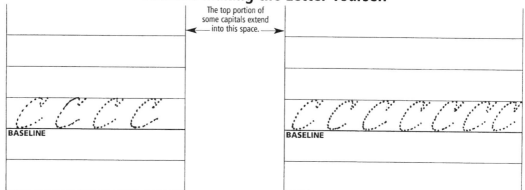

The top portion of some capitals extend into this space.

BASELINE

BASELINE

## Sample Letters / Words for Study
DOTTED DIAGONAL LINES SHOW PROPER LETTER SLANT

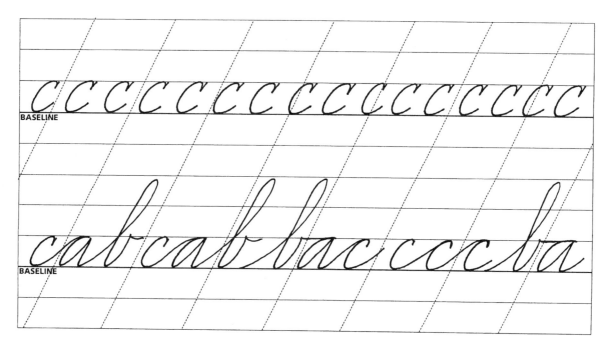

BASELINE

BASELINE

13

## Completed Letter

The top portion of some capitals extend into this space.

THE ASCENDER OF THE d CAN BE MADE
AS A THIN LINE OR AS A LOOP

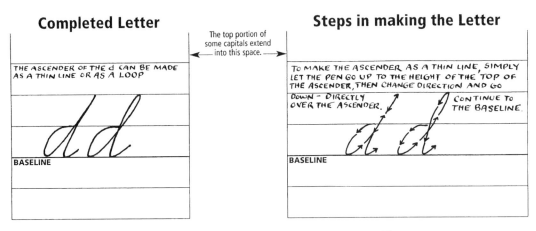

BASELINE

## Steps in making the Letter

TO MAKE THE ASCENDER AS A THIN LINE, SIMPLY
LET THE PEN GO UP TO THE HEIGHT OF THE TOP OF
THE ASCENDER, THEN CHANGE DIRECTION AND GO
DOWN - DIRECTLY
OVER THE ASCENDER.
CONTINUE TO
THE BASELINE.

BASELINE

## Practice making the Letter Yourself

The top portion of some capitals extend into this space.

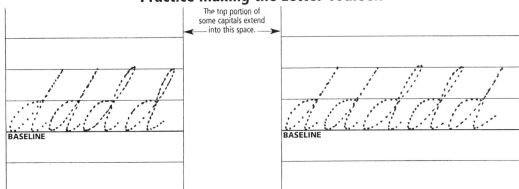

BASELINE

BASELINE

## Sample Letters / Words for Study
DOTTED DIAGONAL LINES SHOW PROPER LETTER SLANT

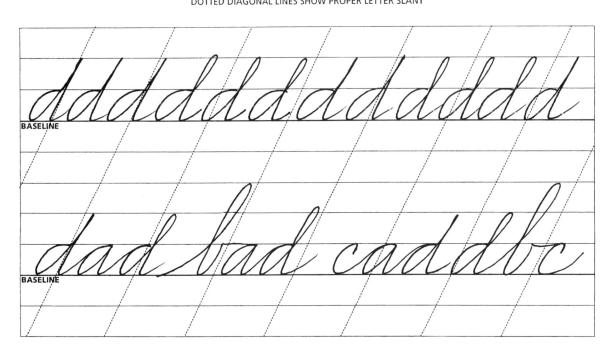

BASELINE

BASELINE

14

## Completed Letter

The top portion of some capitals extend into this space.

BASELINE

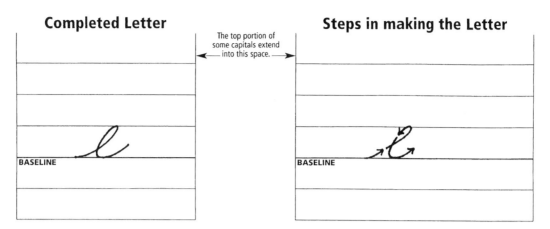

## Steps in making the Letter

BASELINE

## Practice making the Letter Yourself

The top portion of some capitals extend into this space.

BASELINE

BASELINE

## Sample Letters / Words for Study
DOTTED DIAGONAL LINES SHOW PROPER LETTER SLANT

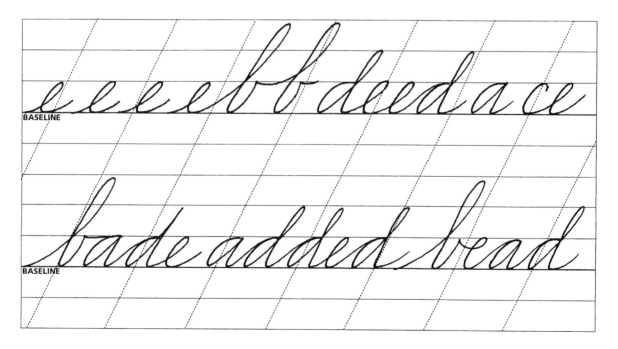

BASELINE

BASELINE

## Completed Letter

The top portion of some capitals extend into this space.

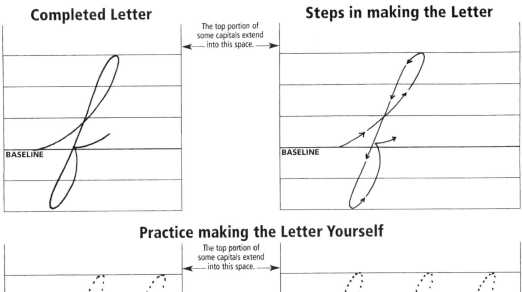

BASELINE

## Steps in making the Letter

## Practice making the Letter Yourself

The top portion of some capitals extend into this space.

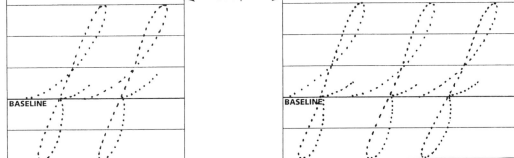

BASELINE

BASELINE

## Sample Letters / Words for Study

DOTTED DIAGONAL LINES SHOW PROPER LETTER SLANT

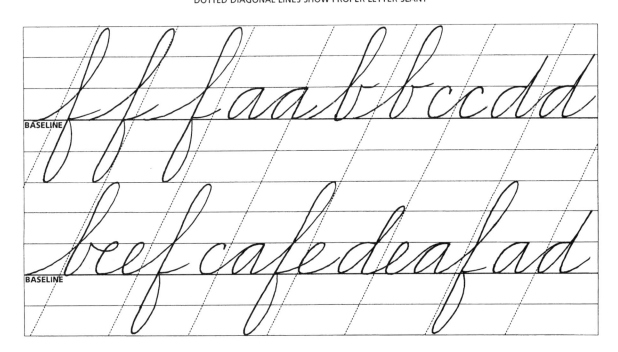

BASELINE

BASELINE

16

## Completed Letter

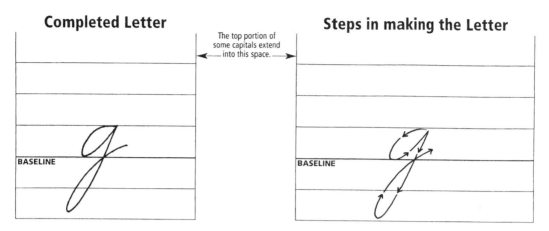

## Steps in making the Letter

## Practice making the Letter Yourself

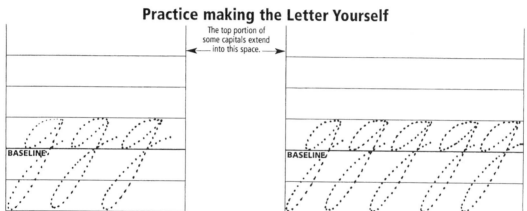

## Sample Letters / Words for Study
DOTTED DIAGONAL LINES SHOW PROPER LETTER SLANT

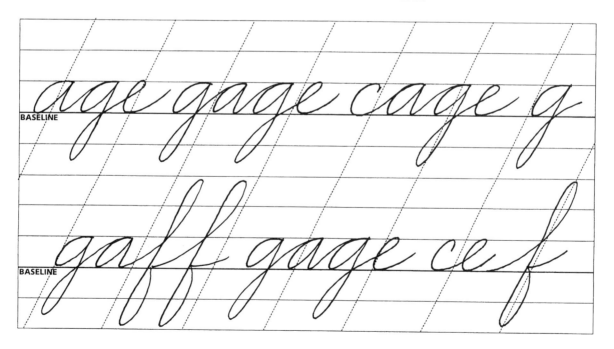

17

## Completed Letter

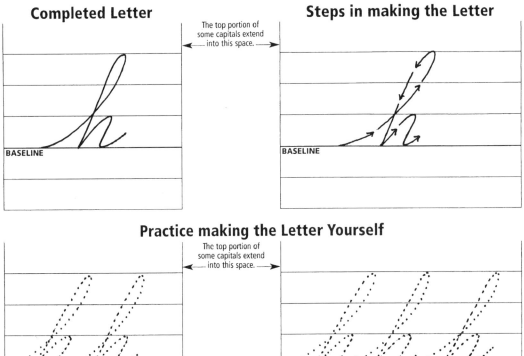

BASELINE

The top portion of some capitals extend into this space.

## Steps in making the Letter

BASELINE

## Practice making the Letter Yourself

The top portion of some capitals extend into this space.

BASELINE

BASELINE

## Sample Letters / Words for Study
DOTTED DIAGONAL LINES SHOW PROPER LETTER SLANT

BASELINE

*head high half*

BASELINE

*hence hedge hh*

## Completed Letter

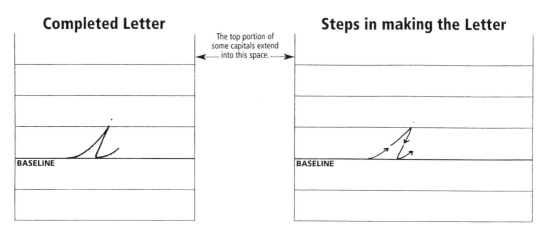

The top portion of some capitals extend into this space.

BASELINE

## Steps in making the Letter

BASELINE

## Practice making the Letter Yourself

The top portion of some capitals extend into this space.

BASELINE

BASELINE

## Sample Letters / Words for Study
DOTTED DIAGONAL LINES SHOW PROPER LETTER SLANT

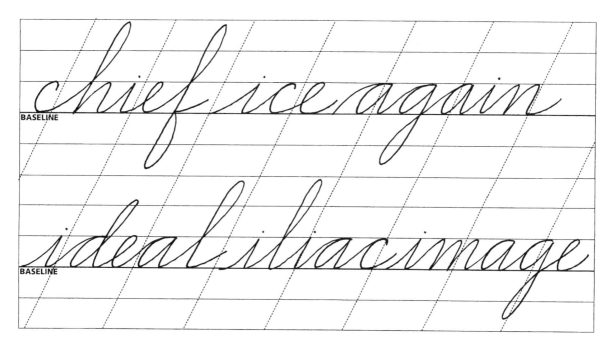

BASELINE

*chief ice again*

BASELINE

*ideal iliac image*

## Completed Letter

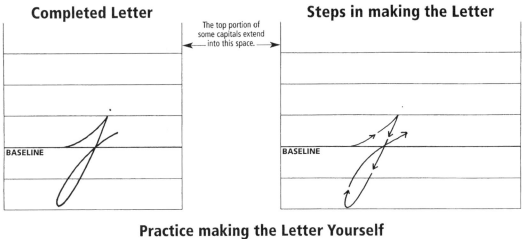

The top portion of some capitals extend into this space.

BASELINE

## Steps in making the Letter

BASELINE

## Practice making the Letter Yourself

The top portion of some capitals extend into this space.

BASELINE

BASELINE

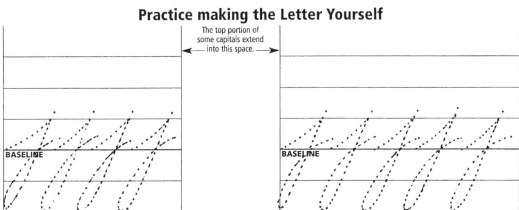

## Sample Letters / Words for Study

DOTTED DIAGONAL LINES SHOW PROPER LETTER SLANT

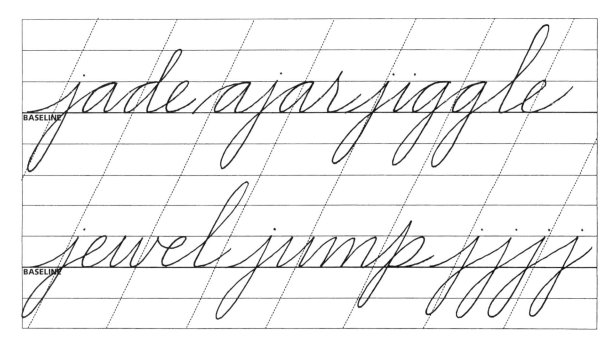

jade ajar jiggle

BASELINE

jewel jump jjjj

BASELINE

## Completed Letter

The top portion of some capitals extend into this space.

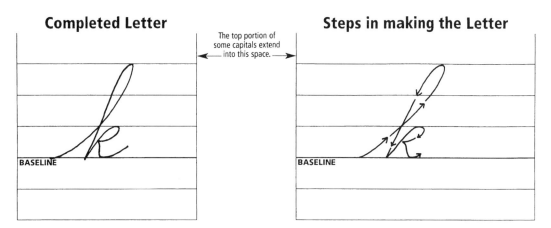

BASELINE

## Steps in making the Letter

## Practice making the Letter Yourself

The top portion of some capitals extend into this space.

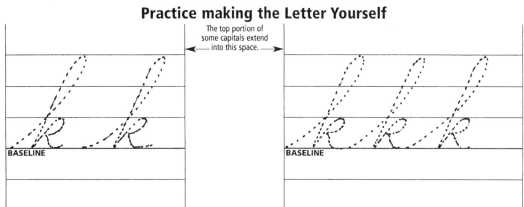

BASELINE

## Sample Letters / Words for Study
DOTTED DIAGONAL LINES SHOW PROPER LETTER SLANT

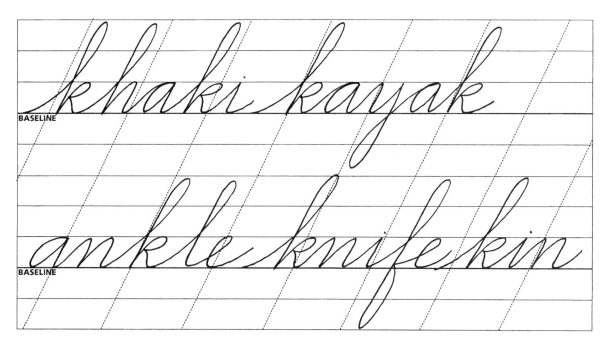

BASELINE

khaki kayak

BASELINE

ankle knife kin

## Completed Letter

## Steps in making the Letter

The top portion of some capitals extend into this space.

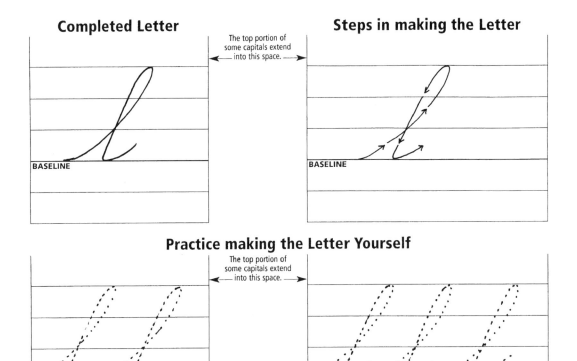

BASELINE

## Practice making the Letter Yourself

The top portion of some capitals extend into this space.

BASELINE

## Sample Letters / Words for Study
DOTTED DIAGONAL LINES SHOW PROPER LETTER SLANT

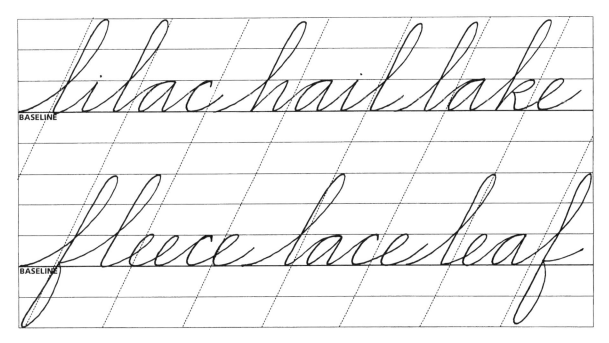

BASELINE

*lilac hail lake*

BASELINE

*fleece lace leaf*

## Completed Letter

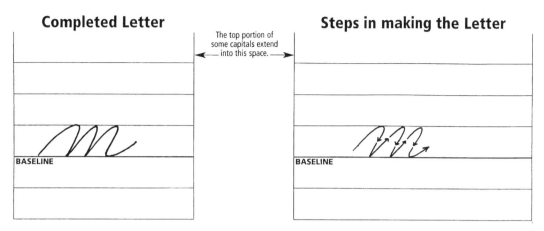

The top portion of some capitals extend into this space.

BASELINE

## Steps in making the Letter

BASELINE

## Practice making the Letter Yourself

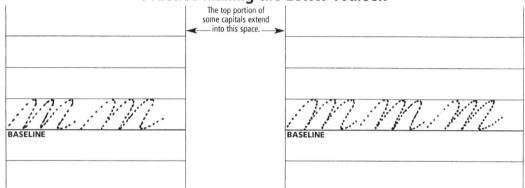

The top portion of some capitals extend into this space.

BASELINE

BASELINE

## Sample Letters / Words for Study
DOTTED DIAGONAL LINES SHOW PROPER LETTER SLANT

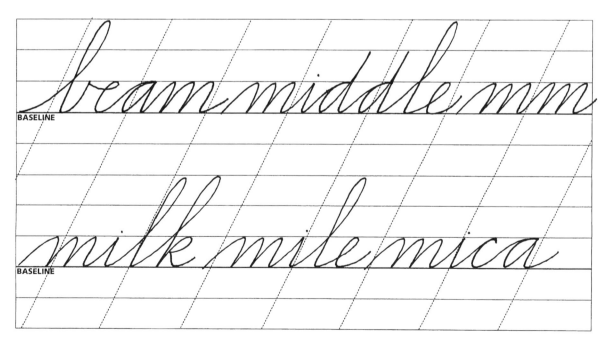

BASELINE

*beam middle mm*

BASELINE

*milk mile mica*

BASELINE

23

## Completed Letter

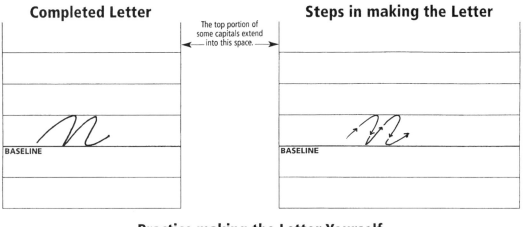

The top portion of some capitals extend into this space.

BASELINE

## Steps in making the Letter

The top portion of some capitals extend into this space.

BASELINE

## Practice making the Letter Yourself

The top portion of some capitals extend into this space.

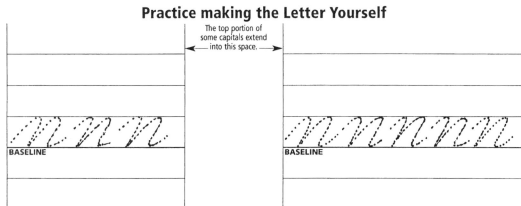

BASELINE

BASELINE

## Sample Letters / Words for Study
DOTTED DIAGONAL LINES SHOW PROPER LETTER SLANT

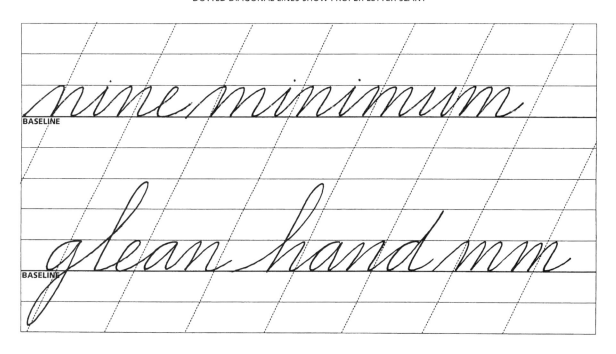

BASELINE

nine minimum

BASELINE

glean hand mm

24

## Completed Letter

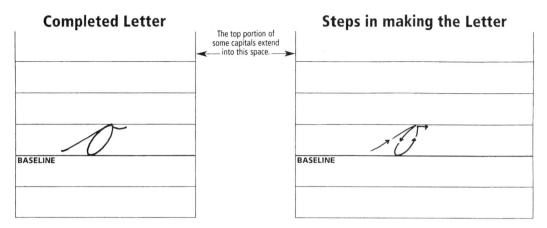

The top portion of some capitals extend into this space.

BASELINE

## Steps in making the Letter

BASELINE

## Practice making the Letter Yourself

The top portion of some capitals extend into this space.

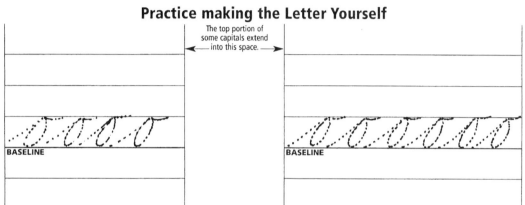

BASELINE

BASELINE

## Sample Letters / Words for Study
DOTTED DIAGONAL LINES SHOW PROPER LETTER SLANT

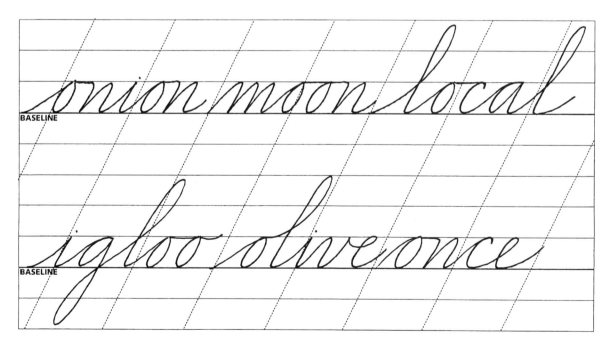

BASELINE

onion moon local

BASELINE

igloo olive once

## Completed Letter

## Steps in making the Letter

The top portion of some capitals extend into this space.

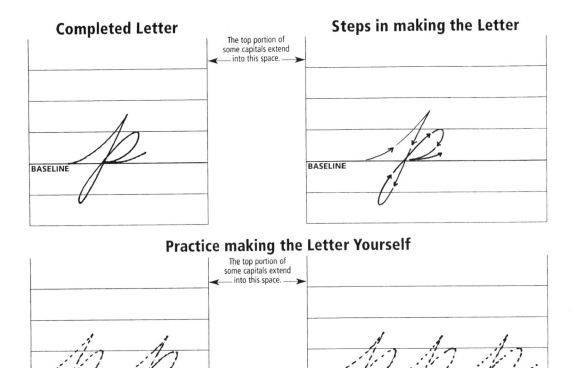

BASELINE

BASELINE

## Practice making the Letter Yourself

The top portion of some capitals extend into this space.

BASELINE

BASELINE

## Sample Letters / Words for Study
DOTTED DIAGONAL LINES SHOW PROPER LETTER SLANT

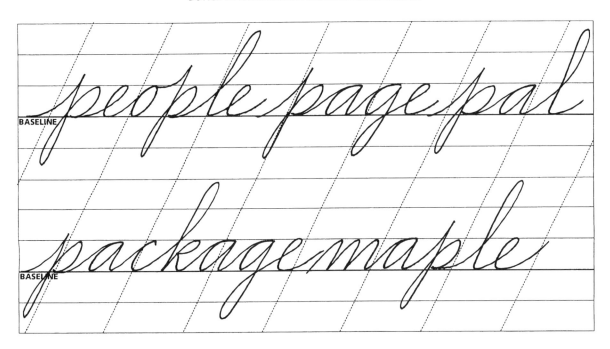

BASELINE

*people page pal*

BASELINE

*package maple*

| Completed Letter | | Steps in making the Letter |
|---|---|---|

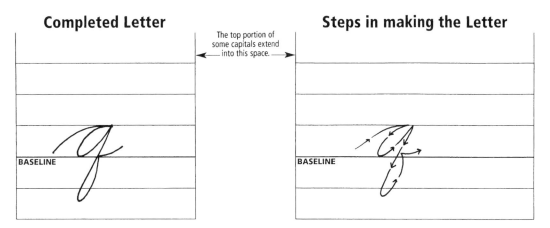

## Practice making the Letter Yourself

The top portion of
some capitals extend
into this space.

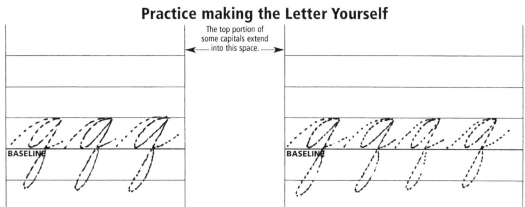

## Sample Letters / Words for Study
DOTTED DIAGONAL LINES SHOW PROPER LETTER SLANT

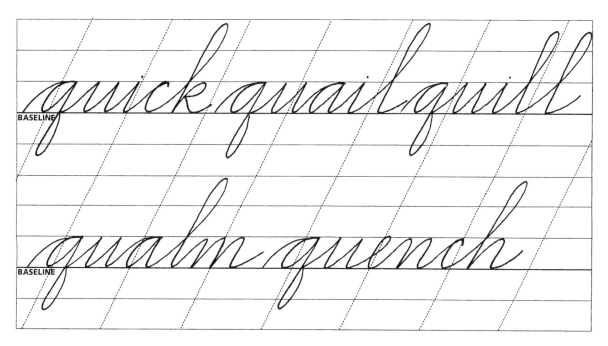

27

## Completed Letter

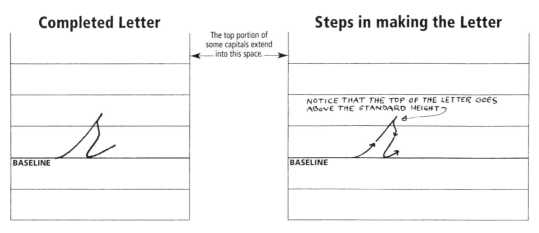

BASELINE

## Steps in making the Letter

The top portion of some capitals extend into this space.

NOTICE THAT THE TOP OF THE LETTER GOES ABOVE THE STANDARD HEIGHT

BASELINE

## Practice making the Letter Yourself

The top portion of some capitals extend into this space.

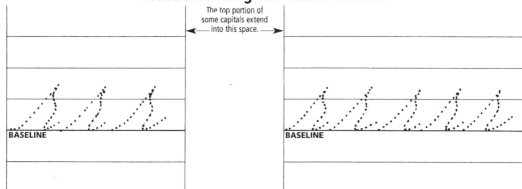

BASELINE

BASELINE

## Sample Letters / Words for Study
DOTTED DIAGONAL LINES SHOW PROPER LETTER SLANT

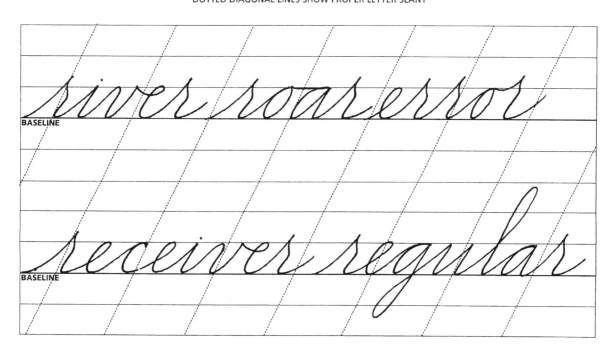

BASELINE

BASELINE

## Completed Letter

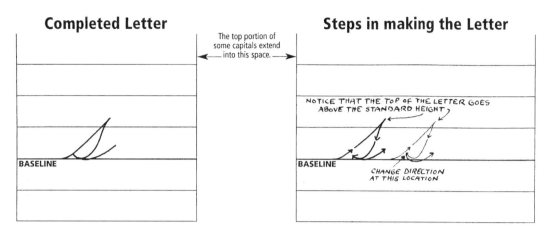

## Steps in making the Letter

NOTICE THAT THE TOP OF THE LETTER GOES ABOVE THE STANDARD HEIGHT

BASELINE

CHANGE DIRECTION AT THIS LOCATION

The top portion of some capitals extend into this space.

## Practice making the Letter Yourself

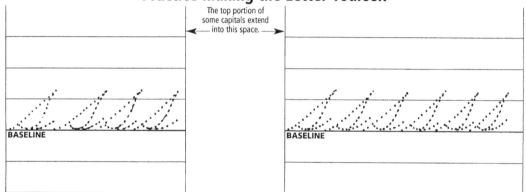

The top portion of some capitals extend into this space.

BASELINE

BASELINE

## Sample Letters / Words for Study
DOTTED DIAGONAL LINES SHOW PROPER LETTER SLANT

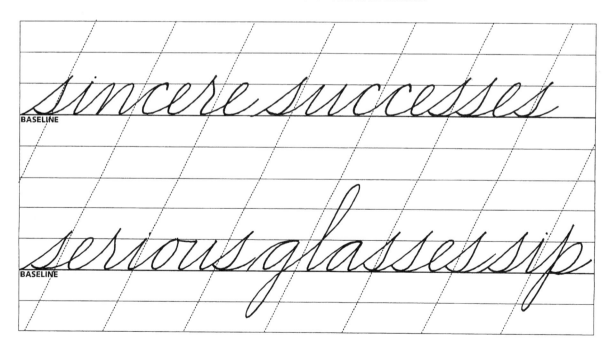

BASELINE

BASELINE

## Completed Letter

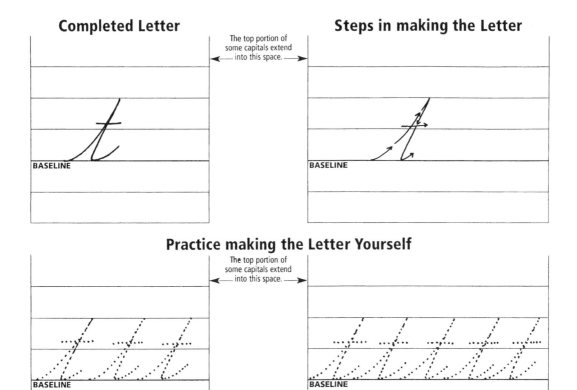

The top portion of some capitals extend into this space.

BASELINE

## Steps in making the Letter

BASELINE

## Practice making the Letter Yourself

The top portion of some capitals extend into this space.

BASELINE

BASELINE

## Sample Letters / Words for Study
DOTTED DIAGONAL LINES SHOW PROPER LETTER SLANT

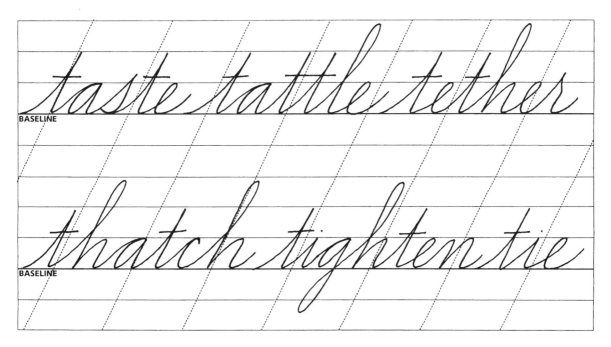

BASELINE

*taste tattle tether*

BASELINE

*thatch tighten tie*

## Completed Letter

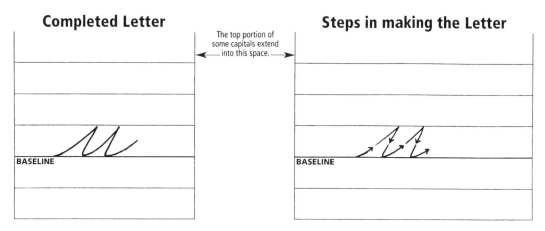

The top portion of some capitals extend into this space.

BASELINE

## Steps in making the Letter

BASELINE

## Practice making the Letter Yourself

The top portion of some capitals extend into this space.

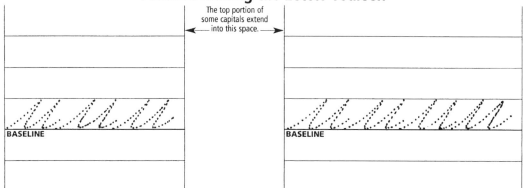

BASELINE

BASELINE

## Sample Letters / Words for Study
DOTTED DIAGONAL LINES SHOW PROPER LETTER SLANT

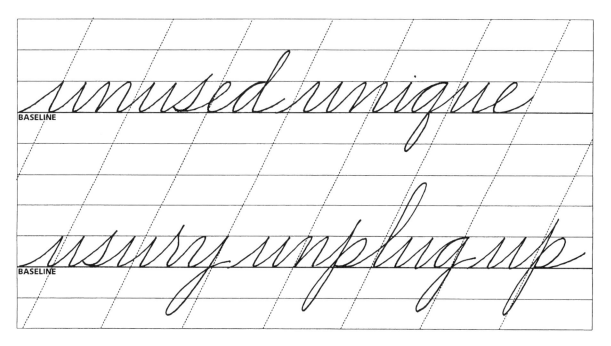

BASELINE

unused unique

BASELINE

usury unplug up

31

## Completed Letter

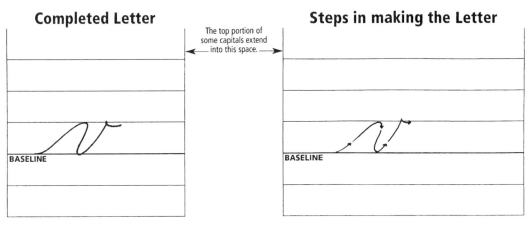

The top portion of some capitals extend into this space.

BASELINE

## Steps in making the Letter

The top portion of some capitals extend into this space.

BASELINE

## Practice making the Letter Yourself

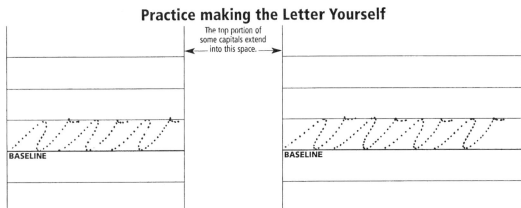

The top portion of some capitals extend into this space.

BASELINE

BASELINE

## Sample Letters / Words for Study
DOTTED DIAGONAL LINES SHOW PROPER LETTER SLANT

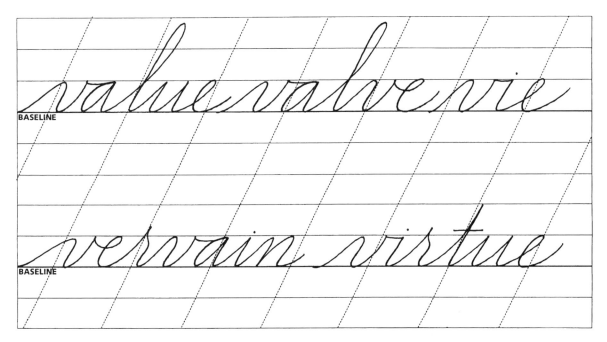

BASELINE

BASELINE

## Completed Letter

## Steps in making the Letter

The top portion of some capitals extend into this space.

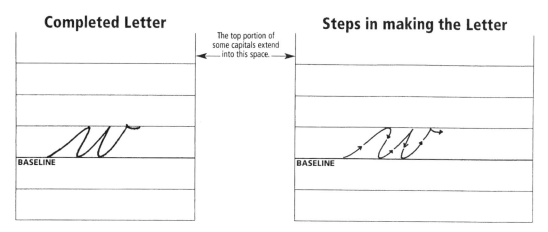

BASELINE

BASELINE

## Practice making the Letter Yourself

The top portion of some capitals extend into this space.

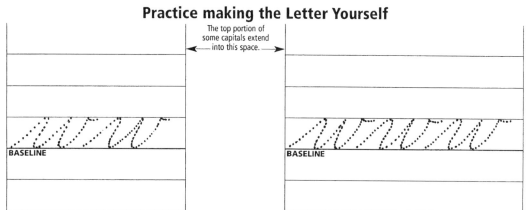

BASELINE

BASELINE

## Sample Letters / Words for Study
DOTTED DIAGONAL LINES SHOW PROPER LETTER SLANT

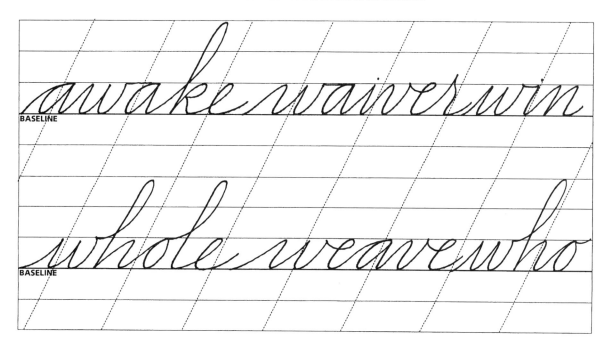

BASELINE

BASELINE

33

## Completed Letter

The top portion of some capitals extend into this space.

BASELINE

## Steps in making the Letter

The top portion of some capitals extend into this space.

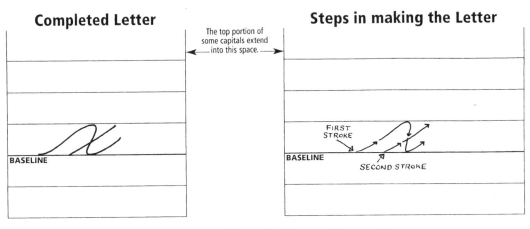

FIRST STROKE

BASELINE

SECOND STROKE

## Practice making the Letter Yourself

The top portion of some capitals extend into this space.

BASELINE

BASELINE

## Sample Letters / Words for Study
### DOTTED DIAGONAL LINES SHOW PROPER LETTER SLANT

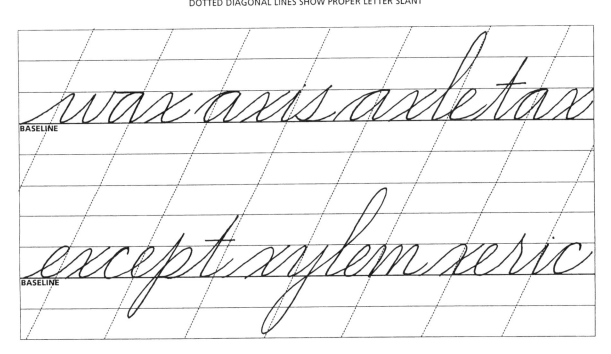

BASELINE

*wax axis axle tax*

BASELINE

*except xylem xeric*

34

## Completed Letter

The top portion of some capitals extend into this space.

BASELINE

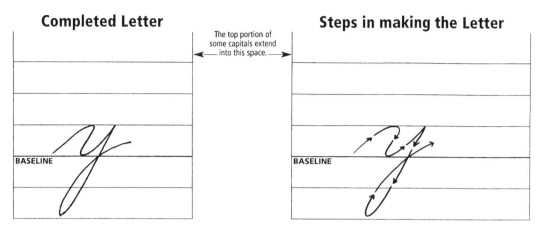

## Steps in making the Letter

The top portion of some capitals extend into this space.

BASELINE

## Practice making the Letter Yourself

The top portion of some capitals extend into this space.

BASELINE

BASELINE

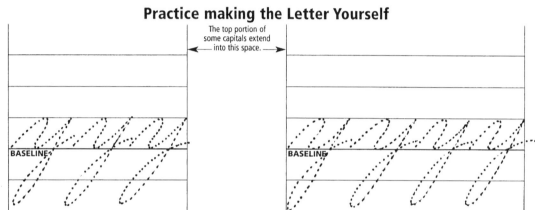

## Sample Letters / Words for Study
DOTTED DIAGONAL LINES SHOW PROPER LETTER SLANT

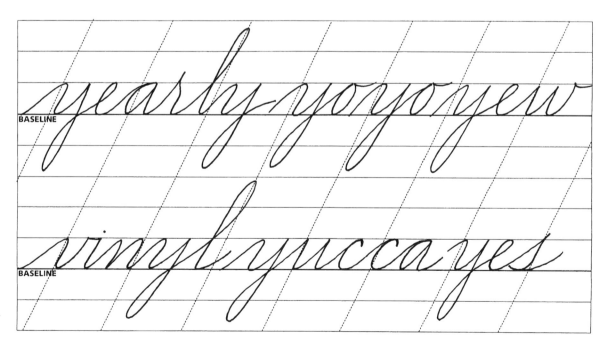

BASELINE

BASELINE

## Completed Letter

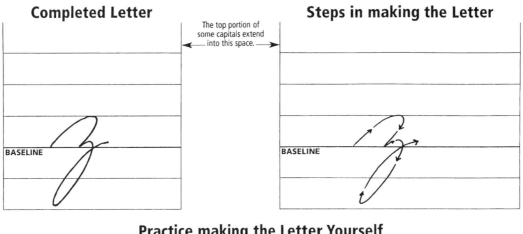

BASELINE

## Steps in making the Letter

BASELINE

## Practice making the Letter Yourself

The top portion of some capitals extend into this space.

BASELINE

BASELINE

## Sample Letters / Words for Study
DOTTED DIAGONAL LINES SHOW PROPER LETTER SLANT

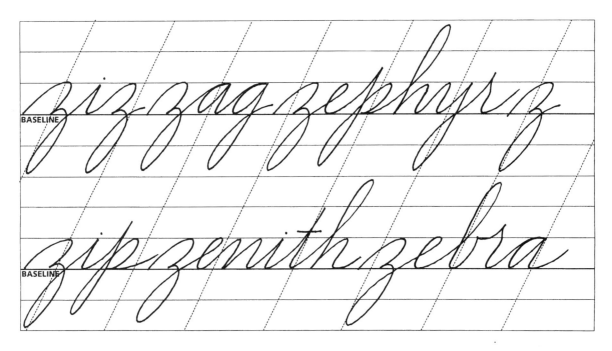

BASELINE

BASELINE

36

## Completed Letter

The top portion of some capitals extend into this space.

BASELINE

## Steps in making the Letter

BASELINE

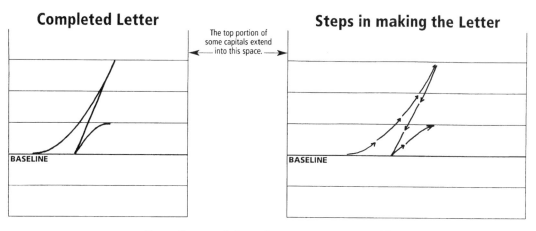

## Practice making the Letter Yourself

The top portion of some capitals extend into this space.

BASELINE

BASELINE

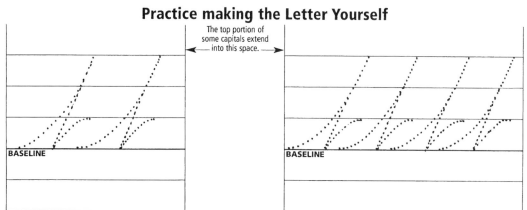

## Sample Letters / Words for Study
DOTTED DIAGONAL LINES SHOW PROPER LETTER SLANT

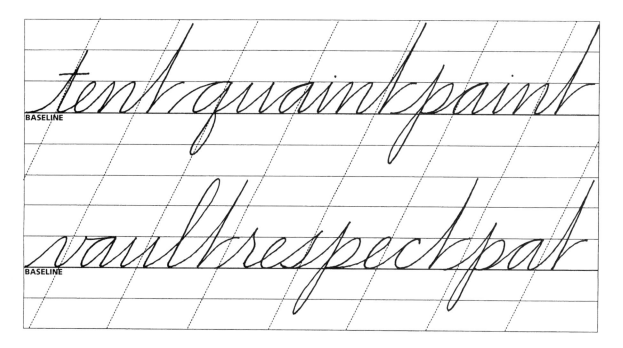

BASELINE

BASELINE

## Completed Letter

## Steps in making the Letter

The top portion of some capitals extend into this space.

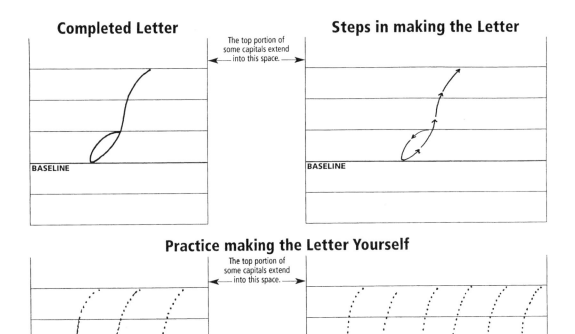

BASELINE

BASELINE

## Practice making the Letter Yourself

The top portion of some capitals extend into this space.

BASELINE

BASELINE

## Sample Letters / Words for Study
DOTTED DIAGONAL LINES SHOW PROPER LETTER SLANT

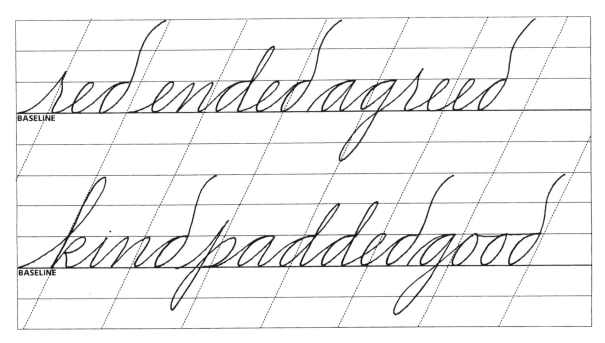

BASELINE

BASELINE

## Completed Letter

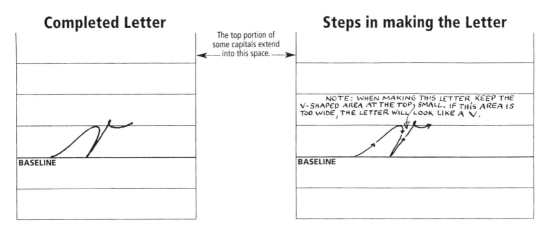

The top portion of some capitals extend into this space.

BASELINE

## Steps in making the Letter

NOTE: WHEN MAKING THIS LETTER, KEEP THE V-SHAPED AREA AT THE TOP, SMALL. IF THIS AREA IS TOO WIDE, THE LETTER WILL LOOK LIKE A V.

BASELINE

## Practice making the Letter Yourself

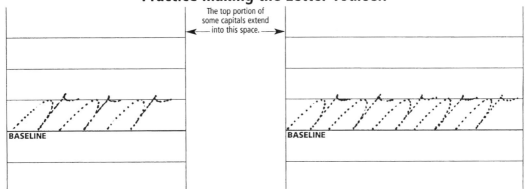

The top portion of some capitals extend into this space.

BASELINE

BASELINE

## Sample Letters / Words for Study
DOTTED DIAGONAL LINES SHOW PROPER LETTER SLANT

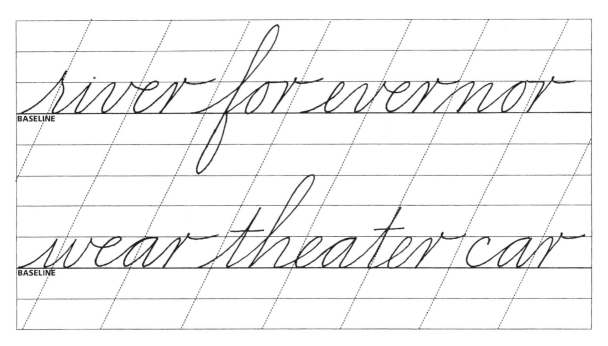

BASELINE

BASELINE

## Completed Letter

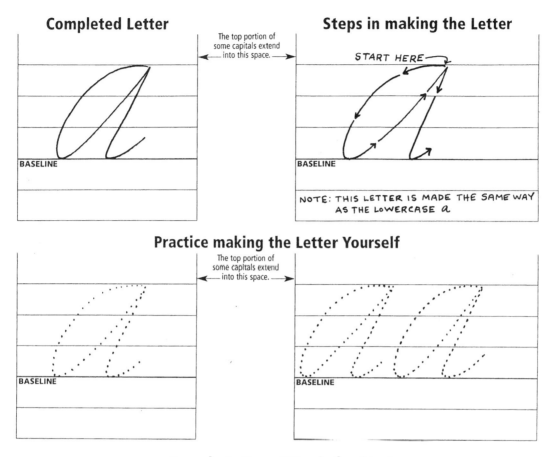

The top portion of some capitals extend into this space.

BASELINE

## Steps in making the Letter

START HERE

BASELINE

NOTE: THIS LETTER IS MADE THE SAME WAY AS THE LOWERCASE a

## Practice making the Letter Yourself

The top portion of some capitals extend into this space.

BASELINE

BASELINE

## Sample Letters / Words for Study
DOTTED DIAGONAL LINES SHOW PROPER LETTER SLANT

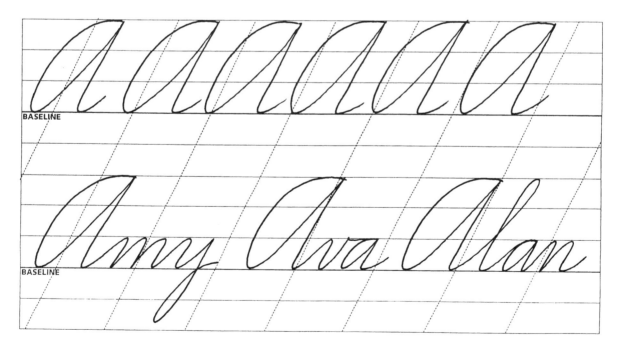

BASELINE

BASELINE

40

## Completed Letter

The top portion of some capitals extend into this space. ◄———►

BASELINE

## Steps in making the Letter

The top portion of some capitals extend into this space. ◄———►

START HERE ───►

BASELINE

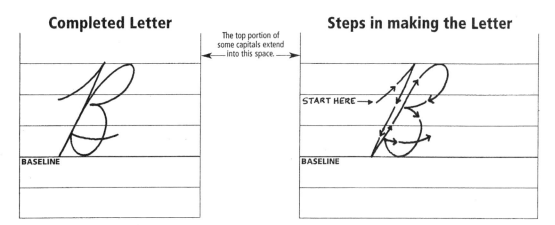

## Practice making the Letter Yourself

The top portion of some capitals extend into this space. ◄———►

BASELINE

BASELINE

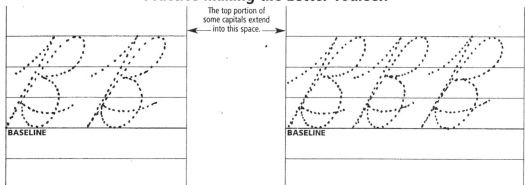

## Sample Letters / Words for Study
DOTTED DIAGONAL LINES SHOW PROPER LETTER SLANT

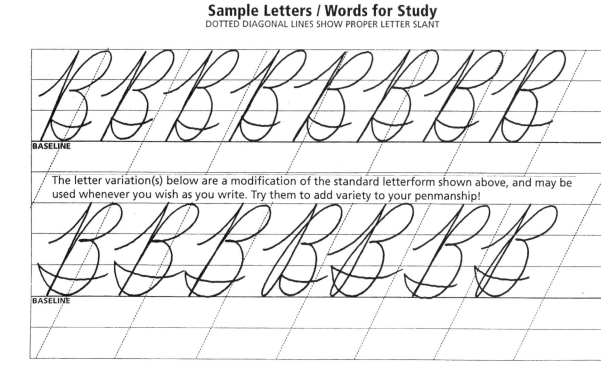

BASELINE

The letter variation(s) below are a modification of the standard letterform shown above, and may be used whenever you wish as you write. Try them to add variety to your penmanship!

BASELINE

41

## Completed Letter

The top portion of some capitals extend into this space.

BASELINE

## Steps in making the Letter

START HERE

BASELINE

## Practice making the Letter Yourself

The top portion of some capitals extend into this space.

BASELINE

BASELINE

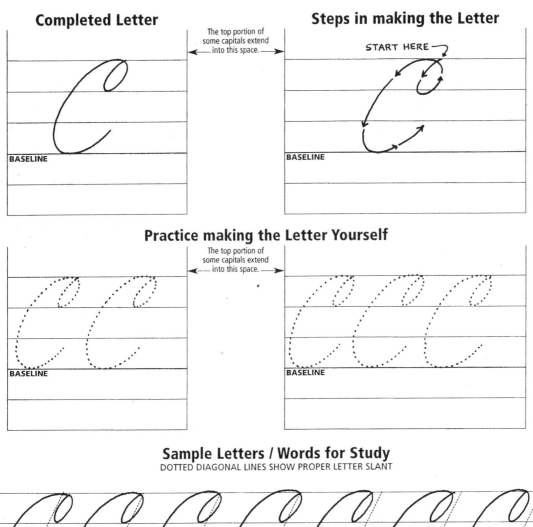

## Sample Letters / Words for Study
DOTTED DIAGONAL LINES SHOW PROPER LETTER SLANT

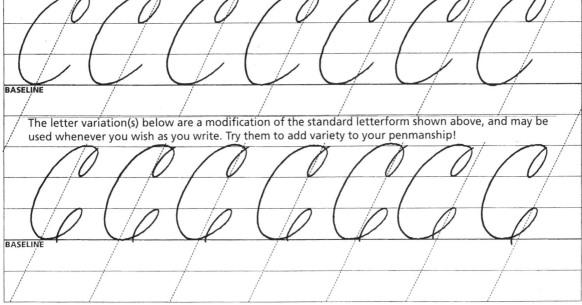

BASELINE

The letter variation(s) below are a modification of the standard letterform shown above, and may be used whenever you wish as you write. Try them to add variety to your penmanship!

BASELINE

## Completed Letter

The top portion of some capitals extend into this space.

BASELINE

## Steps in making the Letter

START HERE

BASELINE

## Practice making the Letter Yourself

The top portion of some capitals extend into this space.

BASELINE

BASELINE

## Sample Letters / Words for Study
DOTTED DIAGONAL LINES SHOW PROPER LETTER SLANT

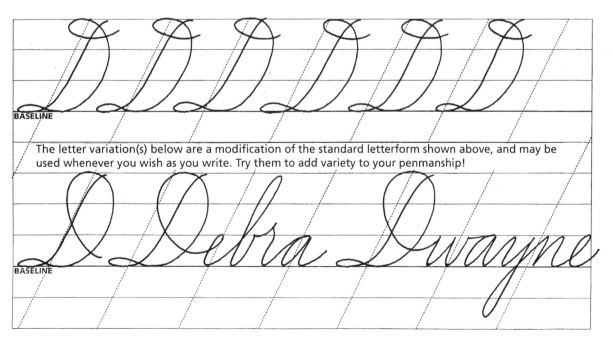

BASELINE

The letter variation(s) below are a modification of the standard letterform shown above, and may be used whenever you wish as you write. Try them to add variety to your penmanship!

BASELINE

43

## Completed Letter

The top portion of some capitals extend into this space.

BASELINE

## Steps in making the Letter

START HERE

BASELINE

## Practice making the Letter Yourself

The top portion of some capitals extend into this space.

BASELINE

BASELINE

## Sample Letters / Words for Study
DOTTED DIAGONAL LINES SHOW PROPER LETTER SLANT

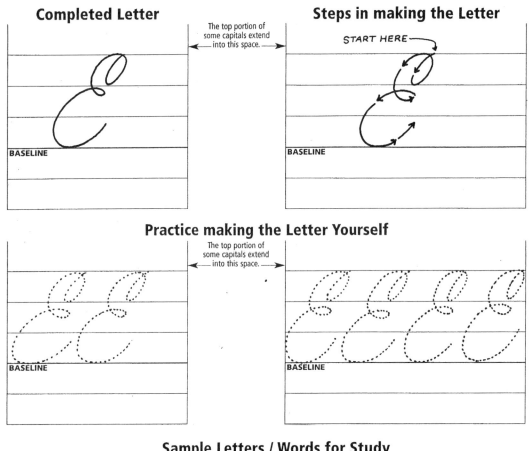

BASELINE

The letter variation(s) below are a modification of the standard letterform shown above, and may be used whenever you wish as you write. Try them to add variety to your penmanship!

BASELINE

## Completed Letter

The top portion of some capitals extend into this space.

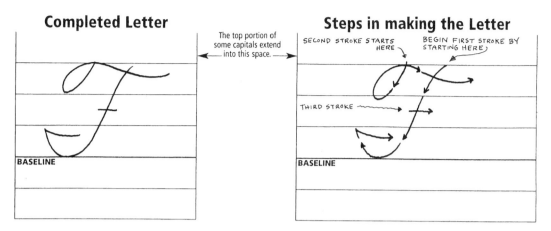

BASELINE

## Steps in making the Letter

SECOND STROKE STARTS HERE

BEGIN FIRST STROKE BY STARTING HERE

THIRD STROKE

BASELINE

## Practice making the Letter Yourself

The top portion of some capitals extend into this space.

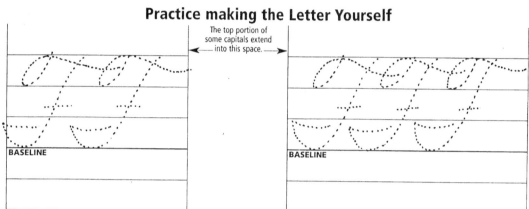

BASELINE

BASELINE

## Sample Letters / Words for Study
DOTTED DIAGONAL LINES SHOW PROPER LETTER SLANT

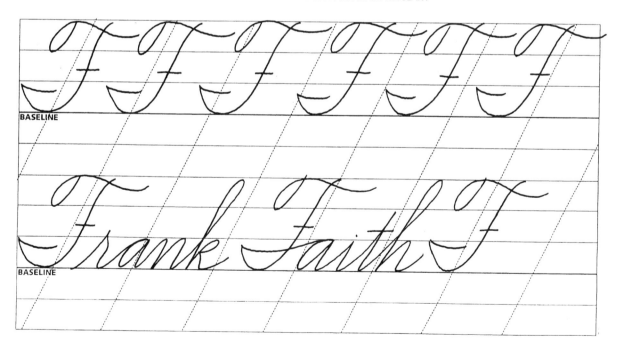

BASELINE

BASELINE

45

## Completed Letter

The top portion of some capitals extend into this space.

BASELINE

## Steps in making the Letter

The top portion of some capitals extend into this space.

START HERE

BASELINE

## Practice making the Letter Yourself

The top portion of some capitals extend into this space.

BASELINE

BASELINE

## Sample Letters / Words for Study

DOTTED DIAGONAL LINES SHOW PROPER LETTER SLANT

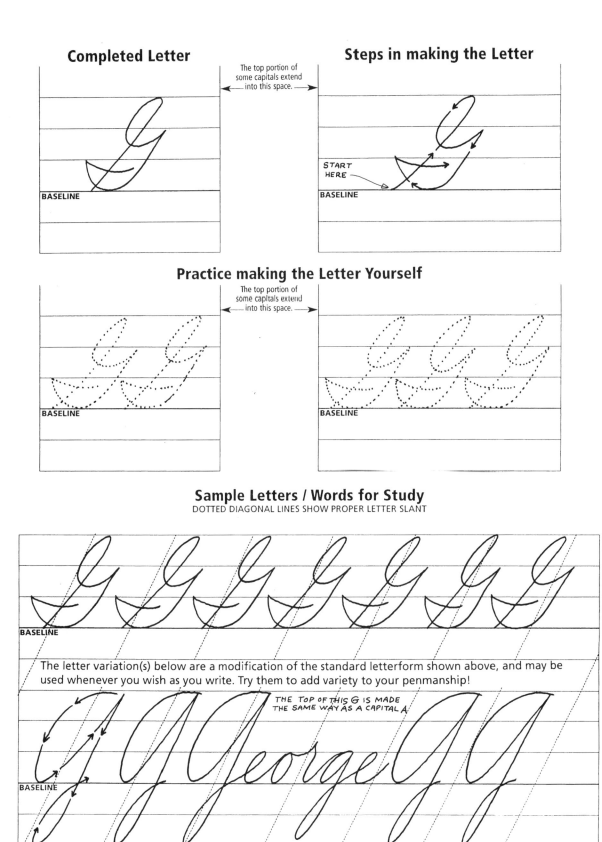

BASELINE

The letter variation(s) below are a modification of the standard letterform shown above, and may be used whenever you wish as you write. Try them to add variety to your penmanship!

THE TOP OF THIS G IS MADE THE SAME WAY AS A CAPITAL A

George

BASELINE

46

## Completed Letter

The top portion of some capitals extend into this space.

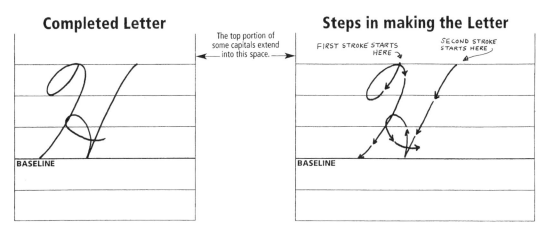

BASELINE

## Steps in making the Letter

FIRST STROKE STARTS HERE

SECOND STROKE STARTS HERE

BASELINE

## Practice making the Letter Yourself

The top portion of some capitals extend into this space.

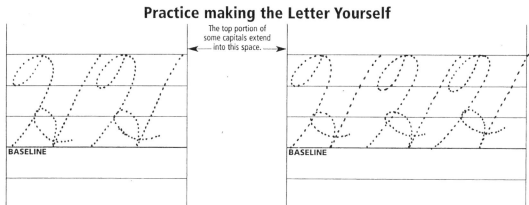

BASELINE

BASELINE

## Sample Letters / Words for Study
DOTTED DIAGONAL LINES SHOW PROPER LETTER SLANT

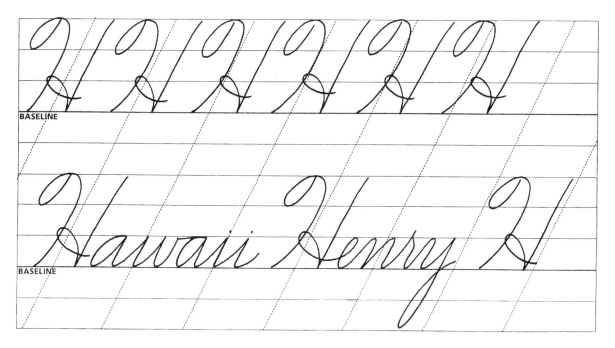

BASELINE

BASELINE

## Completed Letter

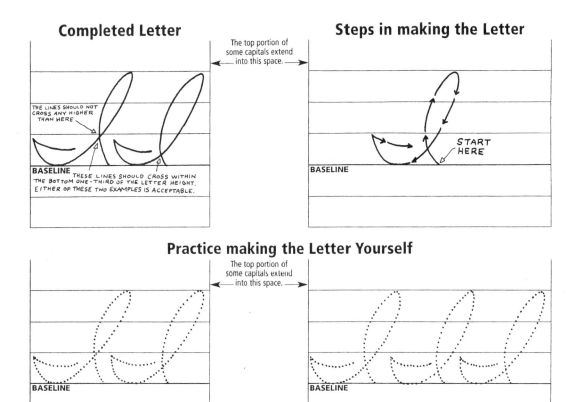

The top portion of some capitals extend into this space.

THE LINES SHOULD NOT CROSS ANY HIGHER THAN HERE

BASELINE

THESE LINES SHOULD CROSS WITHIN THE BOTTOM ONE-THIRD OF THE LETTER HEIGHT. EITHER OF THESE TWO EXAMPLES IS ACCEPTABLE.

## Steps in making the Letter

START HERE

BASELINE

## Practice making the Letter Yourself

The top portion of some capitals extend into this space.

BASELINE

BASELINE

## Sample Letters / Words for Study
DOTTED DIAGONAL LINES SHOW PROPER LETTER SLANT

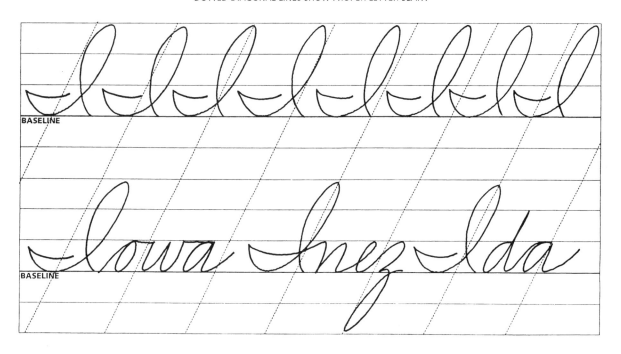

BASELINE

BASELINE

48

## Completed Letter

The top portion of some capitals extend into this space.

BASELINE

## Steps in making the Letter

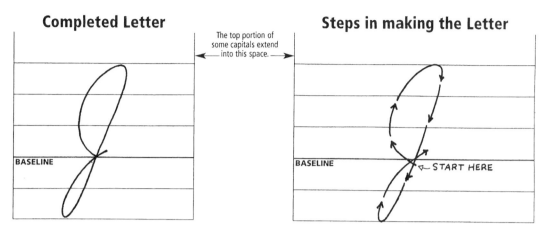

BASELINE

START HERE

## Practice making the Letter Yourself

The top portion of some capitals extend into this space.

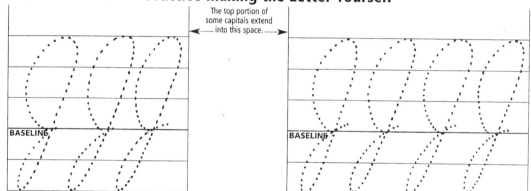

BASELINE

BASELINE

## Sample Letters / Words for Study
DOTTED DIAGONAL LINES SHOW PROPER LETTER SLANT

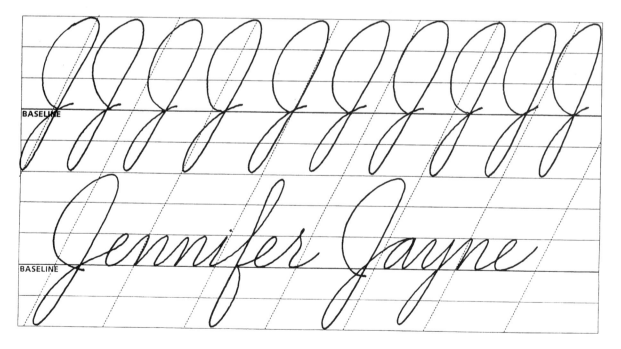

BASELINE

BASELINE

*Jennifer Jayne*

## Completed Letter

The top portion of some capitals extend into this space.

BASELINE

## Steps in making the Letter

FIRST STROKE STARTS HERE

SECOND STROKE STARTS HERE

BASELINE

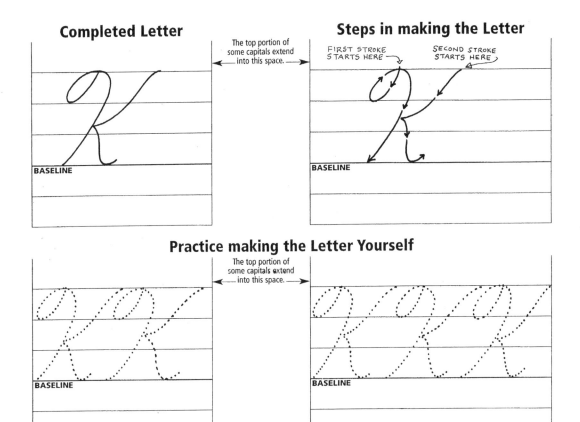

## Practice making the Letter Yourself

The top portion of some capitals extend into this space.

BASELINE

BASELINE

## Sample Letters / Words for Study
DOTTED DIAGONAL LINES SHOW PROPER LETTER SLANT

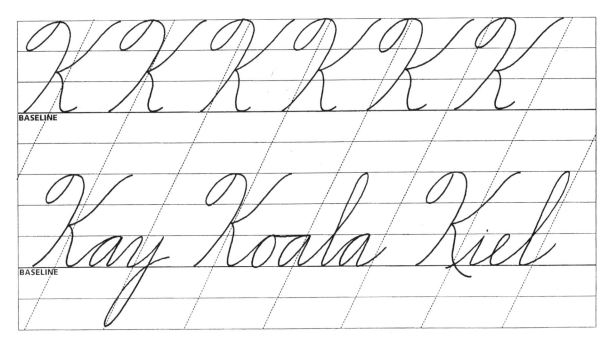

BASELINE

BASELINE

50

## Completed Letter

The top portion of some capitals extend into this space.

## Steps in making the Letter

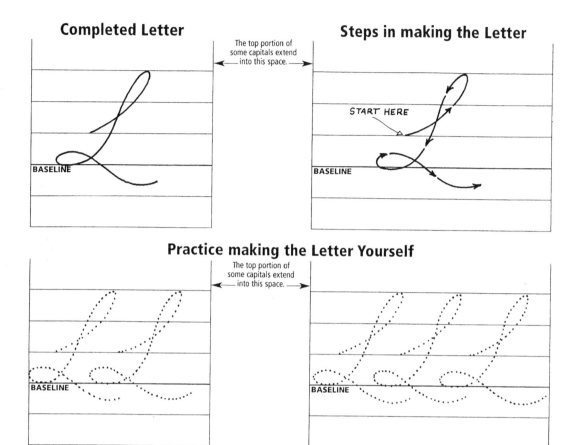

START HERE

BASELINE

BASELINE

## Practice making the Letter Yourself

The top portion of some capitals extend into this space.

BASELINE

BASELINE

## Sample Letters / Words for Study
DOTTED DIAGONAL LINES SHOW PROPER LETTER SLANT

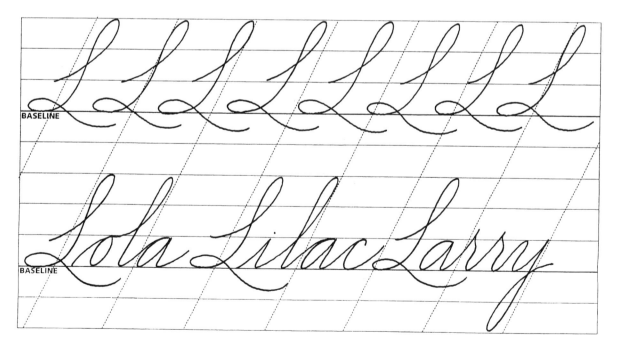

BASELINE

BASELINE

51

## Completed Letter

The top portion of some capitals extend into this space.

BASELINE

## Steps in making the Letter

START HERE

BASELINE

## Practice making the Letter Yourself

The top portion of some capitals extend into this space.

BASELINE

BASELINE

## Sample Letters / Words for Study
DOTTED DIAGONAL LINES SHOW PROPER LETTER SLANT

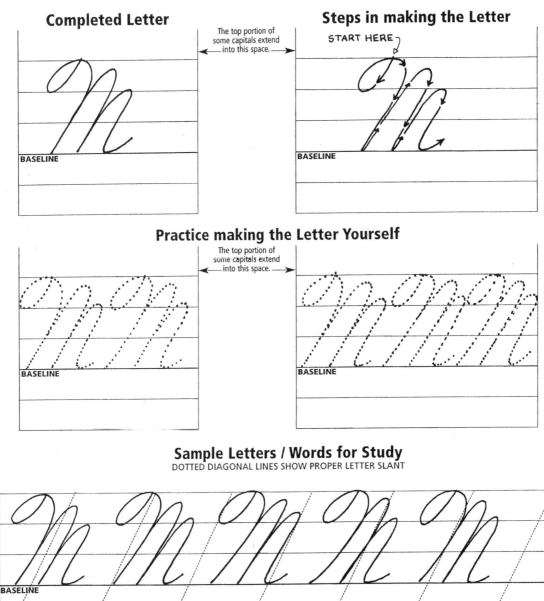

BASELINE

The letter variation(s) below are a modification of the standard letterform shown above, and may be used whenever you wish as you write. Try them to add variety to your penmanship!

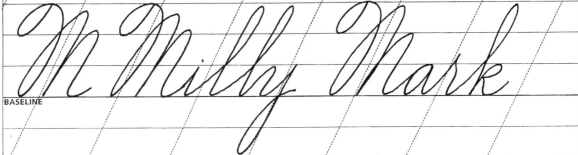

BASELINE

52

## Completed Letter

The top portion of some capitals extend into this space.

BASELINE

## Steps in making the Letter

START HERE

BASELINE

## Practice making the Letter Yourself

The top portion of some capitals extend into this space.

BASELINE

BASELINE

## Sample Letters / Words for Study
DOTTED DIAGONAL LINES SHOW PROPER LETTER SLANT

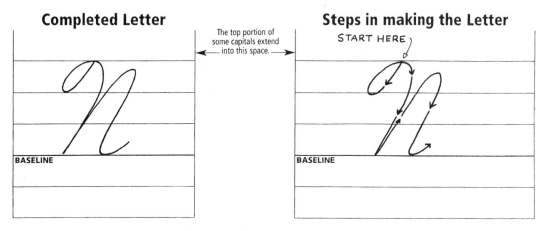

BASELINE

The letter variation(s) below are a modification of the standard letterform shown above, and may be used whenever you wish as you write. Try them to add variety to your penmanship!

BASELINE

## Completed Letter

The top portion of some capitals extend into this space.

BASELINE

## Steps in making the Letter

START HERE

BASELINE

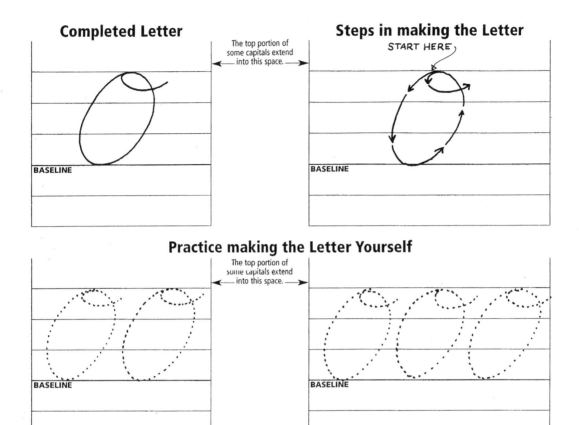

## Practice making the Letter Yourself

The top portion of some capitals extend into this space.

BASELINE

BASELINE

## Sample Letters / Words for Study
DOTTED DIAGONAL LINES SHOW PROPER LETTER SLANT

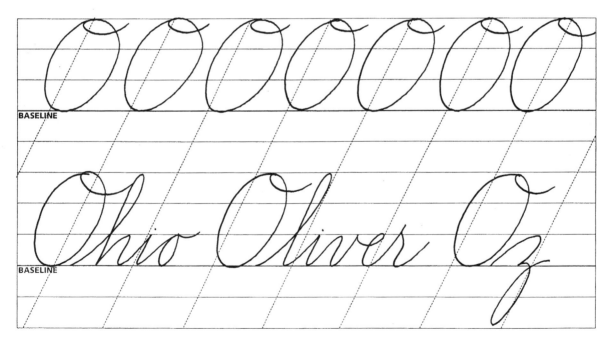

BASELINE

BASELINE

54

## Completed Letter

The top portion of some capitals extend into this space.

BASELINE

## Steps in making the Letter

START HERE

BASELINE

## Practice making the Letter Yourself

The top portion of some capitals extend into this space.

BASELINE

BASELINE

## Sample Letters / Words for Study
DOTTED DIAGONAL LINES SHOW PROPER LETTER SLANT

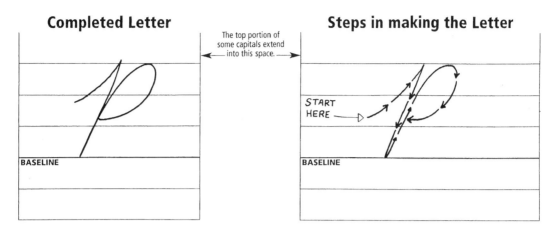

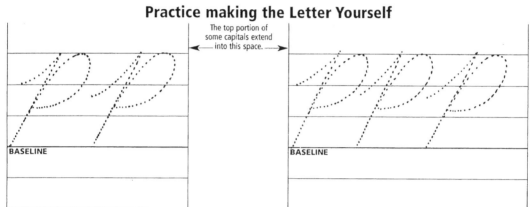

BASELINE

The letter variation(s) below are a modification of the standard letterform shown above, and may be used whenever you wish as you write. Try them to add variety to your penmanship!

BASELINE

## Completed Letter

The top portion of some capitals extend into this space.

BASELINE

## Steps in making the Letter

START HERE

BASELINE

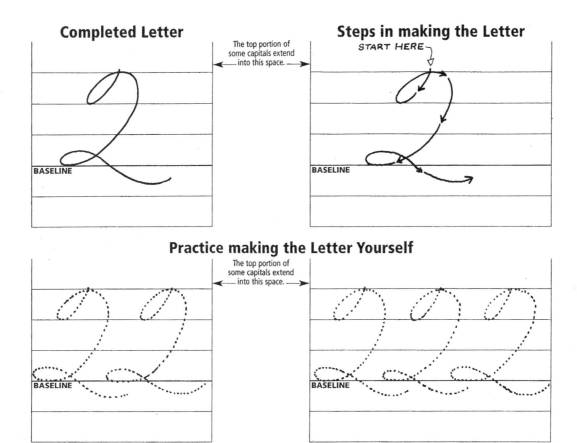

## Practice making the Letter Yourself

The top portion of some capitals extend into this space.

BASELINE

BASELINE

## Sample Letters / Words for Study
DOTTED DIAGONAL LINES SHOW PROPER LETTER SLANT

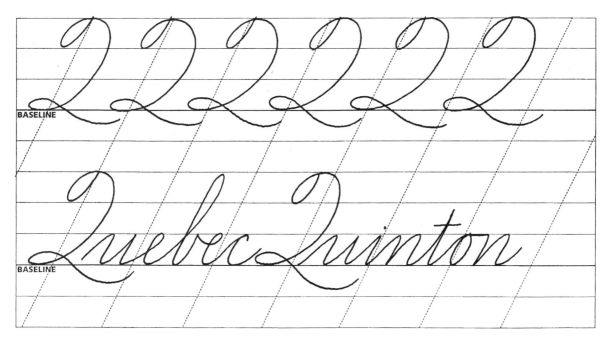

BASELINE

BASELINE

## Completed Letter

The top portion of some capitals extend into this space.

BASELINE

## Steps in making the Letter

START HERE

BASELINE

## Practice making the Letter Yourself

The top portion of some capitals extend into this space.

BASELINE

BASELINE

## Sample Letters / Words for Study
DOTTED DIAGONAL LINES SHOW PROPER LETTER SLANT

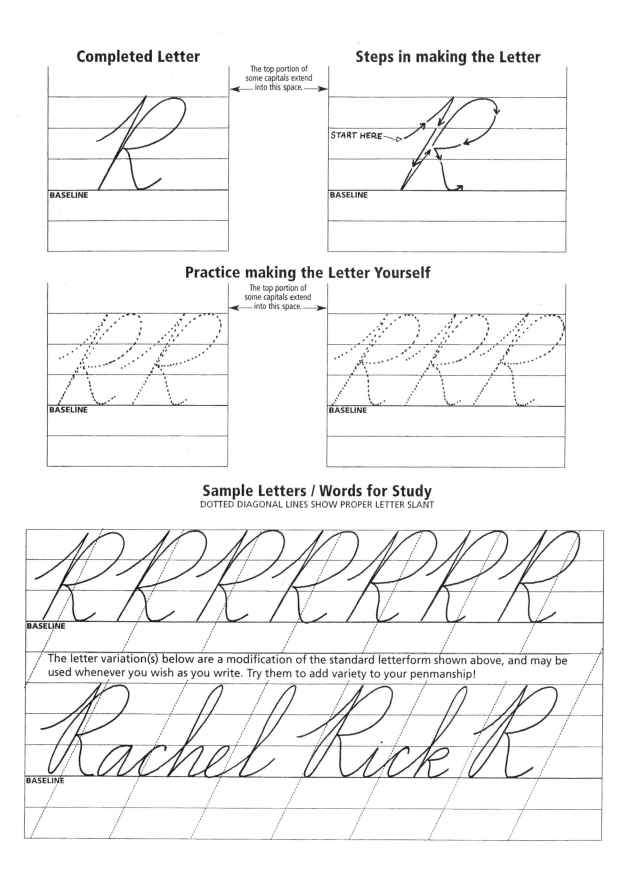

BASELINE

The letter variation(s) below are a modification of the standard letterform shown above, and may be used whenever you wish as you write. Try them to add variety to your penmanship!

BASELINE

*Rachel Rick R*

57

## Completed Letter

The top portion of some capitals extend into this space.

BASELINE

## Steps in making the Letter

The top portion of some capitals extend into this space.

BASELINE

START HERE

## Practice making the Letter Yourself

The top portion of some capitals extend into this space.

BASELINE

BASELINE

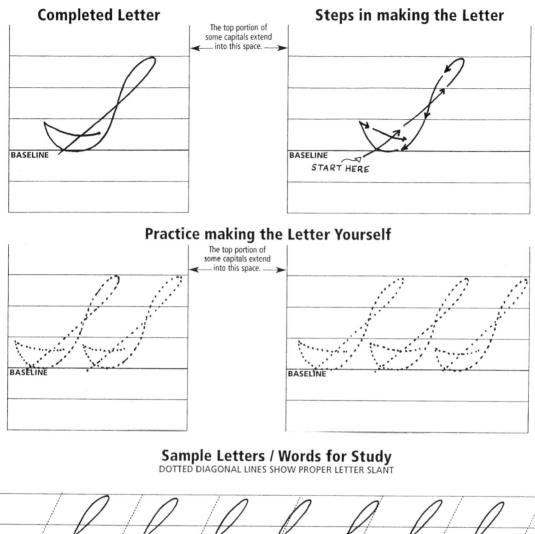

## Sample Letters / Words for Study
DOTTED DIAGONAL LINES SHOW PROPER LETTER SLANT

BASELINE

BASELINE

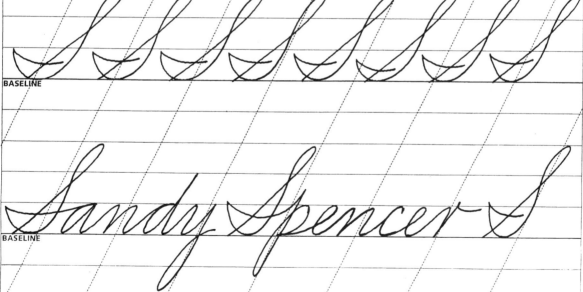

58

## Completed Letter

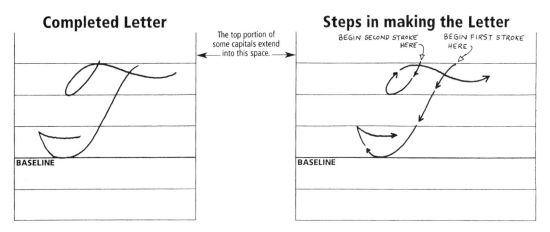

The top portion of some capitals extend into this space.

## Steps in making the Letter

BEGIN SECOND STROKE HERE

BEGIN FIRST STROKE HERE

BASELINE

BASELINE

## Practice making the Letter Yourself

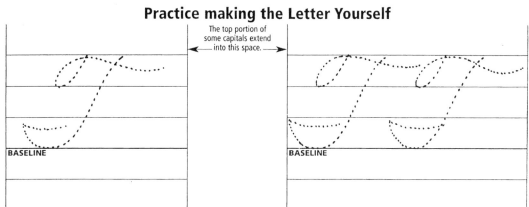

The top portion of some capitals extend into this space.

BASELINE

BASELINE

## Sample Letters / Words for Study

DOTTED DIAGONAL LINES SHOW PROPER LETTER SLANT

BASELINE

BASELINE

*Thomas Thelma*

## Completed Letter

The top portion of some capitals extend into this space.

## Steps in making the Letter

START HERE

BASELINE

BASELINE

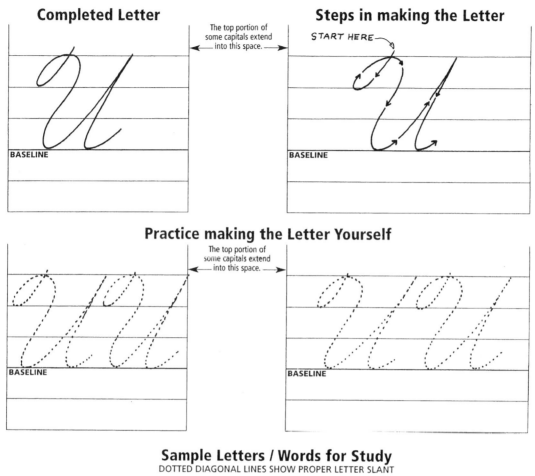

## Practice making the Letter Yourself

The top portion of some capitals extend into this space.

BASELINE

BASELINE

## Sample Letters / Words for Study
DOTTED DIAGONAL LINES SHOW PROPER LETTER SLANT

BASELINE

BASELINE

## Completed Letter

The top portion of some capitals extend into this space.

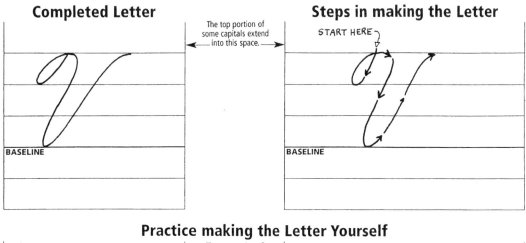

BASELINE

## Steps in making the Letter

START HERE

BASELINE

## Practice making the Letter Yourself

The top portion of some capitals extend into this space.

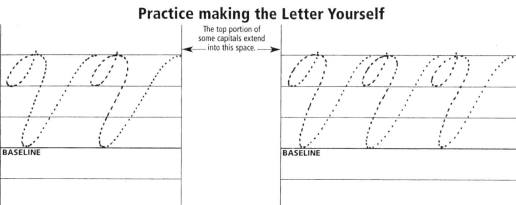

BASELINE

BASELINE

## Sample Letters / Words for Study

DOTTED DIAGONAL LINES SHOW PROPER LETTER SLANT

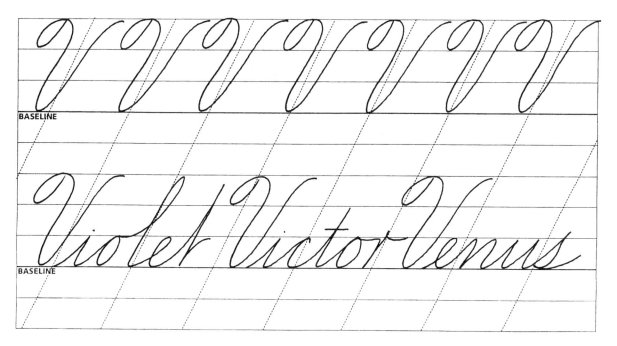

BASELINE

BASELINE

## Completed Letter

The top portion of some capitals extend into this space.

BASELINE

## Steps in making the Letter

START HERE

BASELINE

## Practice making the Letter Yourself

The top portion of some capitals extend into this space.

BASELINE

BASELINE

## Sample Letters / Words for Study
DOTTED DIAGONAL LINES SHOW PROPER LETTER SLANT

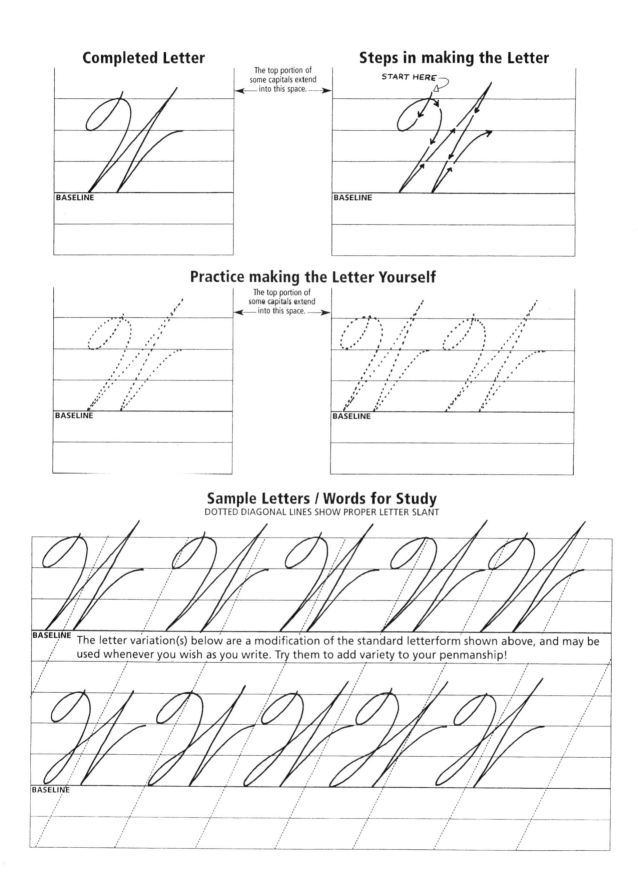

BASELINE

The letter variation(s) below are a modification of the standard letterform shown above, and may be used whenever you wish as you write. Try them to add variety to your penmanship!

BASELINE

## Completed Letter

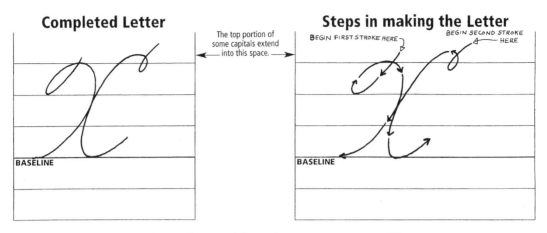

The top portion of some capitals extend into this space.

BASELINE

## Steps in making the Letter

BEGIN FIRST STROKE HERE

BEGIN SECOND STROKE HERE

BASELINE

## Practice making the Letter Yourself

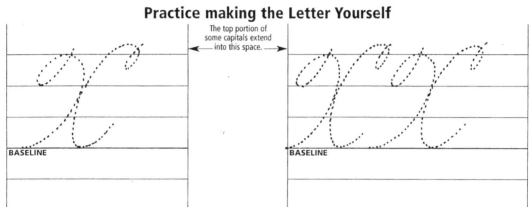

The top portion of some capitals extend into this space.

BASELINE

BASELINE

PRACTICE THIS PART OF THE LETTER FIRST!

## Sample Letters / Words for Study
DOTTED DIAGONAL LINES SHOW PROPER LETTER SLANT

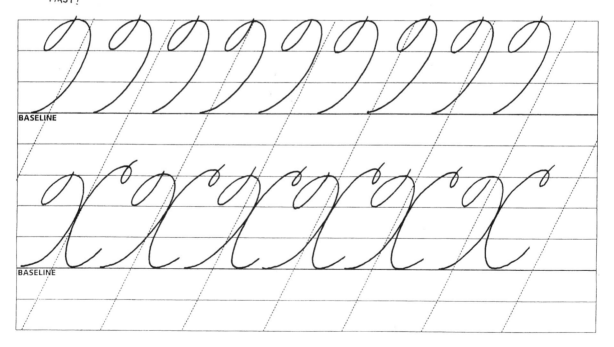

BASELINE

BASELINE

63

## Completed Letter

The top portion of some capitals extend into this space.

BASELINE

## Steps in making the Letter

START HERE

BASELINE

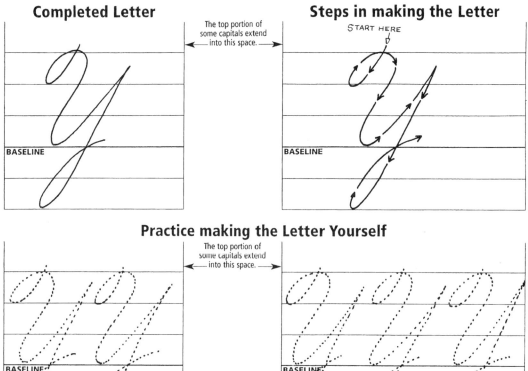

## Practice making the Letter Yourself

The top portion of some capitals extend into this space.

BASELINE

BASELINE

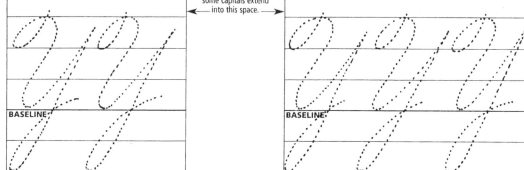

## Sample Letters / Words for Study
DOTTED DIAGONAL LINES SHOW PROPER LETTER SLANT

BASELINE

BASELINE

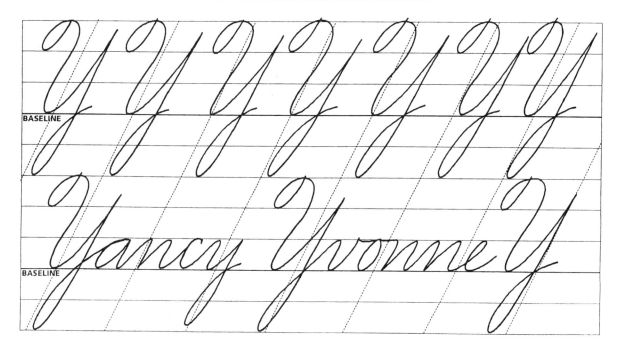

## Completed Letter

The top portion of some capitals extend into this space.

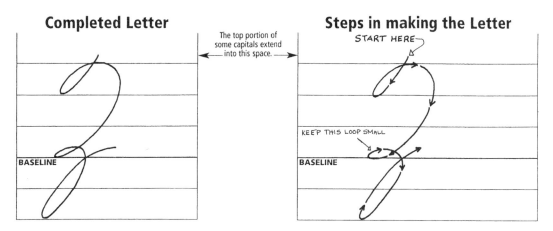

## Steps in making the Letter

START HERE

KEEP THIS LOOP SMALL

BASELINE

## Practice making the Letter Yourself

The top portion of some capitals extend into this space.

BASELINE

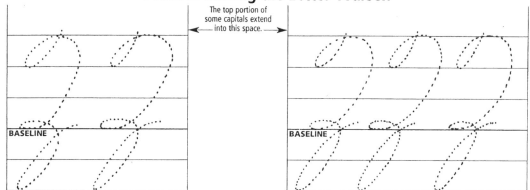

## Sample Letters / Words for Study
DOTTED DIAGONAL LINES SHOW PROPER LETTER SLANT

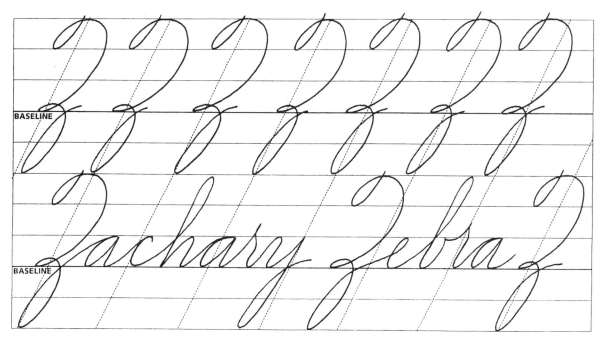

BASELINE

BASELINE

# Model Numbers

*In this section, arrows show the direction of movement as you write each number.*

## Completed Number

The top portion of some capitals extend ←—into this space.—→

BASELINE

## Steps in making the Number

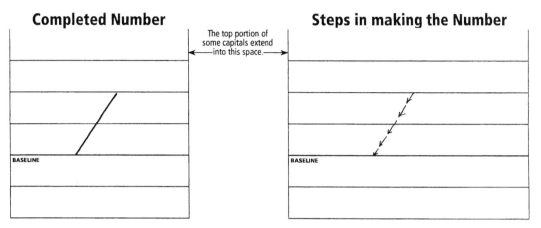

BASELINE

## Practice making the Number Yourself

Trace over the dotted line.

The top portion of some capitals extend ←—into this space.—→

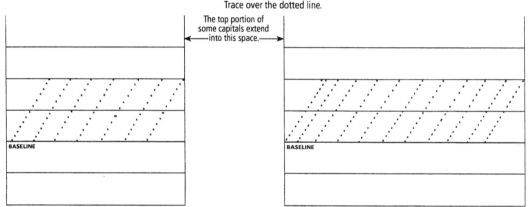

BASELINE

BASELINE

## Sample Numbers for Study and Practice

DOTTED DIAGONAL LINES SHOW PROPER LETTER SLANT (35° FROM THE VERTICAL)

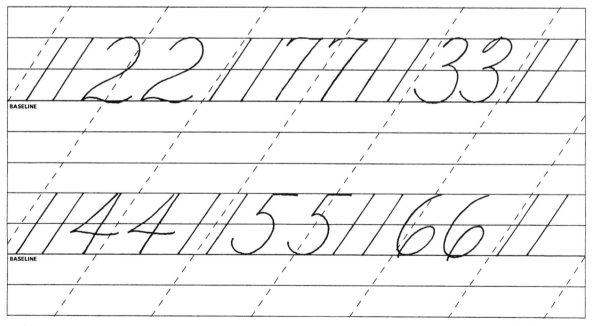

BASELINE

BASELINE

## Completed Number

THIS ALTERNATE VERSION OF THE 2 IS SIMILAR TO THE CAPITAL Q

The top portion of some capitals extend ←into this space.→

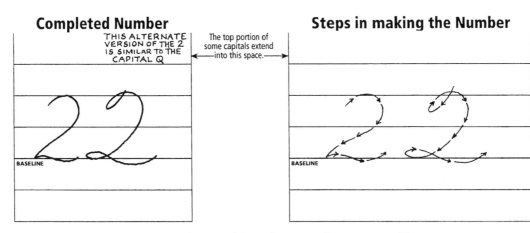

BASELINE

## Steps in making the Number

BASELINE

## Practice making the Number Yourself

Trace over the dotted line.

The top portion of some capitals extend ←into this space.→

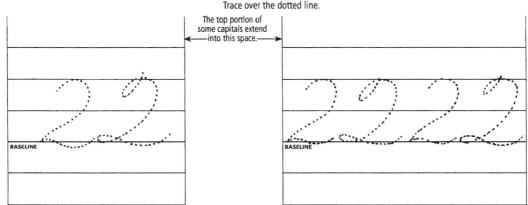

BASELINE

BASELINE

## Sample Numbers for Study and Practice

DOTTED DIAGONAL LINES SHOW PROPER LETTER SLANT (35° FROM THE VERTICAL)

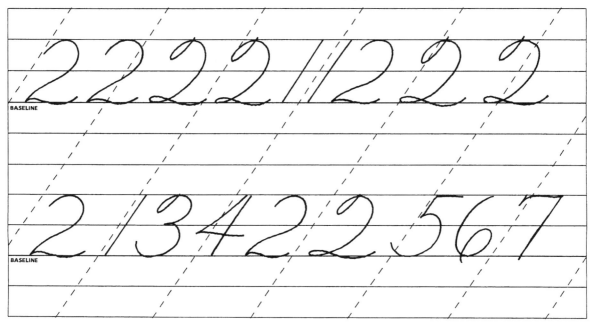

BASELINE

BASELINE

70

## Completed Number

ALTERNATE
VARIETY

The top portion of
some capitals extend
←———into this space.———→

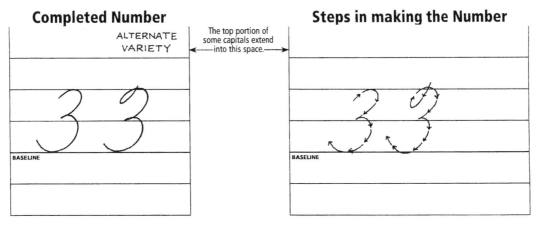

BASELINE

## Steps in making the Number

BASELINE

## Practice making the Number Yourself
Trace over the dotted line.

The top portion of
some capitals extend
←———into this space.———→

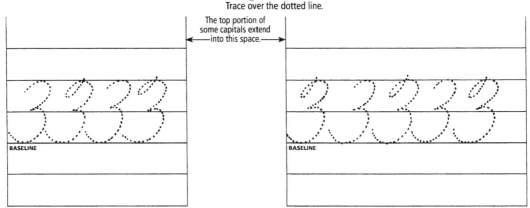

BASELINE

BASELINE

## Sample Numbers for Study and Practice
DOTTED DIAGONAL LINES SHOW PROPER LETTER SLANT (35º FROM THE VERTICAL)

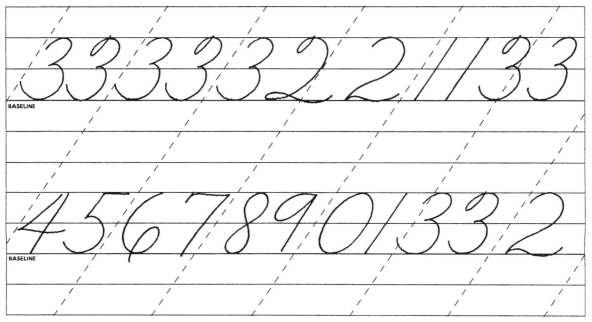

BASELINE

BASELINE

71

## Completed Number

The top portion of some capitals extend into this space.

BASELINE

## Steps in making the Number

THE TOP MAY BE CLOSED IF YOU WISH

BASELINE

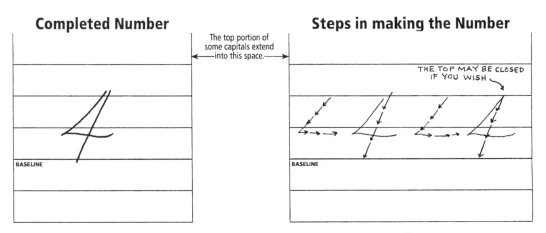

## Practice making the Number Yourself

Trace over the dotted line.

The top portion of some capitals extend into this space.

BASELINE

BASELINE

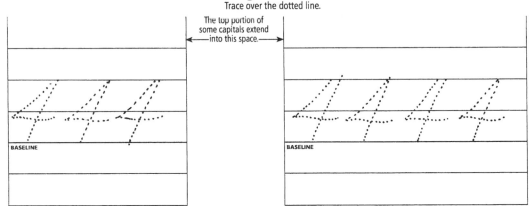

## Sample Numbers for Study and Practice

DOTTED DIAGONAL LINES SHOW PROPER LETTER SLANT (35° FROM THE VERTICAL)

BASELINE

BASELINE

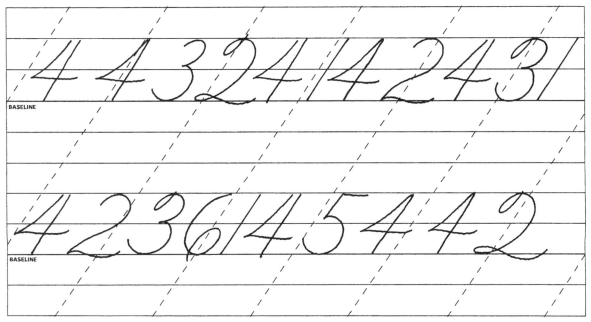

## Completed Number

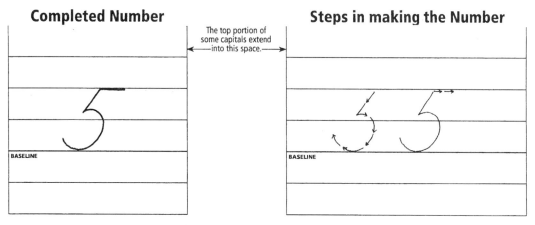

## Steps in making the Number

The top portion of some capitals extend into this space.

BASELINE

## Practice making the Number Yourself
Trace over the dotted line.

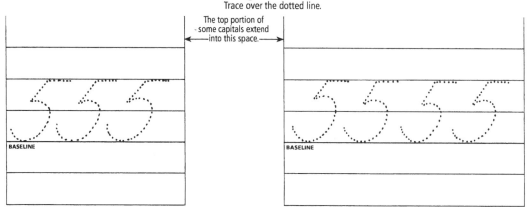

The top portion of some capitals extend into this space.

BASELINE

## Sample Numbers for Study and Practice
DOTTED DIAGONAL LINES SHOW PROPER LETTER SLANT (35° FROM THE VERTICAL)

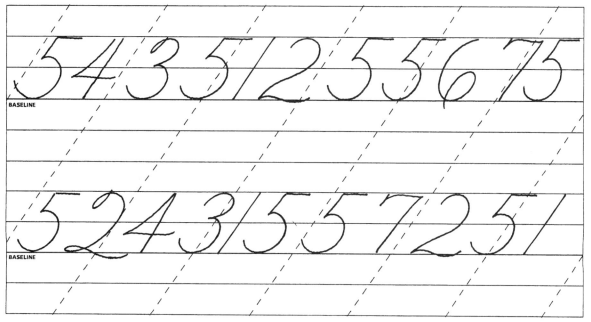

BASELINE

BASELINE

| Completed Number | | Steps in making the Number |
|---|---|---|

The top portion of some capitals extend into this space.

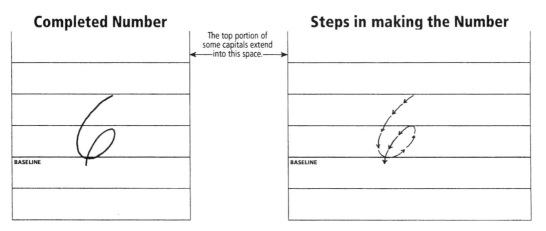

BASELINE

BASELINE

## Practice making the Number Yourself
Trace over the dotted line.

The top portion of some capitals extend into this space.

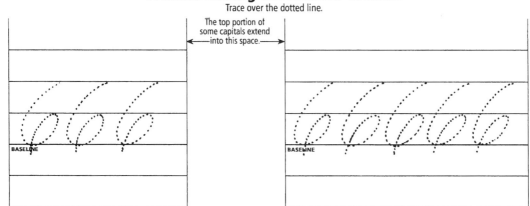

BASELINE

BASELINE

## Sample Numbers for Study and Practice
DOTTED DIAGONAL LINES SHOW PROPER LETTER SLANT (35° FROM THE VERTICAL)

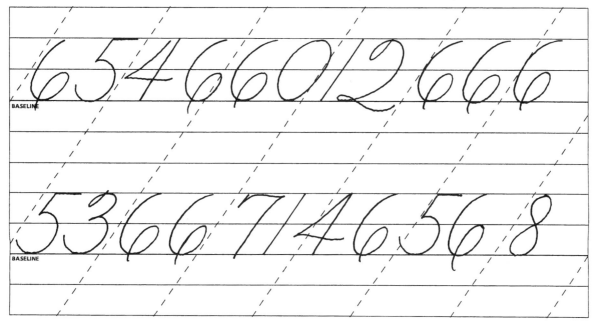

BASELINE

BASELINE

74

## Completed Number

The top portion of some capitals extend into this space.

BASELINE

## Steps in making the Number

The top portion of some capitals extend into this space.

BASELINE

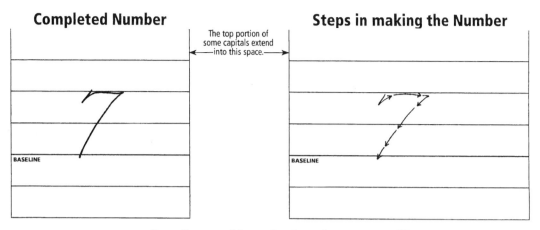

## Practice making the Number Yourself

Trace over the dotted line.

The top portion of some capitals extend into this space.

BASELINE

BASELINE

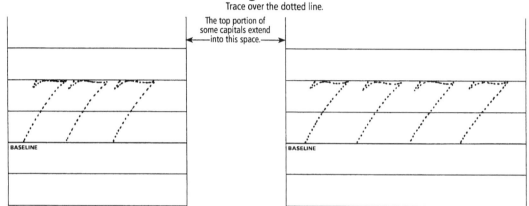

## Sample Numbers for Study and Practice

DOTTED DIAGONAL LINES SHOW PROPER LETTER SLANT (35° FROM THE VERTICAL)

BASELINE

BASELINE

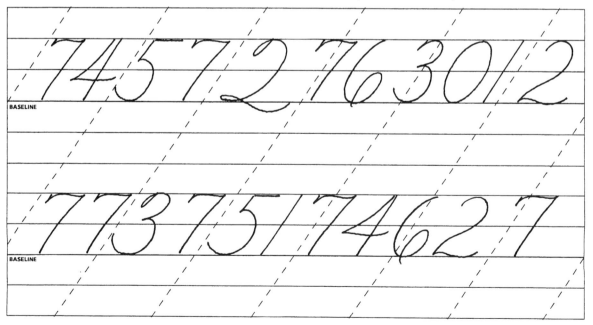

## Completed Number

The top portion of some capitals extend into this space.

BASELINE

## Steps in making the Number

START HERE

BASELINE

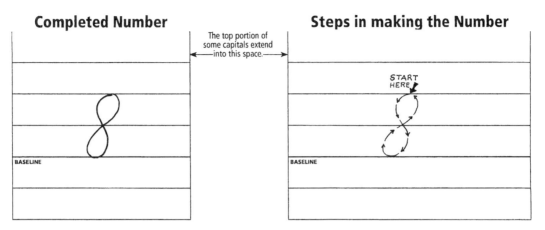

## Practice making the Number Yourself

Trace over the dotted line.

The top portion of some capitals extend into this space.

BASELINE

BASELINE

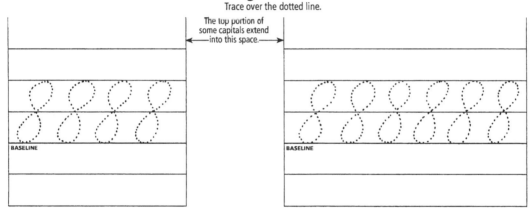

## Sample Numbers for Study and Practice

DOTTED DIAGONAL LINES SHOW PROPER LETTER SLANT (35° FROM THE VERTICAL)

BASELINE

BASELINE

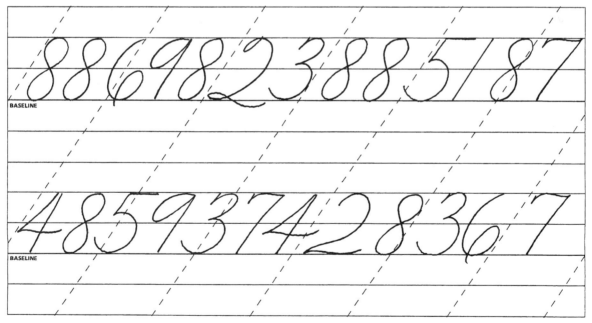

## Completed Number

The top portion of some capitals extend into this space.

BASELINE

## Steps in making the Number

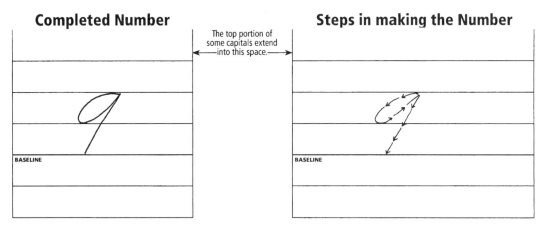

BASELINE

## Practice making the Number Yourself
Trace over the dotted line.

The top portion of some capitals extend into this space.

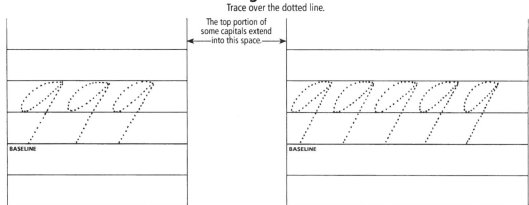

BASELINE

BASELINE

## Sample Numbers for Study and Practice
DOTTED DIAGONAL LINES SHOW PROPER LETTER SLANT (35° FROM THE VERTICAL)

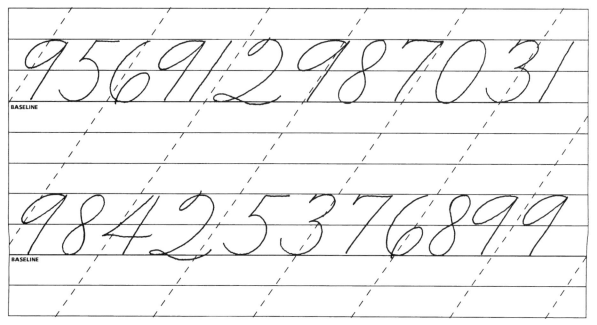

BASELINE

BASELINE

## Completed Number

The top portion of some capitals extend into this space.

BASELINE

## Steps in making the Number

The top portion of some capitals extend into this space.

START HERE

BASELINE

## Practice making the Number Yourself

Trace over the dotted line.

The top portion of some capitals extend into this space.

BASELINE

BASELINE

## Sample Numbers for Study and Practice

DOTTED DIAGONAL LINES SHOW PROPER LETTER SLANT (35° FROM THE VERTICAL)

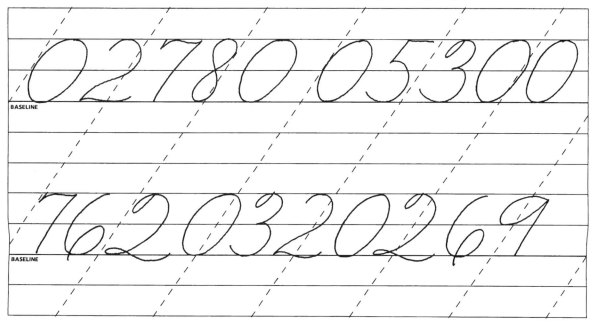

BASELINE

BASELINE

# Chapter 1: What is American Cursive?

In the latter years of the nineteenth century, Austin Norman Palmer, an American penman working in Cedar Rapids, Iowa, began developing a style of penmanship that was easier to read and write than the ornamental Spencerian script of the day. Spencerian writing was indeed beautiful, but its characteristic shaded strokes and large oval forms made it a challenge to learn. At that time, Spencerian was taught using *whole-arm movement*, a method whereby the arm is held above the table surface and the hand glides upon the sides of the third, fourth, and little fingers as one writes. The movement of the hand is completely due to the motion of the entire arm being propelled by the shoulder muscle. This is a difficult and tedious motion.

**FIGURE A**
**SPENCERIAN PENMANSHIP, CIRCA 1860**

**FIGURE B**
**PALMER PENMANSHIP, CIRCA 1910**

Palmer reasoned that if the forearm could remain on the table at all times, and a combination of forearm, wrist, and finger movement could be used to move the pen, handwriting would be physically easier to learn and master. Also, if the letters were written without shade or loops of excessive size, the writing would be easier to read and faster to write. He perfected his style and in 1888 published the first edition of *Palmer's Guide to Muscular Movement Writing*. Through his publications and teaching efforts that followed, Palmer Penmanship, as it came to be known, became the standard style of handwriting taught throughout much of the United States.

During the first several decades of the 20th century, other penmen joined the growing trend toward the teaching of muscular movement handwriting. Many of these penmen were highly skilled and began to write their own teaching guides for children to learn this "new way" to write. Palmer's name remained the most visible, but by the mid-20th century, there were so many adaptations of muscular movement handwriting taught regionally throughout the US that the style simply became known as "cursive" by the general public.

Today we find the general state of handwriting instruction to be a confusing hodgepodge of styles. These styles are often developed or taught by individuals whose systems of writing seem more concerned with shortcuts than with sound, established principles of using one's muscles to write efficiently and well. There is a lack of recognized, professional penmen (a term that traditionally includes women) to teach proper handwriting, and yet there is an ongoing need to teach penmanship to children and adults who want to learn how to "write a good hand."

This course teaches the established forms of cursive handwriting that were taught during the first half of the 20th century, but in a manner that is more conducive to today's pace of living than the hours of repetitive writing drills our great-grandparents endured when they were schoolchildren. The lessons are presented in a traditional *copybook format* (printed model lines with blank lines for student use). The individual lessons will fit into most people's busy lifestyle, requiring approximately thirty minutes of daily practice.

Because many penmen taught this form of writing in years past, I have called it "American Cursive" rather than attributing the style to any one individual. It is essentially the same style that Palmer and subsequent penmen developed by modifying Spencerian penmanship into a simpler form of handwriting.

American Cursive is a flowing, joined form of handwriting that is intended to be written with common writing tools such as pencils, pens, rollerballs, gel writers, or fountain pens. It looks best when written with a fine or medium point instrument. All lowercase letters are connected in a natural, graceful manner, with the exit stroke of one letter joining the following letter as that letter's entry stroke. The capital letters may or may not flow into the lowercase; some letters such as $\mathcal{P}$ and $\mathcal{W}$ do not lend themselves very well to connecting with small letters. The alphabet contains no extra lines or loops purely for ornamentation.

In order to acquire the skill of attractive handwriting, you must be diligent and practice faithfully every day. I recommend that you read the information in this course first and study the appearance of the handwriting on the numerous copybook sheets. You need to have a familiar mental image in your mind as to what this handwriting *looks like* so that you can strive to make your own writing look that way, too. If you follow the lesson plan, your handwriting skill will progress, and your penmanship will be a pleasure to write and read.

# Chapter 2: The Purpose of this Book

You hold in your hands the most thorough self-study adult program in cursive handwriting that has been produced in recent memory. I want you to feel that I created this program especially for you, because in a way, I did. I wrote this course because I believe that there should be a competent guide and course of study available for people, regardless of age, who want to learn the traditional skill of cursive handwriting. In looking through dozens of old writing manuals, it soon became apparent that the concepts and rules of handwriting, shapes of the letters, capitalization, proper use of muscles and posture, and the like, needed to be presented in a clear, understandable way.

All the rules are here, especially the ones that have somehow been "lost" over the past thirty years, such as the paper-shifting movement by your non-writing hand, alternate letterforms, and the idea of the *writing zone*. And there are plenty of models for you to study: more than 150 pages of copybook sheets plus the letter and number model sheets. All you need is a pen or sharp pencil and the self-discipline to work on the lessons every day.

One thing is as true today as it was 150 years ago, when students enrolled in handwriting classes used quill pens: the only thing that will really make this program work and will determine its degree of success is *you*. During the time you are working through this program, you will write thousands of letters and words, and by adhering to the techniques presented within the text, you will be able to positively change your handwriting forever. If you desire to have attractive penmanship that will be easy to write and to read, and if you have the personal commitment to practice on a daily basis, you will certainly succeed.

## Handwriting is Important

It is my firm opinion that good handwriting is still a valuable life skill in the 21st century, just as it has been in the past. Unfortunately, the massive impact of computers and electronic methods of communication today seems so all-encompassing that the skill of handwriting has pretty much been tossed aside. Little or no emphasis is given to penmanship in many schools. In fact, handwriting instruction has been deteriorating for so long now (at least three decades) that many adults do not know the fundamentals of posture, correct muscle use, and proper letterform that are so crucial to the instruction of handwriting.

There has been an opinion among a growing number of educators that the penmanship taught in America during the first half of the 20th century was too fancy, too old-fashioned, and not suited to today's fast pace of life. And while it is true that during our hectic lives the sudden need to jot down a note, write a message, or put some information on a piece of paper often comes at a time when we can't even think of posture, letter-angle, or paper position, good handwriting skills are still important.

In fact, I wish to state emphatically that the cursive handwriting of the early 20th century remains as useful and attractive as ever before. The times when you wish to

send a personal message to a friend; to share private thoughts with someone special; to find your own relaxation in the joy of penmanship for its own sake; and when writing poetry, keeping a journal, maintaining a handwritten list of favorite recipes, detailing a vacation or a garden diary—all these occasions and a thousand more are times when your handwriting *and how it looks* are important to you. And, if you take the time and effort to learn the proper way to write so that your muscles are used most effectively, you can write quickly for long periods of time without any aches, pains, or muscle cramps. It is also true that by acquiring the correct skills of handwriting now, you will forever be conscious of how you write *as you are writing.* As a result, you should be able to avoid the too-common tendency for people today to utter those famous words, "I can't read my own writing!"

Handwriting is important because it is an entirely human activity. Computers can transmit information more quickly and efficiently, but machines can never relay information in the same way as handwriting can. Through handwriting we reveal our emotions, hopes, and wishes, as well as other important information. The very fact that through our fingers, hand, and arm, we can produce legible symbols that are a direct reflection of our thoughts makes each person's penmanship special and as unique as a fingerprint.

Why do we treasure the handwritten notes by friends and family members or of politicians, celebrities, scientists, and everybody who was anybody long ago? It is because those notes, letters, and journals were personal, written by someone's hand of flesh and bone as their brain told them what to think and write.

Handwriting is always available to us; it is always convenient. You do not need a machine of any kind. You do not need an external source of power, such as an electrical outlet or batteries. When you know how to write, the skill is completely portable; you can always communicate, as long as you have a simple tool such as a pencil or pen.

Handwriting is an absolutely human action. Keyboarding on a computer is not; the resulting message will look machine-generated—it will be in type. However, if a thousand people handwrite the same message, each resulting message will look somewhat different—the handwritten messages will reflect each writer in an individual way. When we use our hands to propel a pencil or pen, we are communicating through our physical movements in a very special way. It is a method that is fundamentally close to the source of our thoughts.

That's why a love letter, a correspondence letter, or a handwritten note is so special: the writer took the time to personally share his or her thoughts and feelings with the person towhom they were writing. It is a conversation on paper, and the writer is, in effect, saying to the recipient, "I think so much of you that I am taking my time to handwrite my thoughts to you. You are meaningful to me." You are truly complimenting the person to whom you are writing, for you are giving them your most special gift: you are giving them your time.

It is very important, therefore, that you learn how to do handwriting as well as you can, so that your handwriting (or *penmanship,* as it is also called) will be easy to write, easy to read, and nice to look at. Handwriting that is difficult to read is like listening to someone

who talks too fast or shouts all the time. When this happens, it is hard to understand what the person is saying. Because you will use handwriting throughout your entire life, you should carefully study the lessons that follow and make a habit of practicing your penmanship every day.

## Traditional Versus Modern Trends in Handwriting

The modern trend in handwriting instruction, particularly among educators, has been to simplify the traditional writing styles more and more: altering slant; removing what they call "curlicues" or "excessive loops" at the beginning of letters; and joining fewer and fewer letters, or not joining them at all.

Recently a so-called handwriting expert stated in an interview, "vertical handwriting is faster than slanted handwriting." Nothing could be further from the truth. We write from left to right, and the fastest way to write our letters as we move toward the right side of the paper is to write them at an angle or slant toward the right, in the direction we are going. It's just common sense. It is much slower to write up and down (vertically); the writing motion in such a case does not move to the right. It is also faster and makes more sense to move from one letter to another as you write without frequently lifting your pen.

In the "good old days" of America's Golden Age of Penmanship (1850–1925), people in business and education frequently had to write for hours at a sitting. (This was no longer required after the wide adoption of the typewriter.) Those people wrote for long periods of time without physical aches or pains because they had been taught how to sit properly and to use the correct muscles as they wrote. They didn't have an extra "penmanship muscle" that we lack. Their bodies were physically the same as ours are today, and if they used their muscles improperly, they would soon have felt their own aches and pains.

If you maintain the correct posture for your body and use the best muscles for your handwriting, your penmanship can be written attractively for hours without any physical discomfort. The beginning loops, or "curlicues," in many of the letters, especially the capitals in the early 20th century handwriting styles, were not there just to make the letters look fancy. These loops are part of the letterforms; they are similar to a baseball pitcher "winding up" his arm before he throws the ball. With the hand already moving, the activity of writing the letter is done more smoothly than if the motion of the hand were begun by directly starting to write the letter. It is similar with joins, which have the letters flow into one another. They are a natural outcome of increased speed, not extra stokes.

It should be evident that the human body remains the "engine" that produces handwriting, and since we still use the same alphabet and continue to write in a direction from left to right, the procedures developed long ago for good penmanship still make sense. Changes or abbreviations introduced purely for the sake of getting to the writing more quickly or simplifying the instruction process have negative consequences. They serve as "shortcuts" that ignore the importance of proper training in the use of muscles, posture, and the formation of the letters.

As with any other endeavor, the best way to become skilled at handwriting is to study well and train with diligence. Don't take shortcuts or neglect rules that were created in the past with sound judgment and common sense. The modern trend in handwriting instruction dilutes the quality of handwriting itself and, in its "rush-rush" format, puts little or no emphasis on the best way to use our bodies to get the job done.

If you take the time to familiarize yourself with the correct way to use your muscles and posture as you are learning a graceful style of penmanship, handwriting should become a pleasurable experience. I'm here to tell you that this is true: the action of moving your pen to express your thoughts on paper is the joy of handwriting.

## Improving Your Signature

It's your name, and you've probably written it thousands of times over the years without even thinking about it. And if you're like most adults, your own signature has evolved into a consistent scribble which you perform almost unconsciously in a split second. And the chances are good that only you can read it, or perhaps, only identify it as your name. Unfortunately, this is the common circumstance that most people find themselves in. The universal drive to do everything in haste—to communicate as fast as possible via keyboarding and achieve a degree of proficiency in multi-tasking; these factors have been a major influence in de-emphasizing a person's need to write his or her name legibly. So, the question is this: why does your handwriting, and especially your name, matter at all? The answer is simple and has nothing to do with dollars and cents, social stature, or job performance. Your signature should be important to you because it's *your name*; it's the most personal representation on paper of you to the world. Even today, many people form their initial impression of you when they see your signature. How much self-pride or self-confidence can be implied by an illegible scribble, or what personal qualities can be inferred from a well-written, legible signature? It's a most private consideration, and all that matters is if it is important to you. Personally, it matters a great deal to me, and through your interest in reading this book, I believe that having a better signature is important to you as well. Here, then, are some suggestions as to how you can not only improve your signature, but craft it into a more personal symbol of who you are.

## The Basics

1. Speed kills: slow down! Writing too quickly is the biggest reason why most handwriting has deteriorated into a scrawl. In olden days, people often took great pride in their name and took the time to write it well. Handwriting—penmanship—is a physical skill involving thought, dexterity, and muscular movement. You are not a machine, your name should be important to you, and also to the context of what you write. Allow yourself the brief time it takes for your hand to form the letters legibly. Even with your busy schedule, you should have the few extra seconds of time to do this! By slowing down, not only your signature, but all of your handwriting will improve.

2. Select the best writing instrument for you. Most people simply pick up whatever pencil or pen is handy at the moment and use it to write. Although this is a common occurrence, it is not necessary. Having a quality instrument that writes smoothly and is comfortable in your hand, whether it be a ballpoint pen, rollerball, fountain pen,

or fine-pointed marker can make all the difference in how it actually *feels* when you write. If you haven't shopped for a personal writing tool, you might be surprised at what you find. Pens and writing markers abound in countless styles, colors, and price ranges. They needn't be expensive at all. Visit your local office supply store as a place to start. If you're really serious and are interested in a writing instrument of recognized manufacture, I suggest that you contact a reputable pen store; several of these along with my favorite brands are listed beginning on page 240. I wish to recommend another brand as well: Lamy. Made in Germany, Lamy pens are in the low to moderate price range of good quality writing tools; they are an excellent choice. One particular item of note is the gripping area on their Safari model ballpoints, fountain pens, and rollerballs. This is the area on which your fingers rest as you hold the pen to write, and on this particular model, the gripping area has three flattened sides that are very comfortable to grasp. Furthermore, this encourages you to maintain the best gripping position as you write. All in all, a very nice choice in pens. For further information about all brands of writing instruments, you may wish to subscribe to *Pen World* magazine. It is a wonderful publication that has been an industry standard for many years. Contact information for *Pen World* is on page 242.

Once you purchase a pen or marker that you enjoy, make a habit of carrying it with you wherever you go. After a while, you might wish to obtain one very special pen that you keep at home and another perhaps less expensive model that can always be with you for daily use. If you have the opportunity, attend a pen show sometime during the year. There are more than a dozen pen shows held throughout the United States annually; they are always listed in *Pen World* magazine.

3.  Consider re-sizing your signature. This can be a significant help in improving your signature. Because most people don't give much thought to how they sign their name, and also because many signatures have become simply illegible scrawls, little thought is often given to the size (how large or small) that a name is written. In order to write your name properly in a legible fashion, you must write your letters large enough so that they are distinct and readable. When using ballpoint pens, fountain pens with fine or extra fine points, standard rollerball pens, or fine-pointed markers, the small lowercase letters should be written between $\frac{1}{8}$-inch and $\frac{1}{16}$-inch in height. In this manner, letters such as a, e, o, and s will not close up and fill with ink. However, if you prefer to use a medium, broad, stub-pointed fountain pen, or a large-pointed marker that produces a thick, heavy line, you may need to get into the habit of writing your letters and therefore your signature, larger. The only way you can tell is to experiment by writing your name at different sizes. Chose the size that appeals to you the most.

**Be Creative**

1.  How do you sign your name? In America, the traditional way to sign your name is to write your first name, middle initial, and then your surname (last name). Many people, however, have other personal preferences for what is included in their signature. Again, this is very personal, and the choice is entirely yours. For example, it is not uncommon for people to prefer being known primarily by their middle name.

When writing their signature, they often use the first initial of their first name, then their full middle name, followed by their surname. Other individuals simply use their first and middle initials, followed by their surname. In addition, there have been prominent personages—particularly artists, whose signatures consisted of only their surname, such as Rembrandt an Picasso.

In a more creative vein, people have been known to inscribe a small design or icon in their signature to indicate their circle of interest, profession, or spiritual beliefs. Several American penmen from the late nineteenth and early twentieth centuries were in the habit of adding decorative pen flourishes to their name and initials. This practice of scribing an ornamental signature was common; the beauty of these name-designs became legendary. This type of such work was a unique form of superscription known as "signature writing." Shown below are samples of this in several signatures. They were written with a steel pen that must be dipped in ink.

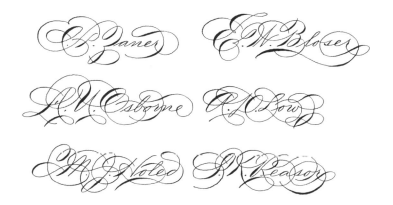

At times, when I sign my name on commissioned penmanship, I add a bird design. Birds and a feather design known as a "quill" were regarded as a symbol of penmanship. If these ideas are of interest to you, I encourage you to look up famous signatures online. You'll be amazed at what you will see. And remember, regardless of how famous a person may be, if their signature is a hectic scrawl or illegible, it is not a good example of proper and practical signature writing. A further touch you may wish to try is to add a brief date under your name, thus indicating when you wrote your signature at that time.

2. Color. This is a brief suggestion, but at times you might find it fun to add a dash of color in signing your name, perhaps using a pen with red ink for either your full signature or just the initial capitals. Of course, this means that you need to have an additional writing tool with you that has a specific colored ink, but adding a touch of color will certainly make your signature stand out in a crowd.

3. Type of Signature. There are countless ways in which you can customize your signature; the Internet offers additional suggestions you may wish to explore. Regardless of your preferences, however, it is most important that you have a "business signature" that will be on record with financial institutions, the government for documentation purposes, and for all legal matters of record. The creative and

decorative signatures are fun and unique, but you should use such crafted signatures for social or informal purposes, such as social correspondence, the signing of artistic or creative works, greeting card signatures, and personal journals. These are, in fact, referred to as "artistic signatures," and you are free to use such name-writing as you deem proper and fitting.

There is no legal statute that says you may only have one form of signature. I have several as shown below. My first name is Michael, but no one in my family addresses me by that name. When I was a boy in the 1950s, the most popular children's show in those early days of television was called *The Mickey Mouse Club*. The cartoon character of the beloved mouse became a national hero to children everywhere. It was most natural then for my family and school friends to refer to me as "Mickey" and I was very proud of that as a youth. The name stuck through my school and college years until I landed my first professional job. It was at that moment that, to myself, "Mickey" seemed too juvenile, and I began referring to myself as "Michael Sull." Even now, however, some sixty years later, all of my family and old friends still call me "Mickey." In signing my own name, these are the common signatures I use:

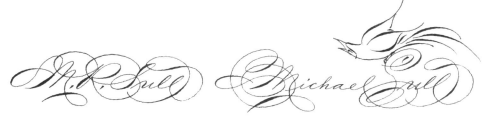

Mickey,
*Family and friends*

Michael R. Sull
*For legal purposes*

*Signature writing*

*Ornamental penmanship*

*As a penman*

## In Closing

Your signature is your most personal form of self-address. It will be unique and therefore become identifiable with you. Always take time to write your letters legibly, regardless of how simple or elaborate you wish your signature to appear. Keep in mind that the faster you write it, the less legible it will tend to be. Take pride in your name and how you write it for others to see. It should always represent you in the best possible way.

# Chapter 3: The Heritage of American Penmanship

Handwriting is not an activity that a person knows from birth by instinct. It is a skill, and like any other art or craft, a person must be trained in the study of penmanship in order to learn all its aspects, rules, movements, and functions. Similarly, in order to gain both knowledge and proficiency in the skill of handwriting, continued practice is necessary. Just because the subject of handwriting does not involve the volume of technical information required to use computers does not mean that handwriting is a simple activity or requires little effort to learn. The truth is that although handwriting is not technical in nature, the only way for children and adults to learn it is through training. Although you have been handwriting all of your life, do not regard handwriting as merely a subject for children. As an adult, this book will help you to re-train yourself in the fundamentals of letter formation and letter spacing.

The writing masters of the past devoted their lives to the perfection of this subject. They strove to personally acquire the highest skill level possible in penmanship and to teach the skill of handwriting to generations of American children. Sadly, though, over the past several decades, the unprecedented advances in technological forms of communication and the popularity of computers have de-emphasized the subject of handwriting in school systems. Consequently, minimal effort is often put forth to properly teach the subject. When it is taught, the teaching method is often carried out in an abbreviated format, concentrating almost wholly on the simple formation of connected or disconnected letters. Little or nothing is taught about such critical topics as posture and proper methods for holding and moving the pen.

Many of us did learn as children the proper techniques of penmanship. However, for many of us our busy lives and responsibilities altered the focus of our priorities, and practicing proper handwriting skills became a forgotten factor in our everyday routine.

Thus, let us start our program of handwriting instruction with this simple idea: the children, men, and women who wrote such beautiful and useful penmanship a century ago were not different than we are today. Their bodies contained the same muscles and bones as ours do, and the correct use of those muscles benefited them in their writing as it will for us now. Our lifestyles may be more hurried than theirs were, and we may not need to handwrite as often today as they did then, but every literate person today still uses handwriting. It remains a necessary and most useful life skill. It is absolutely worth our attention and effort to improve our penmanship skills.

# Platt Rogers Spencer

Before we actually begin our lessons in handwriting, it will help to know a little about the man who created the first system of handwriting that was taught throughout the schools of our great nation. His name was Platt Rogers Spencer.

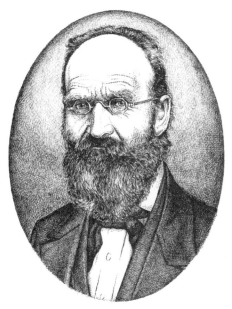

*Platt Rogers Spencer, 1800–1864*
Illustration by Pat Daley

The youngest of eleven children, he was born on November 7, 1800, on a farm in the town of East Fishkill, New York, near the city of Poughkeepsie. His father, Caleb Spencer, was a native of Rhode Island and had been a soldier in the Revolutionary War. His mother, Jerusha Covell Spencer, was originally from Cape Cod, Massachusetts.

As a young boy, Platt Spencer fell in love with the sights of nature he saw all around. The gentle ripples on a stream, the waves on the rivers, the colorful flowers, the trees, the stars at night, the graceful birds and other animals—all were beautiful to him. He became interested in penmanship at age seven, when he began to notice that the handwriting on many of the public notices posted on the door of his schoolhouse was clumsy and often not very pretty to look at. From that point on, he started to practice writing in smooth, continuous strokes on various materials such as tree bark, ice and snow in the winter, the sand along the beach, and scrap pieces of leather from the shoemaker. During this time Platt learned how to use goose quills to write his letters, and at the age of eight he began to actually practice his writing on paper.

When he was ten years old, Platt's family moved to an area along the shore of Lake Erie in northeastern Ohio. His interest in penmanship continued to grow, and by the time he was a teenager, he had become known throughout his school as an excellent penman. As the years went by and Platt Rogers Spencer grew to manhood, he began to develop his

own system of writing. Spencer continued to love nature and was still impressed with the great variety of beautiful plants, animals, stars, and bodies of water he saw.

When he was in his late twenties, Spencer's love of nature and penmanship came together. He felt that the easiest way a person could express their thoughts and feelings in a manner that would be both very special and as varied in appearance as the wonders of nature was through handwriting. He noticed that the shape of curves was present in nearly everything he saw in nature. Flowers, leaves, clouds, birds, the feathers that he used to make his writing quills, the curling waves on Lake Erie, snowdrifts in winter—all of these had curves in their shapes.

He chose the oval-shaped, water-worn pebbles at the lake shore as his model for the basic shape of the curves in his letters. Seeing the waves as a repeating series of curving shapes, one following another, gave Spencer another idea. The movement of the hand as it makes the letters and the spacing between letters was very much like the repeating motion of the curving waves! And so it was that he developed his system of handwriting based on the beautiful curving forms of nature.

Beginning in the 1830s, Spencer started to teach his system of penmanship as he traveled in Ohio, Pennsylvania, and New York. News of his method spread by way of former students, and more and more pupils came to him to learn his new and beautiful style of handwriting. As the years went by, the Spencerian System of Penmanship became more widely accepted than any other writing form, and in the 1850s, it was the standard writing system taught throughout America. No wonder Platt Rogers Spencer is known as "the man who taught America how to write!"

**The Years after Spencer**

By the time of Spencer's death on May 16, 1864, many of his students had become writing masters themselves. During the next ten years, the most skilled penmen in the country began making Spencerian penmanship look fancier by adding extra ovals, swirls, and shaded strokes. The steel penpoint was in common use by this time, replacing the more fragile quill made from a bird's feather. This was a period known as the Golden Age of Penmanship, which lasted from approximately 1850 to 1925. Fancy handwriting became very popular, and a person's skill at handwriting was as important in finding a job as a person's computer skills are today.

In the early years of the 20th century, however, a penman named Austin N. Palmer reasoned that children could learn penmanship faster and more easily if the letters were made without the shaded strokes and extra loops that were found in the Spencerian style at that time. He simplified the letters and taught children to use their forearm muscles in addition to their fingers to move their hand when writing. This new style came to be taught throughout America and lasted into the 1960s. It became known as Palmer Penmanship.

# HANDWRITING

˝. . . that action of emotion, of thought and decision
that has recorded the history of mankind, revealed the
genius of invention, and disclosed the inmost depths of
the soulful heart. Giving ideas tangible form through
symbols and signs, it has forged a bond through
generations and across millennia that not only ties us
to the thoughts and deeds of our forebears, but serves
as an irrevocable link to our humanity as well. Neither
machines nor technology can replace the significance
or continuing importance of this portable skill, so
necessary in every age, and as vital to the enduring
saga of civilization as our very next breath.˝

—Michael R. Sull

# Chapter 4: How to Write American Cursive

## Notes to the Student

You must remember that good handwriting does not happen overnight or even in a few weeks. It takes time, study, and practice. No one else can do your studying and practice for you. They must be done by you. All exercises should be practiced each day until they are thoroughly mastered. If you take the necessary time to study the rules and letters of handwriting and faithfully practice your penmanship every day, you will be able to write well.

Good penmanship is the result of two things:

- *Training your eyes and thoughts so that you know what the letters and proper spacing should look like.* You should have a clear idea of the shape of the letter in order to produce it properly. Study each form until you can picture it in your mind so clearly that you can notice the slightest error as soon as you write the letter on paper. We can only correct our faults in penmanship when we can see them with our eyes. You must always try to write the letters well. Never write more than a line or two without carefully examining your work to find any faults in the shape of your letters, the slant, or the spacing between the letters.

- *Training your hands daily so that you can use the pen or pencil in the best way possible.* Hold your writing tool in a comfortable grip and not too tightly. Remember that your muscles should feel relaxed and that the movement of your hand should be smooth and easy. Make sure that you are sitting correctly, facing the desk, with both feet on the floor. Both of your arms should be on your desk or writing table, with your elbows just a little off the edge of the desk or table.

## Finger and Arm Movement

When we write in the American Cursive style of penmanship, we use a combination of the muscles in our fingers, wrist, and forearm to move the pen or pencil. Our fingers are meant to bend toward the palm of our hand. The thumb can touch the other fingers, and this combination of the fingers bending and touching each other is what allows our hand to properly hold the pen. Although the muscles in our fingers are designed to bend inward, as when you curl your fingers into the center of your hand, the same finger muscles are not meant to move sideways—from left to right. Therefore, the fingers are not the best muscles to use to move from one letter to the next letter. Your wrist and forearm have a much greater range of motion to move the distance of an inch or two as you write toward the right.

As a general rule, you should write no more than four to six letters without briefly lifting your pen off the paper. After six letters or so, the limit of your fingers' short range of motion will usually be reached. If you continue writing without lifting the pen off the paper, your letters will normally begin to "crunch together" and become too close to each other. If you don't change the position of your hand at this point, even just a little, you will be physically unable to space your letters properly.

Therefore, after writing four to six letters, lift your pen off the paper. As you raise your pen just above the surface of the paper, briefly slide your hand a short distance to the right, perhaps a quarter of an inch or so. This is done in about as much time as it takes for you to take a breath—only a moment. Then immediately put your pen back on the paper at the point in the word where you were last writing—where you lifted your pen off the paper—and continue writing. You can do this for about two inches of writing. After two inches, use your non-writing hand to shift the paper to the left another two to three inches. Then continue writing as before.

When we write from the left side of a page to the right side of the page, our pen, and therefore our hand, must move along the baseline of writing toward the right side of the page. Our fingers cannot do this very well; finger muscles can comfortably move only about an inch from left to right. But our wrist contains larger muscles that can easily move several inches from left to right. The action of shifting the paper lets you use these muscles to your advantage when writing. You can always maintain good posture when you write, *and your hand will never have to travel more than two or three inches from left to right!*

## Combination Movement

At the small size that most penmanship is written, such as shown in the model lines of the copybook sheets, the easiest way to write is to use *your finger muscles* to make the lowercase letters and *your wrist and forearm muscles* to move left to right, from letter to letter. This is called *combination movement.* People who are not trained properly in handwriting and use their fingers to do all the writing usually end up with their fingers feeling cramped, sore, or stiff after even just a few lines of writing. Their penmanship

doesn't look graceful, and the letters often bunch together, because the fingers cannot move far enough to space the letters properly.

When writing capital letters, we use our wrist instead of our fingers, and sometimes it is even easier if we use our forearm muscles as well. When using your forearm muscles to write, your arm "rolls" on the fleshy pad of muscle that cushions your arm as it rests upon the desk or table. As you become more skilled at handwriting, using your forearm for the left-to-right movement and capitals will help you in two ways: It will make it easier and less tiring to write, and you'll also be able to write faster.

### Position of the Paper

If you are right-handed, you should place your writing paper in a position similar to that shown in Figure C. The top right and bottom left corners of your paper should be approximately in a straight line pointing toward your body. The left arm holds the paper still as the right hand holds the pen and moves to write. In the process of handwriting, letters should be formed so that they slant correctly (see Figure F). This is true whether you are right or left handed. In order to find the best angle for your page, change the position of your paper after every few words until your writing slants properly. When this happens, the position the paper was in when you wrote the correctly slanted letters is the position you should always use. More detailed instruction on slant is given on page 98.

If you are left-handed, you should place your writing paper in a position similar to that shown in Figure D. Notice the paper is not angled as much as in Figure C. The right arm holds the paper still as the left hand holds the pen and moves to write. The same instructions for slant given above apply to left-handers.

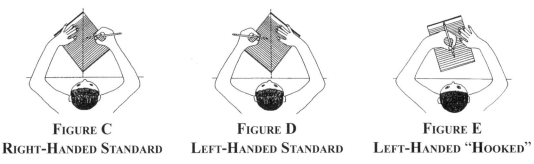

FIGURE C
RIGHT-HANDED STANDARD

FIGURE D
LEFT-HANDED STANDARD

FIGURE E
LEFT-HANDED "HOOKED"

Note: These are the traditional guides for paper placement. The student may modify these as necessary to accomodate their individual posture and hand/arm position.

A small number of lefties hold their pen in the "hooked" position (as shown in Figure E), where their left hand is bent at the wrist and the hand holds the pen in a downward position, thus angling the pen downward, over the area of writing. If at all possible, lefties who hold their pen this way should strive to practice holding their pens in the more standard left-hand position just described. However, if you simply feel most comfortable

holding your pen in such a hooked position, your efforts at handwriting will work better if you adjust your paper to a more vertical position in relation to your body, similar to the position shown in Figure D. Because there is no standard hooked-handed position for writing, there is no standard way to recommend the paper be placed upon the desk or table; however, the letters you write should slant from the bottom left up toward the right. (See Figure F):

*Handwriting is useful*

**FIGURE F**
**LETTER SLANT**

Never write on top of a pad or tablet. The thickness of the pad acts like a bump under your arm as you try to write. This little "bump" or thickness of the pad or tablet makes it harder and less comfortable to move your arm as you write. The best way to write is on a single sheet of paper that rests upon a cushion sheet (such as a piece of blotter paper) on your table or desk.

## Proper Posture and Paper Movement

When you sit down to write, it is very important that you sit facing the front of your desk with both feet on the floor. Do not twist in your seat or sit sideways. The seat height of your chair should position your body so that both forearms are parallel to the desk surface, and your elbows should be just a little off the front edge of the desk. Sit on a cushion if your chair is too low. As you write, bend at the hips and lean forward rather than bending or arching your back. When you sit correctly in this position, the easiest and most natural place to write is in the four-to-six-inch area between your hands, directly in front of your body. This is called the *writing zone* (see Figure G). It is the area where your hand (as it holds the pen) will naturally rest as you write.

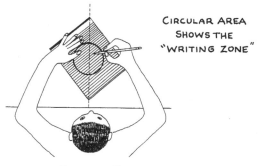

**FIGURE G**
**THE WRITING ZONE**

When we write, however, we not only write in a direction from the left side of the paper to the right side, but as we finish each line of writing, we also move from the top lines on a page to the middle lines and then to the bottom lines. All of this moving in different directions as you write may seem difficult to do while trying to keep your body in the correct writing position at all times. But there is a simple way to make writing in these different directions easy and still keep your body position (also known as *posture*) correct.

Before starting to write, shift the paper to the right until the left side of the paper is in the writing zone. Then, after writing toward the right side of the paper for about two or three inches, stop, shift the paper to the left a few inches, and continue writing for the next few inches. Then shift the paper as before and continue this process throughout to the end of the page. This movement of "writing, stop writing, shift paper, start writing" is done quickly and results in only a very slight interruption in the writing motion.

This paper-shifting action is very important. By continuously shifting the paper every few inches, you will always be writing in the most comfortable and natural position.

It should be mentioned that between the times when you shift the paper, you will need to stop the writing motion of your hand for a quick moment about every three-quarters of an inch or so to move your arm a little bit to the right. Then begin writing once again. This small movement of the arm places the hand in a better, easier position for the wrist and fingers to write the next group of words. After this has been done several times, you will have reached the point where you need to stop, shift your paper to the left, and then commence handwriting as before.

Following this simple practice, you will never have to alter your posture as you write. You will prevent the muscular discomfort in the back, shoulders, and neck that many people experience as they write.

### Proper Pen-Holding Position of the Hand

Correct letterforms can be made most easily if the hand consistently moves in a manner to make the pen work properly. Such movements of the hand can only result when the hand is holding the pen in the best position. This "proper pen-holding position" is extremely important, and, together with maintaining good body posture when you write, will have more effect on the ease and enjoyment of your handwriting than anything else.

As you begin your program of handwriting practice, use a soft wood pencil, such as a common No. 2. Do not use a mechanical pencil, for until you develop your skill in using light pressure on the pencil and paper, the mechanical pencil's point will frequently break off as you write. When writing with your wood pencil, strive to use a fairly light touch, pressing down on the paper only hard enough so that the pencil point leaves dark lines without digging a groove into the paper. The point should be sharp; when your point becomes blunt and leaves very thick lines, stop writing and sharpen your pencil.

Keep your hand somewhat loose, exerting only enough finger pressure to hold the pencil. Do not grasp the pencil in the all-too-familiar "death grip," which produces white

fingernails and a cramped, tired hand. Relax! No one is going to take your writing instrument away from you. Grip the pencil so that it is resting on the middle finger, held in place between the thumb and index finger (see Figure H). This is considered to be the best way to hold a pencil or pen when you write, because it allows the muscles of your fingers and hand to grasp and move the writing tool most efficiently. If you are in the habit of holding your pen or pencil in a grasp that is different than the ones shown in the illustrations below, it may take more effort and practice to gain control and dexterity when writing. Strive to find a comfortable holding position that is natural for you and allows you to control the movement of your writing tool.

LEFT HAND
(STANDARD POSITION)

RIGHT HAND
(STANDARD POSITION)

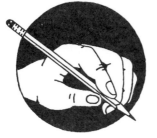

**FIGURE H**
**HAND POSITIONS**

Now you are ready to write! Remember to sit comfortably, both feet on the floor, and try not to let your back be arched or bent over your work. Bend at your hips, instead, so that your entire upper body will move easily without any portion of it—neck, shoulders, left side, right side, or your back—being strained or hurt by cramped muscles. Your progress will not go smoothly if you feel aches or pains as you write. If you have been practicing for a while and begin to feel any soreness or muscular discomfort, stop and rest for ten minutes or so. Then continue to practice.

### Rules of Handwriting

#### *Legibility*

The primary objective of writing is that it can be read easily by anyone knowledgeable of the language in which it was written. This, of course, includes the writer him/herself. It is bad enough when other people cannot read your writing, but it is even worse when a person scribbles so carelessly that he/she cannot read his/her own writing!

Therefore, legibility is the first and most valuable feature of handwriting. For a letter to be as legible as possible, it must be formed as much like the printed models as possible. Because each student will write a little differently from everyone else, slight variations from one person's writing to another will appear. This is natural and entirely within the scope of proper handwriting. As long as the shape, slant, and spacing of your letters are

uniform, consistent, and do not stray too far from the examples shown in the models, your handwriting should be easy to read.

The major cause of poor legibility today is speed; that is, people write too fast. As you start to practice, remember to move your hand at a free and easy pace, but never so quickly that you do not give your hand enough time to correctly make each letter. Handwriting that cannot be read is useless and a waste of time.

### *Arrangement of Letters*

When we write upon a page, we are arranging the letters in a direction from left to right upon a horizontal line that runs across the page. This horizontal line is called the *baseline* and serves as the foundation or floor upon which the letters are written. The baseline is usually an actual printed line on the piece of paper. It can be an imaginary line, however, such as when a person writes on a blank sheet of paper.

The *slant line* is the imaginary line that shows the angle at which all the letters lean toward the right. The proper slant of letters in American Cursive writing is about thirty-five degrees from the vertical, or about fifty-five degrees from the baseline (see Figure I). What is most important is that you write all of your letters with a uniform and consistent slant. That is, all your letters should lean the same amount to the right, and they should all appear to be slanted alike. You should try to make your letters slant the same way as shown in the printed models, but as long as you write all of your letters with a consistent slant, they will be acceptable, even if the angle at which you write is a little different than that shown in Figure I.

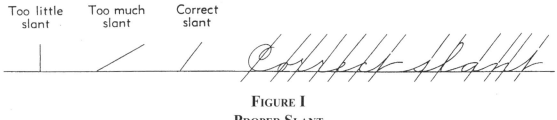

**FIGURE I**
**PROPER SLANT**

Letters that are written almost vertically cannot be written very quickly, and the writing tends to look stiff and not graceful. Writing that slants too much is not very attractive, and the letters can look like they are going to fall over.

The *spacing* of your letters as you write is also important. Letters should be arranged so they look like they are evenly spaced. Because some letters are wider than others and because we are human beings and not machines, there is no mathematical or measured amount to the spacing between letters. They should look as if they are spaced evenly, and this is done "by eye." That means that the person doing the writing spaces the letters apart from each other in a way that *looks* even and appealing. If the letters are placed too close together, they look bunched or squeezed. If they are placed too far apart, the

words become hard to read. The printed examples in this course of study show the recommended spacing of letters.

Generally, the spacing between words should be greater than the spacing between letters, and spacing between sentences should be greater than that between words.

### *Height of Letters*

The standard measurement of all lowercase letters is based on the shape of an *oval*. The perfect oval that we use in handwriting is two times as tall as it is wide. That is, its length, or height, is twice the size of its width. The ideal oval is represented by the small letter *o*, and the height of this letter determines the height of all the other short lowercase letters. All of the *loop letters* (**b, f, g, h, j, k, l, p, q, y, z**) are three times the length of the short letters, and the *semi-extended letters* (**d** and **t**) are two times the height of the short letters. Capital letters are three times the height of the short letters, and sometimes, depending upon the letter, even a little taller—almost four times the height of the short letters.

These are the traditional heights that everyone should learn in their initial efforts. However, as an adult, the heights of the tall, looped letters can be somewhat shortened. This is because in everyday handwriting, you will be spontaneously writing on a single baseline such as a sheet of lined paper. Rather than trying to concentrate on making your looped letters *exactly* three times the height of the short letters, it is much easier and more natural to simply make them *visually* taller than the short letters.

### *Height of Numbers*

Numbers are a special subject in handwriting. You will write many more letters than numbers, but whenever numbers appear, the information they provide is often exceedingly important. The difference between the way we perceive letters and the way we perceive numbers illustrates the importance of making numbers more visible.

We should always strive to spell our words accurately when we write, but if we make a mistake and spell a word incorrectly, we can usually read the word correctly anyway. That is because when we learn to read, we train our brains to read groups of letters as words, not individual letters. If one letter is written wrong in a word, or if two letters are misplaced in a word (such as **ie** or **ei**), our brains will usually still be able to recognize the general arrangement of the rest of the letters in the word. With the other words in the sentence giving meaning to the thought of the sentence, it often isn't difficult to know what the misspelled word is supposed to be.

The same is not true with numbers. There are no recognizable groups of numbers like there are groups of letters. When numbers appear, they signify an exact amount of

something. If the wrong number is written, it means a completely different quantity of whatever is being referred to. Because numbers are so important and yet are written so seldom compared to letters, it is proper to write the numbers a little larger than the short lowercase letters. This way the numbers will not be "hidden" among all the rest of the writing. The rule, then, is this:

Numbers are written two times the height of the short lowercase letters or the same height as the semi-extended letters (see Figure J).

**FIGURE J**
**HEIGHT OF NUMBERS**

### *Perception of the Letters*

Before we focus our attention on the letters themselves, we must become familiar with two of the most important topics in the study of handwriting: Perception and Speed. Regardless of how regularly a student practices writing the strokes and letters, his/her practice work will only lead to consistently good results when the student can see the correct letters in his/her mind before the pen touches the paper.

Many hours of purely physical "pen-pushing" practice may produce a good-looking letter here and there, but you'll only get consistently good letters when you can see the correct letters in your mind right from the start.

If you heard the word "circle," you would immediately see the shape of a circle in your mind, perhaps as the moon, the sun, or a ball. You see these shapes that represent a circle so often—every day—that you can't help but think of them when the word "circle" is spoken. If the picture you drew did not look as much like a circle as you thought it should, then you would try and try again, each time mentally comparing your efforts with the picture you have in your mind of what a circle *should* look like.

This same idea is true in handwriting. To become skillful in penmanship, you must study the shapes of the letters so well that you will actually be able to clearly see them in your mind. Only then will you know what the letters should look like on paper before you pick up the pen or pencil.

## Speed of Writing

You should not write too fast or too slowly. When you sit down to write, think of which words you want to use and how they are correctly spelled, before you move your pen on the paper. Be sure to take the necessary time to study the letterforms first, then write with just enough speed that you are still able to see the forms in your mind as you write.

Every aspect of handwriting should be comfortable to you, including your grasp of the pen and the speed at which you write. Use only enough pressure on the pen or pencil to allow you to make smooth, graceful lines. Do not hold the pen or pencil too tightly in your hand or press too hard upon the paper.

During the early decades of the 20th century, all of the handwriting manuals stressed the importance of being able to write quickly. On nearly every page of instruction were recommendations of how many letters the student should write per minute as they practiced. Perhaps the goal of the handwriting authors of that time was to make the student's output of writing as efficient as possible. Perhaps it was to train the student in such a way as to make them more competitive, and therefore more marketable, when they might need rapid penmanship skills to get a job. It was likely a combination of both.

While it is certainly helpful to write as quickly as possible, if a person writes too quickly, a point will be reached where there is not enough time in the writing process for the hand to shape a letter correctly before it begins to write the next letter. When this happens, the letterforms, and therefore the handwriting, will deteriorate quickly. Legibility will decline, and the writing will become difficult to read.

Compare handwriting with your speech when you're talking with someone. If you speak too fast, your words are hard for the other person to understand. Your speech tends to slur, and words run together. It's hard for someone to hear and understand what you are trying to say. The same thing happens when you write too quickly, except that the difficulty is in reading rather than listening.

Strive to write so the action of handwriting is spontaneous and the speed at which you write feels natural and comfortable without any sacrifice of letterform or letter-spacing. You shouldn't draw your letters slowly, nor should you feel compelled to race across the page.

As a general guideline, strive to achieve a goal of writing at least sixty letters per minute. That's one letter per second, and by the time you are practicing on the small-scale writing sheets, this rate should easily be possible. When you begin this course and start working on the Set 1 practice sheets, your earliest efforts may produce only thirty to forty letters per minute, but be assured that with diligent practice, your writing speed will steadily improve.

Over time, you will develop a comfortable rhythm in your writing—a speed that feels natural and allows you to write well. Diligent practice on a daily basis is the surest way to success.

# Chapter 5: The Letters and Preliminary Exercises

### The Letters

Letters are wonderful symbols. In the English language, there are twenty-six different letters. When these letters are used in various groups we call words, they can express and describe everything we see, feel, touch, eat, and think. Words made from letters allow us to communicate with each other through writing.

### Letter Groups

As we learn how to write the letters, it is easiest to study them in groups based upon the heights of the letters. Some letters within a group will be very similar to each other, such as the **n, m,** and **u.** Other letters will be unique; that is, there will be no other letters like them, such as the **r, s,** and **x.** All of the letters within one group, however, will be of the same height. The lowercase letters are divided into three groups: short letters, short extended letters, and loop letters. Capital letters are separated into two groups: the standard size capitals and those with lower loops. The lowercase and capital letter groups are shown in Figure K. Some capital letters can be modified slightly, and an alternate letterform is available for the capital G. These variations are shown in detail on the model letter sheets (page 9).

### Alternate Letterforms

Of the letters in the alphabet, three lowercase letters can be written in alternate forms: **d, r,** and **t.** These three letters are unique because in addition to their standard shapes, they have what is called an *ending form* (see Figure L). That is, whenever any of these letters come at the end of a word, the **d, r,** or **t** may be written in its special ending form.

These ending forms are not better than the standard forms of the letters; they exist to give the writer a "shortcut" in completing the letter and the word. This is because these letters are completed without having to move the pen back to the baseline. It should be pointed out, however, that you do not have to use these ending forms if you do not wish to do so. The standard letterforms may always be used, but the ending forms will add variety and interest to your penmanship, as well as save a little bit of time in your writing.

## SHORT LETTERS

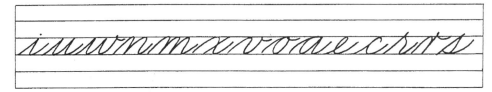

## SHORT EXTENED LETTERS

## LOOP LETTERS

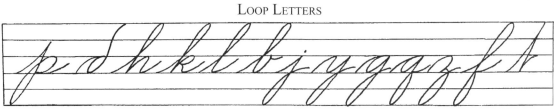

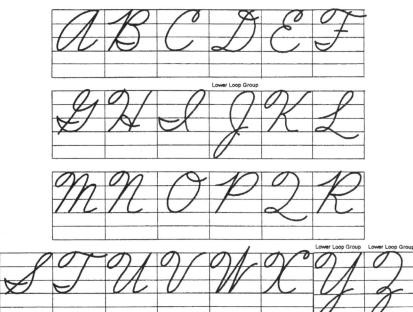

**FIGURE K**
**THE ALPHABET**

**FIGURE L**
**ENDING FORMS:**
THESE SPECIAL LETTERS ARE MEANT TO BE USED ONLY AS THE LAST LETTER
AT THE END OF A WORD.

## Curves

There are two elementary (or fundamental) characters in American Cursive writing—
*straight lines* and *curves*. Straight lines are the shortest distance between two given
points. The curves are parts of ovals. The top curve of an oval is called an *over-curve*; the
bottom curve of an oval is called an *under-curve*. The letters are formed by a combination
of straight and curved lines, and all lowercase letters usually begin with an upward or
connecting stroke. Every time you make a curving stroke in a small letter, you should try
to mentally see the whole oval that the curved stroke is part of (see Figure M).

**FIGURE M**
**CURVES AND OVALS IN LETTERS**

Thus, you should try to make every curve as smooth and graceful as possible in order for
the imaginary oval you mentally envision to be smooth and graceful as well. If the letters
you write look wobbly, too narrow, or too round, think of how they should look, how you
want them to look. Then begin again to write them on your paper, making the curves as
smooth and graceful as you can.

## Movement Exercise Practice Sheet

We use the muscles of our arm, wrist, and fingers constantly when we write. To a large
extent, the more easily we can move these muscles, the easier it will be for us to write,
and the smoother our handwriting will be. One simple way to prepare your muscles for
the activity of handwriting is to practice *movement exercises* each day before you begin to
write. These exercises warm your muscles and get them moving, so they are ready to

write; therefore, the movement exercises (including *cross-drill exercises*) are often referred to as *warm-up exercises*.

### *How to Complete a Movement Exercise Practice Sheet*

The lesson plan in Chapter 7 includes movement exercises. When you do movement exercises, use the same tool that you will be writing with—a pen or pencil of your choice. Keep the pencil sharp, and if you use a ball-point pen, it should have either a medium or fine point. Rollerball pens or markers should have either a fine or an extra-fine point. The goal you should strive for when doing these exercises is to maintain consistency in the spacing and shape of the ovals and lines.

Use your entire hand to move the pencil or pen by letting your arm move and bounce on the fleshy muscle of your forearm rather than by using your fingers. Try to keep your muscles and the movement of the pen or pencil relaxed and easy, and avoid tensing your muscles or grasping your writing tool tightly. Maintain an easy, light touch, and try to make all your curves, ovals, and lines smooth, graceful, and consistent in spacing. Handwriting is meant to be comfortable, graceful, and not tiring at all.

Figure N demonstrates the gracefulness of lines and ovals that can be achieved in the movement exercise. Daily practice is the key to steady improvement!

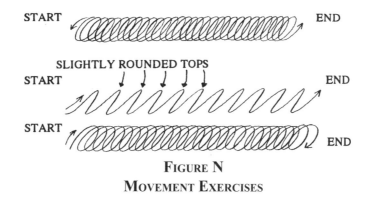

FIGURE N
MOVEMENT EXERCISES

A Movement Exercise Practice Sheet is shown on page 109 and included in Appendix 1. It is recommended that you practice these movement exercises for five to ten minutes before you begin to write letters during your daily practice.

### *Key Points to Remember*

• Slant your Push-Pulls, Ovals, and Spirals (shown on the Sample Movement Exercise Practice Sheet, see page 110) at the same angle that your letters will slant when you are writing. In order to make this happen, place your Movement Exercise Practice Sheet in the writing zone on the table in front of you in the same position that you normally place a sheet of paper for handwriting (see Figures C, D, and E, page 94, Position of the Paper).

• Because you are using the muscles of your hand (to hold the pen or pencil) and arm (to move the pen or pencil) when doing these exercises, practice the same paper-shifting motions during the movement exercises as you do in handwriting (see page 95, Proper Posture and Paper Movement).

• When doing the Spirals and Connecting Spirals exercises, start with an oval that is the same size as the ovals printed on the practice sheet. As you continue to make your ovals, make them smaller and smaller so that the ovals decrease in size until your last oval is very tiny and is in the center of the oval design. For the Connecting Spirals exercise, after you complete one spiral oval, instead of lifting your pen, move it in a large curve from the center of the spiraling oval you have just completed to the outside edge of the next printed oval design to the right. Begin spiraling in the new oval and continue in the same manner, joining to the next oval on the right as soon as you finish the spiraling oval you have just completed. The result is that your spiraling ovals will be connected.

### Cross-Drill Exercises

The movement exercises that were just explained and shown in Figure N are designed to get your hand and arm "warmed up" and comfortably in motion. The purpose of *cross-drill exercises*, a type of movement exercise that was part of standard penmanship training for many years, is more specific. The exercises are designed to help the student develop a consistent movement as the hand glides from letter to letter. This is not the action of actually making the letter, but the movement from one letter to another, which determines the consistency of the spacing *between letters*.

The characteristic of consistent letter-spacing exhibited by American Cursive handwriting is a product of a combination of hand movement and arm movement that was referred to as the penman's *writing rhythm*. The cross-drill exercise (also known as *cross writing*) was the traditional method employed to train students to achieve this movement and the spacing between letters. The following Cross-Drill Practice Sheet is designed to assist the student in daily practice to acquire such letter-spacing (a blank sheet can be found on page 111 and in Appendix 1.) With diligent use (ten to fifteen minutes each day), the rhythmic arm movement necessary to produce this uniform letter-to-letter distance will become an automatic, nearly effortless technique.

### *How to Do Cross-Drill Exercises*

Note that in opposite diagonal corners of the guide sheet are the following designations: VERTICAL FORMAT and HORIZONTAL FORMAT. With the sheet positioned in front of you so that the words VERTICAL FORMAT appear at the top left and bottom right corners, proceed to write continuously from left to right on the line marked by the letter X. The writing rhythm should be such that a single letter is written upon each X, and immediately after the letter is completed, the pencil or pen moves (without being lifted off the paper) to the next X on the right, where another letter is written.

In practicing cross writing, write at least five inches per line from left to right. After you finish this first line of writing, go to the next line of the letter X underneath the first line and repeat the writing as before. Continue in this fashion until a five-inch "block" of writing has been produced. Once this has been done, turn the sheet so that the words HORIZONTAL FORMAT appear at the top left and bottom right corners. Now proceed in the manner just explained, writing on the lines marked by the letter O until all the lines within the five-inch block have been used (see Figure O).

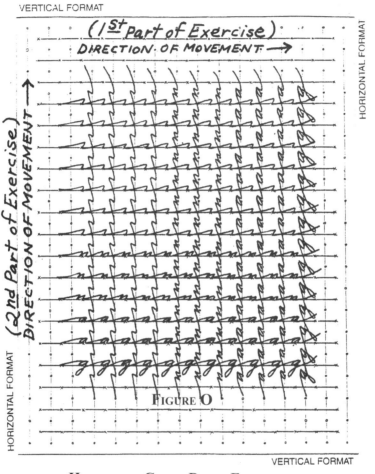

**HOW TO DO CROSS-DRILL EXERCISES**

### *Speed of Writing During Cross-Drill Practice*

Write at a comfortable speed: not too fast (at the sacrifice of good letter form) or too slowly (resulting in a stiff, ungraceful appearance of the letters). Remember that the lateral motion of moving from a finished letter to the point where the next letter will begin—that is, from one letter to another—is made with arm movement. This means that your arm moves by shifting slightly on your forearm muscles. Making the letters themselves is done with finger movement. It is essential that this combination of finger/arm movement is practiced to ensure proper writing habits (see Figure P).

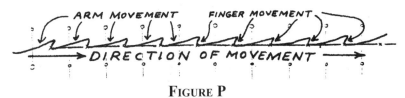

**Figure P**
**Arm and Finger Movement in Writing**

Throughout your cross-drill exercises, maintain a light, comfortable grip on the pencil or pen with your hand. Do not tighten your grasp; your writing tool and your hand must have the freedom to move upon the paper with ease. Keep in mind the paper-shifting movement described on page 94: after writing for two to three inches, stop writing for a moment and use your non-writing hand to briefly shift the paper two inches to the left. Then begin writing again. This will allow you to maintain correct posture as you write.

## Copybook Practice Sheets

Most of the practice sheets in this program are Copybook Practice Sheets, consisting of a series of lines, both blank ones and one or more lines of printed handwriting examples. The lines of printed handwriting are called *model lines* because they are the lines of writing that the student practices by writing in the blanks below. To use the Copybook Practice Sheet, study the model lines of writing, and then lightly trace directly over them with a pencil. Then study the model lines again and begin to write the words of the model line on the blank line underneath. Continue to write the same words on each of the additional lines until you reach the next model line.

## Blank Practice Sheets

Once you have finished working on the sheets with the printed model lines in each lesson, you can start writing on the blank handwriting practice sheets that have no model lines on them (located in Appendix 1). Write your own words, and study your own writing after every two lines of your work. Practice at least twenty to thirty minutes every day. As you continue to study and practice, look carefully at every detail of your letters: every curve, every line, the shapes of the loops, and the spacing between letters. Ask yourself these questions:

1.  How and where does the first line in a letter begin?

2.  Is the first line of the letter (after the entry or connecting stroke) made with an upward or downward stroke?

3.  How tall is the letter and how wide is its widest part?

4.  How much running space (length) does it occupy?

5.  In what direction should the pen move in beginning, continuing, and completing the letter? How even (consistent) is the spacing of the letters?

# Movement Exercise Practice Sheet

ARROWS INDICATE DIRECTION OF MOVEMENT

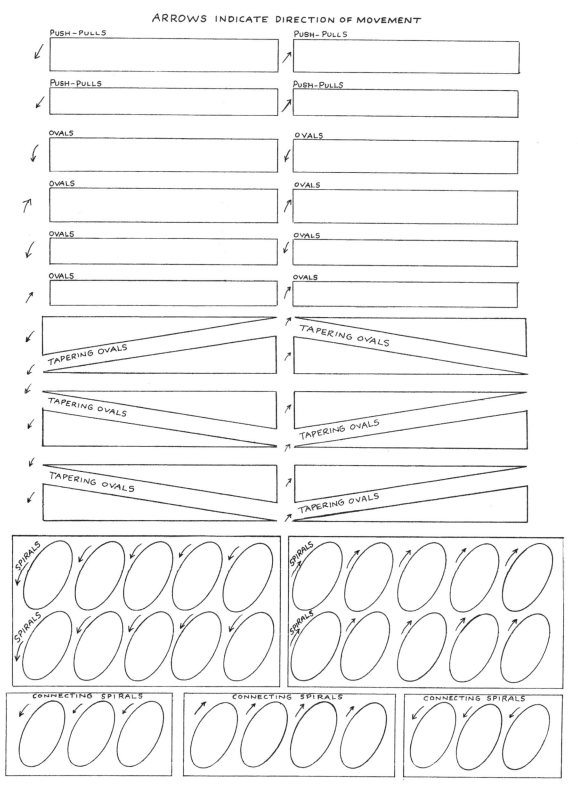

# Completed Movement Exercise Practice Sheet

ARROWS INDICATE DIRECTION OF MOVEMENT

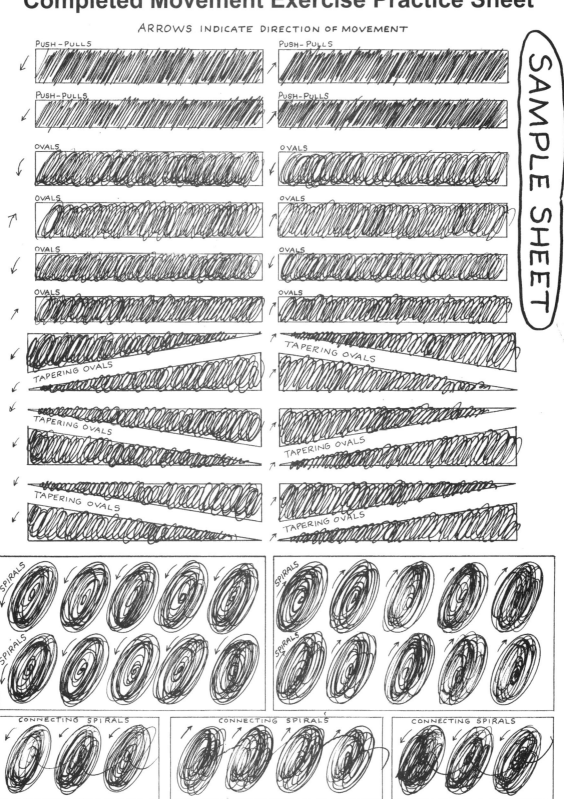

110

# Cross-Drill Exercise Practice Sheet

This guide sheet focuses on arm movement, which is very important in proper muscle use in American Cursive handwriting. The spacing of this cross-drill sheet (3/8 inch from x to x and o to o) is purposely designed to be much wider than the normal spacing of cursive letters so that it forces the student to use arm movement to move from x to x and o to o. The 3/8-inch spacing is too wide to be used with finger muscles only so the student can't fall back on old habits and use their fingers to do the exercise. Once you become skilled at doing cross-drill exercises with arm movement, the correct and attractive spacing of letters when writing normal cursive penmanship should be easy!

111

# Completed Cross-Drill Practice Exercises

*Exercixe A*

*Exercixe B*

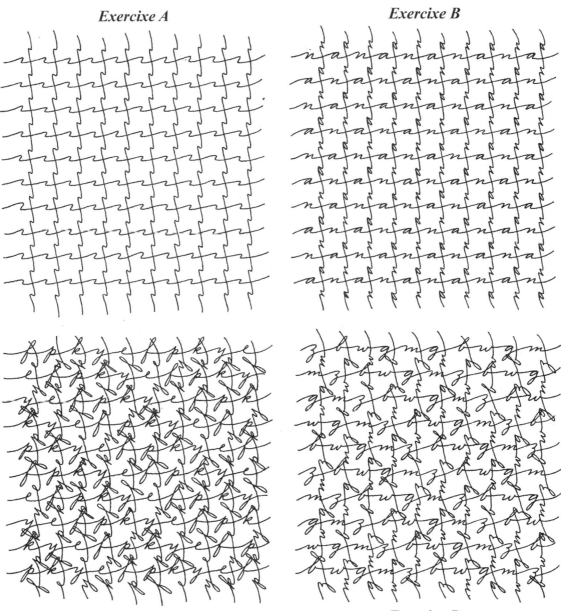

*Exercixe C*

*Exercixe D*

# Chapter 6: Scales of Writing

## Standard Scale Writing

Writing at a standard scale means writing so that the small letters are ⅛" high, which is a size that is large enough to readily create the letters using the proper hand and arm muscles. This is the small letter height featured on the Set 1 Copybook Practice Sheets. At this height (or scale), you can acquire a "natural" speed of writing (not too slow, as if they were trying to draw each letter) as they gain a sense of comfort using the proper hand and arm muscles. Diligent handwriting practice at this size will further prepare students for the small scale format that follows in this curriculum.

## Small Scale Writing

The ultimate goal is to be able to write spontaneously at a speed that allows the thought process (as you think of what letters or words you wish to write) to work in coordination with the hand and arm in the action of writing. When this goal is achieved, you can write faster than on previous practice sheets. It takes more time to write large-size letters than small-size letters, so once you feel comfortable with the movement of the hand and arm in the action of writing, you'll be able to write faster by writing smaller letters and thus taking less time to write each individual letter.

The small scale format guides you to write the small letters at a height of approximately ¹⁄₁₆-inch, which is the smallest size that allows the finger muscles to accurately write each letter while the hand and arm move toward the right side of the paper. People can usually think of what they want to write faster than they can actually perform the handwriting; writing at this small size allows you to write at a speed that is closer to the rate at which you think of the words you wish to write. Thus, the small scale format is the most efficient size for you to use.

## Advanced (Small Scale) Writing

At this point in the curriculum, you should be fairly comfortable in the action of handwriting involving the shape and size of letters and the pace or speed at which the hand moves across the paper. However, from this point on, it is not recommended to continue the use of practice sheets that have lines indicating the height of the letters. Since all the spontaneous writing that a person will do during his/her lifetime will be on paper that has no such guidelines of height, it is prudent now to write on simple lined paper, with your practice experience and acquired knowledge of handwriting to guide your penmanship. Diagonal lines indicating the consistent slant of the letters is still provided on the Advanced (Small Scale) Practice Sheets, but soon you should find these to be unnecessary as well.

| | | |
|---|---|---|
| **Set 1**<br>(Standard Scale) | Small letter height: 1/8"<br><br>Model lines of lettering show correct form of letters. Dotted lines indicate correct writing size. Student writes on the practice sheet. | |
| **Set 2**<br>(Small Scale) | Small letter height: 1/16"<br><br>Model lines of lettering show correct form of letters. Dotted lines indicate correct writing size. Student writes on the practice sheet. | |
| **Set 3**<br>(Small Scale)<br>Same scale as<br>Set 2 | Small letter height: 1/16"<br><br>Model lines of lettering show correct form of letters. Dotted lines have been removed. Student writes on the practice sheet. | |
| **Advanced**<br>(Small Scale)<br>Same scale as<br>Set 2 & Set 3 | Small letter height: 1/16"<br><br>Model lines of lettering are presented as paragraphs, quotations, etc. Dotted lines have been removed. Student practices on separate sheet of paper. | |

(Samples are shown at reduced size for illustration purposes)

FIGURE Q
COMPARISON OF SCALES OF WRITING

114

# Chapter 7: Lesson Plans

This course and lesson plan is designed as a recommended program of self-study. The course consists of assignment sheets for instruction with separate supplemental sheets of movement and cross-drill exercises (for hand/arm movement and letter spacing) (Appendix 1), Copybook Practice Sheets featuring pre-printed model lines of lettering (located after each respective lesson plan), and Blank Handwriting Practice Sheets (Appendix 1). Model pages of American Cursive handwriting letters and numbers in the front of this book show the directional steps involved in making each letter and number.

Strive to complete a minimum of one lesson assignment or exercise each day, with a total of at least thirty minutes devoted to daily handwriting practice. Two fifteen-minute sessions with a break or short rest period in between is recommended. If you complete an assignment in less than thirty minutes, continue to the next lesson or assignment until the thirty-minute time has been reached. Every day, review the model sheets of the letters that are featured in all the assignments you have practiced thus far, as well as the new letters for that day's lesson. If it is easier to allow yourself three sessions of ten minutes each, one in the morning before your first cup of coffee, one during lunch, and one at night, then such a schedule will work best for you. Just do the best you can.

## Copybook Practice Sheet Instructions

On each sheet in this series there are three model lines of writing and five blank lines beneath each model line. Carefully study the writing printed in the model lines. Then using the model writing as a guide, write the same letters or words that appear on the model line on the five blank lines beneath, striving to make your handwriting look like the model writing.

Notice that on the Model Letter sheets of the lowercase letters, lines indicating the height of the tall letters and the length of the descending letters show them to be three times the height of the short letters. However, the dotted lines on the Copybook Practice Sheets in this book show the height and lengths of these tall and looped letters to be approximately 2½ times the height of the short letters (see Figure R). There is a practical reason for this height and length variation.

The purpose of the difference in the lined sheets is this: the goal is to write with ease on lined tablet or correspondence paper, where no "height lines" are printed. It is natural that as we write, all the taller letters will not be exactly the same height. The important thing to keep in mind is that the loops of the tall letters need to be significantly taller than the height of the short letters (**a, c, e, i, m, n, o, r, s, u, v, w, x, z**). Therefore, when you write, it is not necessary that the loop letters be exactly three times the height of the short letters. If you make the loop letters at least as tall as the dotted line that is printed above the baseline of writing, your loops will be long enough to appear graceful with the rest of your writing (see Figure R).

| MODEL LETTER & HANDWRITING COPYBOOK PRACTICE SHEETS, PRIMARY SCALE | HANDWRITING COPYBOOK PRACTICE SHEETS, (SET 1) | COPYBOOK PRACTICE SHEETS (SMALL SCALE) (SET 2 & 3) |
|---|---|---|

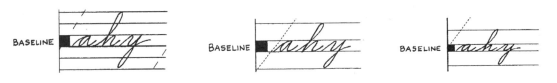

**FIGURE R**

**SCALE (HEIGHT) OF LETTERS IN COPYBOOK PRACTICE SHEETS**

By practicing with a dotted line as your guide to looped-letter height and not having to try to make the loop letters precisely three times the height of the short letters, you will be able to write more naturally, more gracefully, and with more speed. Also, by knowing you wish to make the looped-letters just a little taller than the height of the short letters, rather than depending upon two extra printed lines to indicate a precise letter height, it will be much easier for you to progress to smaller-sized letters. You will progress from Copybook Practice Sheets (Set 1) to Copybook Practice Sheets (Set 2 and 3) and then on to the Advanced (Small Scale) Practice Sheets. You will then naturally progress further to write on single-lined tablet or correspondence paper.

As you write, maintain a comfortable (not tight) grasp on your pen or pencil, and strive to move across the page in a graceful, easy fashion. Don't go too slowly in an effort to "trace" the image of the model letter or word on your paper. Remember also to shift the paper frequently—about every two to three inches—with your non-writing hand. This will keep the action of handwriting within your writing zone at all times and help you to maintain good posture. Once you have learned and diligently practiced the letterforms and methods of using paper and pen to write, handwriting will be a joyful activity for the rest of your life.

### Fitting Practice Time into the Adult Schedule

If, like most adults, your schedule is so full of appointments, responsibilities, and personal commitments that you can't imagine how you could possible fit in a period of time each day to practice handwriting, here are some thoughts that may be of help. It's really a two-step process.

### Step 1: Daily Handwriting

The idea that you want to improve your handwriting infers that whatever handwriting you produce each day displeases you in its appearance and/or in the difficulty or discomfort you experience when you write. This statement confirms one very important fact: that you actually do accomplish some amount of handwriting each day. You might not write very much each day, and there are probably some days you might just sign your signature or not write at all, but it is fair to say that you do write to some degree—for whatever reasons—nearly every day. So here is the first suggestion for daily practice: let every

instance that you write serve as practice! This does mean that you must adopt a change of attitude toward your handwriting. Every time you write you must now consciously regard the movement of your fingers and hand as your personal effort to improve the way you currently write. No more will you simply dash off a scribbled sentence, signature, or grocery list. Every word and every letter are items to be more carefully considered as you write. As your practice in this manner continues, together with the suggestions that follow in Step 2, you will note that your efforts will not really take up much extra time at all. The reason why is easily explained.

Although you will consciously strive to improve each letter as you write, whatever words you are writing are, in fact, elements of whatever important language you are communicating at that time. This is what I refer to as "Practical Practice." If your handwriting—letters or words—displeases you or appears unfavorable, do not take the time to either erase (if in pencil) or start over on a new sheet. Simply take a second to look at what you've written, make a mental note of which parts of the letters or words look improper, and then simply continue to write. Chances are good that whatever you write will still be legible, and at this moment in your daily schedule, legibility is all that matters. Also, with the additional practice described in Step 2 that follows, all the writing you do will build up a consistency in your "writing rhythm." Writing rhythm is the speed and consistent pace at which you write. This is the movement of your fingers and hand to write each letter, and also of your hand and forearm to move from one letter to the next as you write. The goal is for you to develop your writing rhythm as an almost unconscious, automatic movement. With practice you should strive to write at a comfortable speed— not too fast or too slowly—so that the muscle memory of your fingers, hand, and forearm will be developed to always move, and therefore write, at a consistent pace. Once you develop your writing rhythm, you may look at each letter as you write, but your fingers, hand, and forearm will "automatically" continue writing until the word or sentence is completed. Because your writing will most likely be legible, do not worry about any inconsistencies you wish to correct. Strive to make such improvements as you continue to write, but not with what you have already written. During the following weeks as you continue to practice, you will be surprised at the development of your consistent writing rhythm. Like your consistent heartbeat or natural pace when you walk, or even the normal intervals of your own breathing, the movement of your muscles and resultant speed of your handwriting will become fairly consistent without mental thought.

### Step 2: Planned or Scheduled Practice

Even with a busy schedule of family and work, there are brief intervals during the day when carefully planned moments of ten or fifteen minutes can be set aside to practice your penmanship. If scheduled and adhered to with a degree of self-discipline, these private sessions of practice need not interfere with everything else in your normal, though hectic, schedule. Think of these practice times as gifts to yourself of quiet moments of self-improvement, and yes—even fun! Here are some suggestions:

1. Set your alarm to wake up twenty to thirty minutes earlier in the morning. Brush your teeth, get your coffee, and then put in at least ten minutes of practice. Do this before you shower and dress, because once you have

completed your morning ablutions, your thoughts will tend to focus on all your other responsibilities for the day. Establish a goal to complete one of this curriculum's lessons during this morning practice time.

2. If possible, reserve ten minutes during your lunch break to practice.

3. Similarly, discipline yourself to practice an additional ten to fifteen minutes before you retire for the night.

During these practice times, concentrate on improving your skill on the alphabet itself; the lesson plan assignments will serve as a guide for which letters, words, or sentences will be most helpful to you. Once you gain skill and confidence in writing the letters, you can start work on "composition writing." You can become very proficient at writing the letters, but for practical purposes you need to be skilled and comfortable writing words, sentences, and paragraphs. Only by doing this will you reach your final goal of writing *language*. This, then, is composition writing.

4. When you have reached this stage, try this: in addition to your daily practice, make it a goal on a weekend or day off to write someone a correspondence letter. Don't get too carried away at first; a single-page letter and addressed envelope is fine. Now you're using your handwriting for a personal, most meaningful purpose! This would also be a great instance to write and address greeting cards for holidays, birthdays, anniversaries, or other special occasions.

5. Another option is to begin a personal journal at the end of each day. Date each entry and briefly write about your day's accomplishments. Mention not only your handwriting practice, but anything of significance or interest with family, friends, or work. As the weeks and months ago by, it will be rewarding to look back on this diary of your life's activities.

All of these ideas will help you continue to practice and keep writing. As mentioned, you must focus on your personal goal of handwriting improvement and maintain the self-discipline to stick to your schedule. Hopefully, if you can, find a friend or relative who will share you interest and similarly correspond with you. Receiving letters—not just sending them—is always a most meaningful incentive for handwriting. By continuing your daily practice, handwriting often becomes a lifelong habit that draws you closer to the people who matter most of all.

# Plan for Lessons 1-13

## Standard Scale Writing

| | |
|---|---|
| **LESSON 1** | **Basic Principles of Handwriting**<br><br>Practice the correct placement of the paper in front of you as you are seated, and practice the proper way to hold the pen/pencil in your hand (page 92). Understand what the writing zone is and why it is the best place to position your paper when you write (page 94). Review the information about good posture (page 95). |
| **LESSON 2** | Why is it important that all letters slant the same way?<br>Which muscles should we use when we write?<br>What is "combination movement"?<br><br>Complete two pages of the Movement Exercise Practice Sheet. |
| **LESSON 3**<br>Study Model Letters **i**, **n**, **m**, and **u**. | Review the importance of the paper-shifting movement (page 94 and as described in the cross-drill instructions on page 107). Why is this important? On one Cross-Drill Exercise Practice Sheet, do the cross-drill labeled Exercise A on page 112.<br><br>Complete one Movement Exercise Practice Sheet.<br><br>Note: For each lesson that follows in this lesson plan, use a new Movement Exercise or Cross-Drill Exercise Practice Sheet by photocopying the blank Movement Exercise and Cross-Drill sheets in Appendix 1. |
| **LESSON 4** | Complete one page of cross-drill exercises using the following letters or letter-groups:<br>        three rows of the letter **i**<br>        three rows of the letter **u**<br>        three rows of the letter **n**<br>        three rows of the letter **m**<br><br>When you have completed writing the lines in the first direction, turn the paper sideways (ninety degrees) and write the same exercise across the page. Use this method to complete all cross-drill exercises that follow. |

| LESSON 5 | Complete one Movement Exercise Practice Sheet. Complete a cross-drill using the following letter pairs—three rows of each:<br><br>**i n**<br>**n m**<br>**m u**<br>**u i**<br>**n u** |
|---|---|
| LESSON 6 | Read Copybook Practice Sheet Instructions on page 115. Complete one Movement Exercise Practice Sheet.<br><br>Complete Copybook Practice Sheet (Set 1), page 123. |
| LESSON 7<br>Study Model<br>Letters **l**, **j**, **v**, and **w** | Complete a cross-drill of the following—three rows of each:<br>letter **l** only<br>letter **j** only<br>letter **v** only<br>letter **w** only<br>letter combination **u v w j**<br><br>Complete Copybook Practice Sheet (Set 1), page 124. |
| LESSON 8<br>Study Model<br>Letters **a**, **b**, **c**, **d**, and **e** | Complete a cross-drill of the following, doing the first five rows as indicated, then repeating the five-row sequence two more times. This will give you a completed cross-drill of fifteen lines in each direction:<br>first row—letter **f** only<br>second row—letter **g** only<br>third row—letter **h** only<br>fourth row—letter **t** only<br>fifth row—letter **y** only |
| LESSON 9 | Complete one Movement Exercise Practice Sheet.<br><br>Complete Copybook Practice Sheets (Set 1), pages 125 and 126. |
| LESSON 10<br>Study Model<br>Letters **a**, **b**, **c**, **d**, and **e** | Complete a cross-drill of the following—three rows of each:<br>letter **a** only<br>letter **b** only<br>letter **c** only<br>letter **d** only<br>letter **e** only<br><br>Complete Copybook Practice Sheets (Set 1), pages 127 and 128. |

| | |
|---|---|
| **LESSON 11**<br>Study Model<br>Letters **k**, **o**, **p**,<br>and **q** | Complete a cross-drill of the following—three rows of each:<br>    letter **k** only<br>    letter **o** only<br>    letter **p** only<br>    letter **q** only<br><br>Complete Copybook Practice Sheet (Set 1), page 129. |
| **LESSON 12**<br>Study Model<br>Letters **r**, **s**, **x**,<br>and **zz** | Complete a cross-drill of the following—three rows of each:<br>    letter **r** only<br>    letter **s** only<br>    letter **x** only<br>    letter **z** only<br><br>Complete Copybook Practice Sheets (Set 1), pages 130 and 131. |
| **LESSON 13**<br>Study Model<br>Letters **l**, **j**, **v**,<br>and **w** | **Alternate Lowercase Letters—Ending Forms**<br><br>Alternate letters add variety, beauty, and at times, additional speed to your writing.<br><br>Warm-up exercise: student's choice. Because these alternate lowercase letters are only used as the last letter at the end of a word, they are not designed to connect with another letter on their right side. Therefore, when practicing cross-drills, simply lift your pen when you complete an ending form letter and then resume your writing for the next group of letters.<br><br>Complete a cross-drill of the following, using the alternate (ending) forms for **d**, **r**, and **t**: Three rows of each: **end xpr ict bzd fst qvd mar yot led kir hjt ubr** (see Figure S on following page).<br><br>Student may choose to do a Movement Exercise Practice Sheet instead of the cross-drill. (Or do both!)<br><br>Complete Copybook Practice Sheets (Set 1), pages 132 and 133. |

You have now practiced all the lowercase letters of the alphabet. Continued handwriting practice must be maintained on a daily basis for consistent progress to be achieved. It is recommended that from this point on, daily practice should include a warm-up exercise (such as a cross-drill exercise with the student choosing the letters he or she wishes to use to make a five-by-five inch pattern, or one page of the Movement Exercise Practice Sheet) and at least one or two pages of word practice (as suggested in the remaining lessons of this course).

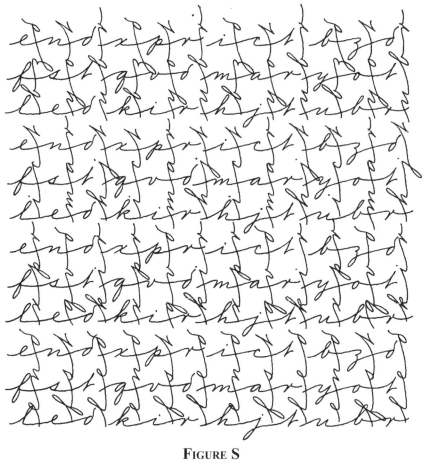

**FIGURE S**
**LESSON 13 CROSS-DRILL EXAMPLE USING ENDING FORMS**

# Copybook Practice Sheet (Set 1) Lesson 6

On each Set 1 sheet there are three model lines of writing and five blank lines beneath each model line. Carefully study the writing in the model lines. Using the model writing as a guide, write the same letters or words that appear on the model line on the five blank lines beneath it. Strive to make your handwriting look as much like the model writing as possible. (Remember: Diagonal lines are indicators of proper letter slant.)

Date_____

**Model** *iii nnn mmm uuu iii nnn*

**1**

**2**

**3**

**4**

**5**

**Model** *immu numi miun uinm iumn*

**1**

**2**

**3**

**4**

**5**

**Model** *minimum minimum minimum*

**1**

**2**

**3**

**4**

**5**

# Copybook Practice Sheet (Set 1) Lesson 7

On each Set 1 sheet there are three model lines of writing and five blank lines beneath each model line. Carefully study the writing in the model lines. Using the model writing as a guide, write the same letters or words that appear on the model line on the five blank lines beneath it. Strive to make your handwriting look as much like the model writing as possible. (Remember: Diagonal lines are indicators of proper letter slant.)

Date_____

Model  *jm ln vu wi jm ln vu wi jm ln vu wi*

1

2

3

4

5

Model  *jlvw wjvl lwjv jlvw wjvl lwjv jlvw wjvl*

1

2

3

4

5

Model  *njwi vmlu julm njwi vmlu julm*

1

2

3

4

5

# Copybook Practice Sheet (Set 1) Lesson 9a

On each Set 1 sheet there are three model lines of writing and five blank lines beneath each model line. Carefully study the writing in the model lines. Using the model writing as a guide, write the same letters or words that appear on the model line on the five blank lines beneath it. Strive to make your handwriting look as much like the model writing as possible. (Remember: Diagonal lines are indicators of proper letter slant.)

Date_____

**Model** *iumn iumn muni muni umin umin*

**1**

**2**

**3**

**4**

**5**

**Model** *jlvw jlvw vlwj vlwj jvwl jvwl lwjv lwjv*

**1**

**2**

**3**

**4**

**5**

**Model** *fghty fghty hytfg hytfg tyhgf tyhgh*

**1**

**2**

**3**

**4**

**5**

# Copybook Practice Sheet (Set 1) Lesson 9b

On each Set 1 sheet there are three model lines of writing and five blank lines beneath each model line. Carefully study the writing in the model lines. Using the model writing as a guide, write the same letters or words that appear on the model line on the five blank lines beneath it. Strive to make your handwriting look as much like the model writing as possible. (Remember: Diagonal lines are indicators of proper letter slant.)

Date_____

**Model** *fun willy nilly fun willy nilly fun*

1

2

3

4

5

**Model** *tilt fig living tilt fig living tilt fig*

1

2

3

4

5

**Model** *giving until winning giving until winnin*

1

2

3

4

5

# Copybook Practice Sheet (Set 1) Lesson 10a

On each Set 1 sheet there are three model lines of writing and five blank lines beneath each model line. Carefully study the writing in the model lines. Using the model writing as a guide, write the same letters or words that appear on the model line on the five blank lines beneath it. Strive to make your handwriting look as much like the model writing as possible. (Remember: Diagonal lines are indicators of proper letter slant.)

Date_____

**Model** *flow swim lead flow swim lead flow*

**1**

**2**

**3**

**4**

**5**

**Model** *jungle cost each jungle cost each jungle*

**1**

**2**

**3**

**4**

**5**

**Model** *fifteen wind tingle fifteen wind tingle*

**1**

**2**

**3**

**4**

**5**

# Copybook Practice Sheet (Set 1) Lesson 10b

On each Set 1 sheet there are three model lines of writing and five blank lines beneath each model line. Carefully study the writing in the model lines. Using the model writing as a guide, write the same letters or words that appear on the model line on the five blank lines beneath it. Strive to make your handwriting look as much like the model writing as possible. (Remember: Diagonal lines are indicators of proper letter slant.)

Date_____

**Model** *lvy lvy lvy ufa ufa ufa mgc mgc mgc*

1

2

3

4

5

**Model** *nte nte nte jwd jwd jwd hib hib hib*

1

2

3

4

5

**Model** *nine or ten men went mining in a mine*

1

2

3

4

5

128

# Copybook Practice Sheet (Set 1) Lesson 11

On each Set 1 sheet there are three model lines of writing and five blank lines beneath each model line. Carefully study the writing in the model lines. Using the model writing as a guide, write the same letters or words that appear on the model line on the five blank lines beneath it. Strive to make your handwriting look as much like the model writing as possible. (Remember: Diagonal lines are indicators of proper letter slant.)

Date_____

Model  *height again dear bean height again dear*

1

2

3

4

5

Model  *ice cube laughed decree ice cube laughed*

1

2

3

4

5

Model  *dead end cadence faded dead end cadence*

1

2

3

4

5

129

# Copybook Practice Sheet (Set 1) Lesson 12a

On each Set 1 sheet there are three model lines of writing and five blank lines beneath each model line. Carefully study the writing in the model lines. Using the model writing as a guide, write the same letters or words that appear on the model line on the five blank lines beneath it. Strive to make your handwriting look as much like the model writing as possible. (Remember: Diagonal lines are indicators of proper letter slant.)

Date_____

Model *apple banana peach grape pear pawpaw*

1

2

3

4

5

Model *quince oak lilac maple rose spirea ash*

1

2

3

4

5

Model *spruce alder beech elm hedge pine fir*

1

2

3

4

5

# Copybook Practice Sheet (Set 1) Lesson 12b

On each Set 1 sheet there are three model lines of writing and five blank lines beneath each model line. Carefully study the writing in the model lines. Using the model writing as a guide, write the same letters or words that appear on the model line on the five blank lines beneath it. Strive to make your handwriting look as much like the model writing as possible. (Remember: Diagonal lines are indicators of proper letter slant.)

Date_____

**Model** *the kindness of friends is a blessing*

**1**

**2**

**3**

**4**

**5**

**Model** *marigolds and petunias are pretty flowers*

**1**

**2**

**3**

**4**

**5**

**Model** *our new house has bright red shutters*

**1**

**2**

**3**

**4**

**5**

131

# Copybook Practice Sheet (Set 1) Lesson 13a

On each Set 1 sheet there are three model lines of writing and five blank lines beneath each model line. Carefully study the writing in the model lines. Using the model writing as a guide, write the same letters or words that appear on the model line on the five blank lines beneath it. Strive to make your handwriting look as much like the model writing as possible. (Remember: Diagonal lines are indicators of proper letter slant.)

Date_____

Model    *the wild geese flew over the hill to our pond*

1

2

3

4

5

Model    *autumn is beautiful when leaves change color*

1

2

3

4

5

Model    *never lose your loyalty for what you believe*

1

2

3

4

5

# Copybook Practice Sheet (Set 1) Lesson 13b

On each Set 1 sheet there are three model lines of writing and five blank lines beneath each model line. Carefully study the writing in the model lines. Using the model writing as a guide, write the same letters or words that appear on the model line on the five blank lines beneath it. Strive to make your handwriting look as much like the model writing as possible. (Remember: Diagonal lines are indicators of proper letter slant.)

Date_____

**Model** *bend flower wilt surround tender veer*

**1**

**2**

**3**

**4**

**5**

**Model** *ended river rent spirit afraid server spent*

**1**

**2**

**3**

**4**

**5**

**Model** *tilt decipher respect decided reservoir never*

**1**

**2**

**3**

**4**

**5**

# Plan for Lessons 14-34

## Standard Scale Writing

### *Using Copybook Practice Sheet (Set 1)*

For Lessons 14 through 34, follow the same practice format used in the previous lessons. In each lesson, practice a warm-up exercise of your choice, and then write eight to ten lines, using any quotation or selection of literature or poetry. Use the Standard Scale Practice Sheet (Set 1) located in Appendix 1 for this practice. The poems and quotations in Chapter 8 are for this daily handwriting practice, or you may prefer to use selections from other sources.

If you would like to write on paper that has no lines printed on it for your practice, put the guideline sheet under the unlined paper. With good lighting, such as a desk lamp, you can usually see the guidelines through the paper and use the lines as a guide, even though they are not actually printed on your writing paper.

After you have written eight to ten lines, complete the appropriate Copybook Practice Sheet noted in each lesson. Complete at least one lesson per day.

---

**Helpful Hint:** When writing quotations or selections from literature or poems, use all lowercase letters for your practice. Whenever a word is capitalized, simply write it as a small (lowercase) letter.

---

| LESSON 14 | Warm-up exercise of student's choice. Write 8-10 lines (½ to 1 full page) of practice writing using any of the quotations and selections from literature and poetry provided in Chapter 8, or selection of student's choosing. Complete Copybook Practice Sheet (Set 1), page 139. |
|---|---|
| LESSON 15 | Warm-up exercise of student's choice. Write 8-10 lines (½ to 1 full page) of practice writing using any of the quotations and selections from literature and poetry provided in Chapter 8, or selection of student's choosing. Complete Copybook Practice Sheet (Set 1), page 140. |
| LESSON 16 | Warm-up exercise of student's choice. Write 8-10 lines (½ to 1 full page) of practice writing using any of the quotations and selections from literature and poetry provided in Chapter 8, or selection of student's choosing. Complete Copybook Practice Sheet (Set 1), page 141. |

| Lesson 17 | Warm-up exercise of student's choice. Write 8-10 lines (½ to 1 full page) of practice writing using any of the quotations and selections from literature and poetry provided in Chapter 8, or selection of student's choosing. Complete Copybook Practice Sheet (Set 1), page 142. |
|---|---|
| Lesson 18 | Warm-up exercise of student's choice. Write 8-10 lines (½ to 1 full page) of practice writing using any of the quotations and selections from literature and poetry provided in Chapter 8, or selection of student's choosing. Complete Copybook Practice Sheet (Set 1), page 143. |
| Lesson 19 | Warm-up exercise of student's choice. Write 8-10 lines (½ to 1 full page) of practice writing using any of the quotations and selections from literature and poetry provided in Chapter 8, or selection of student's choosing. Complete Copybook Practice Sheet (Set 1), page 144. |
| Lesson 20 | Warm-up exercise of student's choice. Write 8-10 lines (½ to 1 full page) of practice writing using any of the quotations and selections from literature and poetry provided in Chapter 8, or selection of student's choosing. Complete Copybook Practice Sheet (Set 1), page 145. |
| Lesson 21 | Warm-up exercise of student's choice. Write 8-10 lines (½ to 1 full page) of practice writing using any of the quotations and selections from literature and poetry provided in Chapter 8, or selection of student's choosing. Complete Copybook Practice Sheet (Set 1), page 146. |
| Lesson 22 | Warm-up exercise of student's choice. Write 8-10 lines (½ to 1 full page) of practice writing using any of the quotations and selections from literature and poetry provided in Chapter 8, or selection of student's choosing. Complete Copybook Practice Sheet (Set 1), page 147. |

| LESSON 23 | Warm-up exercise of student's choice.<br>Write 8-10 lines (½ to 1 full page) of practice writing using any of the quotations and selections from literature and poetry provided in Chapter 8, or selection of student's choosing.<br><br>Complete Copybook Practice Sheet (Set 1), page 148. |
|---|---|
| LESSON 24 | Warm-up exercise of student's choice.<br>Write 8-10 lines (½ to 1 full page) of practice writing using any of the quotations and selections from literature and poetry provided in Chapter 8, or selection of student's choosing.<br><br>Complete Copybook Practice Sheet (Set 1), page 149. |
| LESSON 25 | Warm-up exercise of student's choice.<br>Write 8-10 lines (½ to 1 full page) of practice writing using any of the quotations and selections from literature and poetry provided in Chapter 8, or selection of student's choosing.<br><br>Complete Copybook Practice Sheet (Set 1), page 150. |
| LESSON 26 | Warm-up exercise of student's choice.<br>Write 8-10 lines (½ to 1 full page) of practice writing using any of the quotations and selections from literature and poetry provided in Chapter 8, or selection of student's choosing.<br><br>Complete Copybook Practice Sheet (Set 1), page 151. |
| LESSON 27 | Warm-up exercise of student's choice.<br>Write 8-10 lines (½ to 1 full page) of practice writing using any of the quotations and selections from literature and poetry provided in Chapter 8, or selection of student's choosing.<br><br>Complete Copybook Practice Sheet (Set 1), page 152. |

| LESSON 28 | Warm-up exercise of student's choice. |
|---|---|
| | Write 8-10 lines (½ to 1 full page) of practice writing using any of the quotations and selections from literature and poetry provided in Chapter 8, or selection of student's choosing. |
| | Complete Copybook Practice Sheet (Set 1), page 153. |
| LESSON 29 | Warm-up exercise of student's choice. |
| | Write 8-10 lines (½ to 1 full page) of practice writing using any of the quotations and selections from literature and poetry provided in Chapter 8, or selection of student's choosing. |
| | Complete Copybook Practice Sheet (Set 1), page 154. |
| LESSON 30 | Warm-up exercise of student's choice. |
| | Write 8-10 lines (½ to 1 full page) of practice writing using any of the quotations and selections from literature and poetry provided in Chapter 8, or selection of student's choosing. |
| | Complete Copybook Practice Sheet (Set 1), page 155. |
| LESSON 31 | Warm-up exercise of student's choice. |
| | Write 8-10 lines (½ to 1 full page) of practice writing using any of the quotations and selections from literature and poetry provided in Chapter 8, or selection of student's choosing. |
| | Complete Copybook Practice Sheet (Set 1), page 156. |
| LESSON 32 | Warm-up exercise of student's choice. |
| | Write 8-10 lines (½ to 1 full page) of practice writing using any of the quotations and selections from literature and poetry provided in Chapter 8, or selection of student's choosing. |
| | Complete Copybook Practice Sheet (Set 1), page 157. |
| LESSON 33 | Warm-up exercise of student's choice. |
| | Write 8-10 lines (½ to 1 full page) of practice writing using any of the quotations and selections from literature and poetry provided in Chapter 8, or selection of student's choosing. |
| | Complete Copybook Practice Sheet (Set 1), page 158. |

| LESSON 34 | Warm-up exercise of student's choice. |
| --- | --- |
| | Write 8-10 lines (½ to 1 full page) of practice writing using any of the quotations and selections from literature and poetry provided in Chapter 8, or selection of student's choosing. |
| | Complete Copybook Practice Sheet (Set 1), page 159. |

# Copybook Practice Sheet (Set 1) Lesson 14

On each Set 1 sheet there are three model lines of writing and five blank lines beneath each model line. Carefully study the writing in the model lines. Using the model writing as a guide, write the same letters or words that appear on the model line on the five blank lines beneath it. Strive to make your handwriting look as much like the model writing as possible. (Remember: Diagonal lines are indicators of proper letter slant.)

Date_____

**Model** *a dented car went down the old road too fast*

**1**

**2**

**3**

**4**

**5**

**Model** *the faint hint of a red sunset left the violet sky*

**1**

**2**

**3**

**4**

**5**

**Model** *the first mockingbird of the year is in flight*

**1**

**2**

**3**

**4**

**5**

# Copybook Practice Sheet (Set 1) Lesson 15

On each Set 1 sheet there are three model lines of writing and five blank lines beneath each model line. Carefully study the writing in the model lines. Using the model writing as a guide, write the same letters or words that appear on the model line on the five blank lines beneath it. Strive to make your handwriting look as much like the model writing as possible. (Remember: Diagonal lines are indicators of proper letter slant.)

Date_____

**Model** *daily handwriting practice will be rewarding.*

1

2

3

4

5

**Model** *patience and determination are keys to success.*

1

2

3

4

5

**Model** *maintain a smooth movement as you write.*

1

2

3

4

5

# Copybook Practice Sheet (Set 1) Lesson 16

On each Set 1 sheet there are three model lines of writing and five blank lines beneath each model line. Carefully study the writing in the model lines. Using the model writing as a guide, write the same letters or words that appear on the model line on the five blank lines beneath it. Strive to make your handwriting look as much like the model writing as possible. (Remember: Diagonal lines are indicators of proper letter slant.)

Date_____

Model *this is a sample of my handwriting as of today.*

1

2

3

4

5

Model *using a good pen or sharp pencil is important.*

1

2

3

4

5

Model *try not to be in such a big hurry as you write.*

1

2

3

4

5

# Copybook Practice Sheet (Set 1) Lesson 17

On each Set 1 sheet there are three model lines of writing and five blank lines beneath each model line. Carefully study the writing in the model lines. Using the model writing as a guide, write the same letters or words that appear on the model line on the five blank lines beneath it. Strive to make your handwriting look as much like the model writing as possible. (Remember: Diagonal lines are indicators of proper letter slant.)

Date_____

Model *it is a special gift to write a letter to a friend.*

1

2

3

4

5

Model *strive to handwrite at least one page each day.*

1

2

3

4

5

Model *try to make the spacing of your letters consistent*

1

2

3

4

5

# Copybook Practice Sheet (Set 1) Lesson 18

On each Set 1 sheet there are three model lines of writing and five blank lines beneath each model line. Carefully study the writing in the model lines. Using the model writing as a guide, write the same letters or words that appear on the model line on the five blank lines beneath it. Strive to make your handwriting look as much like the model writing as possible. (Remember: Diagonal lines are indicators of proper letter slant.)

Date_____

Model *a gardener always looks forward to the spring*

1

2

3

4

5

Model *autumn is a beautiful season of the year.*

1

2

3

4

5

Model *winter is a quiet time when snow covers the land*

1

2

3

4

5

143

# Copybook Practice Sheet (Set 1) Lesson 19

On each Set 1 sheet there are three model lines of writing and five blank lines beneath each model line. Carefully study the writing in the model lines. Using the model writing as a guide, write the same letters or words that appear on the model line on the five blank lines beneath it. Strive to make your handwriting look as much like the model writing as possible. (Remember: Diagonal lines are indicators of proper letter slant.)

Date_____

Model *the quick sly fox jumped over the lazy brown dog.*

1

2

3

4

5

Model *kindness, compassion and patience are keys in life*

1

2

3

4

5

Model *the meadow is bright with flowers in the summer.*

1

2

3

4

5

# Copybook Practice Sheet (Set 1) Lesson 20

On each Set 1 sheet there are three model lines of writing and five blank lines beneath each model line. Carefully study the writing in the model lines. Using the model writing as a guide, write the same letters or words that appear on the model line on the five blank lines beneath it. Strive to make your handwriting look as much like the model writing as possible. (Remember: Diagonal lines are indicators of proper letter slant.)

Date_____

**Model** *when was the last time you wrote a letter to a friend?*

1

2

3

4

5

**Model** *treat yourself and purchase some nice stationery*

1

2

3

4

5

**Model** *a fine-pointed fountain pen is my favorite tool.*

1

2

3

4

5

# Copybook Practice Sheet (Set 1) Lesson 21

On each Set 1 sheet there are three model lines of writing and five blank lines beneath each model line. Carefully study the writing in the model lines. Using the model writing as a guide, write the same letters or words that appear on the model line on the five blank lines beneath it. Strive to make your handwriting look as much like the model writing as possible. (Remember: Diagonal lines are indicators of proper letter slant.)

Date_____

**Model** *cross-drill and movement exercises are important.*

**1**

**2**

**3**

**4**

**5**

**Model** *never write on top of a tablet; use a single sheet.*

**1**

**2**

**3**

**4**

**5**

**Model** *keep your writing desk or table free of clutter.*

**1**

**2**

**3**

**4**

**5**

# Copybook Practice Sheet (Set 1) Lesson 22

On each Set 1 sheet there are three model lines of writing and five blank lines beneath each model line. Carefully study the writing in the model lines. Using the model writing as a guide, write the same letters or words that appear on the model line on the five blank lines beneath it. Strive to make your handwriting look as much like the model writing as possible. (Remember: Diagonal lines are indicators of proper letter slant.)

Date_____

**Model** *we saw some exquisite jewelry on exhibition.*

1

2

3

4

5

**Model** *taking long walks is a wonderful exercise.*

1

2

3

4

5

**Model** *always keep a dictionary nearby as you write.*

1

2

3

4

5

# Copybook Practice Sheet (Set 1) Lesson 23

On each Set 1 sheet there are three model lines of writing and five blank lines beneath each model line. Carefully study the writing in the model lines. Using the model writing as a guide, write the same letters or words that appear on the model line on the five blank lines beneath it. Strive to make your handwriting look as much like the model writing as possible. (Remember: Diagonal lines are indicators of proper letter slant.)

Date_____

**Model** *everyone should visit their library during the year.*

1

2

3

4

5

**Model** *working in a corporation involves many meetings.*

1

2

3

4

5

**Model** *the reading of books and poetry is one of life's joys*

1

2

3

4

5

148

# Copybook Practice Sheet (Set 1) Lesson 24

On each Set 1 sheet there are three model lines of writing and five blank lines beneath each model line. Carefully study the writing in the model lines. Using the model writing as a guide, write the same letters or words that appear on the model line on the five blank lines beneath it. Strive to make your handwriting look as much like the model writing as possible. (Remember: Diagonal lines are indicators of proper letter slant.)

Date_____

**Model** *we watched the cattle come down from the pasture.*

1

2

3

4

5

**Model** *we woke up early to do our chores on the family farm*

1

2

3

4

5

**Model** *the wheat harvest is always an exciting time for us.*

1

2

3

4

5

# Copybook Practice Sheet (Set 1) Lesson 25

On each Set 1 sheet there are three model lines of writing and five blank lines beneath each model line. Carefully study the writing in the model lines. Using the model writing as a guide, write the same letters or words that appear on the model line on the five blank lines beneath it. Strive to make your handwriting look as much like the model writing as possible. (Remember: Diagonal lines are indicators of proper letter slant.)

Date_____

Model  *a robin sang on the rail fence outside my window.*

1

2

3

4

5

Model  *tornados are quite common in the plains states*

1

2

3

4

5

Model  *the seagulls in the bay follow the fisherman's boat.*

1

2

3

4

5

# Copybook Practice Sheet (Set 1) Lesson 26

On each Set 1 sheet there are three model lines of writing and five blank lines beneath each model line. Carefully study the writing in the model lines. Using the model writing as a guide, write the same letters or words that appear on the model line on the five blank lines beneath it. Strive to make your handwriting look as much like the model writing as possible. (Remember: Diagonal lines are indicators of proper letter slant.)

Date_____

**Model** *mother often shops at the neighborhood grocery store.*

1

2

3

4

5

**Model** *the jewelry store sells watches, rings and necklaces.*

1

2

3

4

5

**Model** *hundreds of wild geese are flying over our property.*

1

2

3

4

5

# Copybook Practice Sheet (Set 1) Lesson 27

On each Set 1 sheet there are three model lines of writing and five blank lines beneath each model line. Carefully study the writing in the model lines. Using the model writing as a guide, write the same letters or words that appear on the model line on the five blank lines beneath it. Strive to make your handwriting look as much like the model writing as possible. (Remember: Diagonal lines are indicators of proper letter slant.)

Date_____

**Model** *the daffodils and hyacinths are poking above ground*

1

2

3

4

5

**Model** *the buds on our lilacs are beginning to look green.*

1

2

3

4

5

**Model** *the pansies are blooming in our garden containers*

1

2

3

4

5

# Copybook Practice Sheet (Set 1) Lesson 28

On each Set 1 sheet there are three model lines of writing and five blank lines beneath each model line. Carefully study the writing in the model lines. Using the model writing as a guide, write the same letters or words that appear on the model line on the five blank lines beneath it. Strive to make your handwriting look as much like the model writing as possible. (Remember: Diagonal lines are indicators of proper letter slant.)

Date_____

Model: *politeness and courtesy should not diminish with age.*

Model: *strive to learn and master one new word every week.*

Model: *by this time my handwriting should be improving*

# Copybook Practice Sheet (Set 1) Lesson 29

On each Set 1 sheet there are three model lines of writing and five blank lines beneath each model line. Carefully study the writing in the model lines. Using the model writing as a guide, write the same letters or words that appear on the model line on the five blank lines beneath it. Strive to make your handwriting look as much like the model writing as possible. (Remember: Diagonal lines are indicators of proper letter slant.)

Date_____

Model *you must learn what not to do before you don't do it.*

1

2

3

4

5

Model *patience, practice and the will to succeed will win.*

1

2

3

4

5

Model *the moon is a natural satellite of the planet earth*

1

2

3

4

5

# Copybook Practice Sheet (Set 1) Lesson 30

On each Set 1 sheet there are three model lines of writing and five blank lines beneath each model line. Carefully study the writing in the model lines. Using the model writing as a guide, write the same letters or words that appear on the model line on the five blank lines beneath it. Strive to make your handwriting look as much like the model writing as possible. (Remember: Diagonal lines are indicators of proper letter slant.)

Date_____

**Model** *our path took us further and further along the river.*

**1**

**2**

**3**

**4**

**5**

**Model** *we love to remember friends whenever we sit to write*

**1**

**2**

**3**

**4**

**5**

**Model** *the clouds seem to gather as they hover overhead.*

**1**

**2**

**3**

**4**

**5**

# Copybook Practice Sheet (Set 1) Lesson 31

On each Set 1 sheet there are three model lines of writing and five blank lines beneath each model line. Carefully study the writing in the model lines. Using the model writing as a guide, write the same letters or words that appear on the model line on the five blank lines beneath it. Strive to make your handwriting look as much like the model writing as possible. (Remember: Diagonal lines are indicators of proper letter slant.)

Date_____

**Model** *the deer nibbled on a ripe pear that grew on our tree.*

1

2

3

4

5

**Model** *the mountains appear to go on forever very far away.*

1

2

3

4

5

**Model** *the summer birds fly near the feeder by our door.*

1

2

3

4

5

# Copybook Practice Sheet (Set 1) Lesson 32

On each Set 1 sheet there are three model lines of writing and five blank lines beneath each model line. Carefully study the writing in the model lines. Using the model writing as a guide, write the same letters or words that appear on the model line on the five blank lines beneath it. Strive to make your handwriting look as much like the model writing as possible. (Remember: Diagonal lines are indicators of proper letter slant.)

Date_____

**Model** *the weather today was warmer than it was yesterday.*

1

2

3

4

5

**Model** *mother and father braved the rainshower to visit me.*

1

2

3

4

5

**Model** *the lavender blooms of the heather plants are lovely.*

1

2

3

4

5

# Copybook Practice Sheet (Set 1) Lesson 33

On each Set 1 sheet there are three model lines of writing and five blank lines beneath each model line. Carefully study the writing in the model lines. Using the model writing as a guide, write the same letters or words that appear on the model line on the five blank lines beneath it. Strive to make your handwriting look as much like the model writing as possible. (Remember: Diagonal lines are indicators of proper letter slant.)

Date_____

**Model** *an error will occur if we do not pay attention.*

1

2

3

4

5

**Model** *the evening glimmer of winter twilight is peaceful.*

1

2

3

4

5

**Model** *we favor the flavor of peanut butter ice cream.*

1

2

3

4

5

# Copybook Practice Sheet (Set 1) Lesson 34

On each Set 1 sheet there are three model lines of writing and five blank lines beneath each model line. Carefully study the writing in the model lines. Using the model writing as a guide, write the same letters or words that appear on the model line on the five blank lines beneath it. Strive to make your handwriting look as much like the model writing as possible. (Remember: Diagonal lines are indicators of proper letter slant.)

Date_____

**Model** *a competing athlete exercises with extra vigor.*

1

2

3

4

5

**Model** *the lawyer and police officer often confer together.*

1

2

3

4

5

**Model** *the actor posed by the mirror at an early hour.*

1

2

3

4

5

# Plan for Lessons 35-72

## Standard Scale Writing

### *Using Copybook Practice Sheet (Set 1)*

Each new lesson will consist of first practicing a warm-up exercise of your choice, then writing eight to ten lines, using any quotation or selection of literature or poetry. The poems and quotations in Chapter 8 are for this daily handwriting practice, or you may prefer to use selections from other sources. Use a copy of the Standard Scale Practice Sheet (Set 1) located in Appendix 1 for this practice.

After you have written eight to ten lines, complete the appropriate Copybook Practice Sheet noted in each lesson. Complete at least one lesson per day.

# Copybook Practice Sheet (Set 1) Lesson 35

On each Set 1 sheet there are three model lines of writing and five blank lines beneath each model line. Carefully study the writing in the model lines. Using the model writing as a guide, write the same letters or words that appear on the model line on the five blank lines beneath it. Strive to make your handwriting look as much like the model writing as possible. (Remember: Diagonal lines are indicators of proper letter slant.)

Date_____

**Model** *Alabama Alicia Alaska Abraham Alan*

**1**

**2**

**3**

**4**

**5**

**Model** *Andrew A A A A A Aberdeen Alexandra*

**1**

**2**

**3**

**4**

**5**

**Model** *Atlantic Antarctica Aegean Aardvark*

**1**

**2**

**3**

**4**

**5**

# Copybook Practice Sheet (Set 1) Lesson 36

On each Set 1 sheet there are three model lines of writing and five blank lines beneath each model line. Carefully study the writing in the model lines. Using the model writing as a guide, write the same letters or words that appear on the model line on the five blank lines beneath it. Strive to make your handwriting look as much like the model writing as possible. (Remember: Diagonal lines are indicators of proper letter slant.)

Date_____

**Model** *Buffalo Birmingham Barnaby Buttercup*

1
2
3
4
5

**Model** *B B B B B B B Barbara Bridgeport*

1
2
3
4
5

**Model** *Bobolink Baltic Brownville Benjamin B*

1
2
3
4
5

# Copybook Practice Sheet (Set 1) Lesson 37

On each Set 1 sheet there are three model lines of writing and five blank lines beneath each model line. Carefully study the writing in the model lines. Using the model writing as a guide, write the same letters or words that appear on the model line on the five blank lines beneath it. Strive to make your handwriting look as much like the model writing as possible. (Remember: Diagonal lines are indicators of proper letter slant.)

Date_____

**Model** *Charles Celeste Catherine Caesar Cynthia*

1

2

3

4

5

**Model** *C C C CCCC Conrad Crestwood Chillicothe*

1

2

3

4

5

**Model** *Celosia Coleus Carrot Cairo Chicago CC*

1

2

3

4

5

# Copybook Practice Sheet (Set 1) Lesson 38

On each Set 1 sheet there are three model lines of writing and five blank lines beneath each model line. Carefully study the writing in the model lines. Using the model writing as a guide, write the same letters or words that appear on the model line on the five blank lines beneath it. Strive to make your handwriting look as much like the model writing as possible. (Remember: Diagonal lines are indicators of proper letter slant.)

Date_____

Model *Dakota Denver David Dublin Dogwood*

1

2

3

4

5

Model *Dallas D D D D D D Detroit Danube*

1

2

3

4

5

Model *Dolphin Dahlia Devonian Delaware D*

1

2

3

4

5

164

# Copybook Practice Sheet (Set 1) Lesson 39

On each Set 1 sheet there are three model lines of writing and five blank lines beneath each model line. Carefully study the writing in the model lines. Using the model writing as a guide, write the same letters or words that appear on the model line on the five blank lines beneath it. Strive to make your handwriting look as much like the model writing as possible. (Remember: Diagonal lines are indicators of proper letter slant.)

Date_____

**Model** *Ellinwood Elvis England Edinburgh Eden*

**1**

**2**

**3**

**4**

**5**

**Model** *Europe E E E E E E E E E E Equator Everglades*

**1**

**2**

**3**

**4**

**5**

**Model** *Evansdale Eldorado Errol Evonne Eddie*

**1**

**2**

**3**

**4**

**5**

# Copybook Practice Sheet (Set 1) Lesson 40

On each Set 1 sheet there are three model lines of writing and five blank lines beneath each model line. Carefully study the writing in the model lines. Using the model writing as a guide, write the same letters or words that appear on the model line on the five blank lines beneath it. Strive to make your handwriting look as much like the model writing as possible. (Remember: Diagonal lines are indicators of proper letter slant.)

Date_____

**Model** *Faith Frank Felicia Fulton Fayetteville*

1

2

3

4

5

**Model** *Fillmore F F F F F F Faulkner F*

1

2

3

4

5

**Model** *Ford Freud France Fairbanks Freeport*

1

2

3

4

5

# Copybook Practice Sheet (Set 1) Lesson 41

On each Set 1 sheet there are three model lines of writing and five blank lines beneath each model line. Carefully study the writing in the model lines. Using the model writing as a guide, write the same letters or words that appear on the model line on the five blank lines beneath it. Strive to make your handwriting look as much like the model writing as possible. (Remember: Diagonal lines are indicators of proper letter slant.)

Date_____

**Model** *Georgia Gainesville Gillespie Gregory*

**1**

**2**

**3**

**4**

**5**

**Model** *Glendale Galveston G G G G G G G G G*

**1**

**2**

**3**

**4**

**5**

**Model** *Geneva Galena Gardner Germany G G*

**1**

**2**

**3**

**4**

**5**

167

# Copybook Practice Sheet (Set 1) Lesson 42

On each Set 1 sheet there are three model lines of writing and five blank lines beneath each model line. Carefully study the writing in the model lines. Using the model writing as a guide, write the same letters or words that appear on the model line on the five blank lines beneath it. Strive to make your handwriting look as much like the model writing as possible. (Remember: Diagonal lines are indicators of proper letter slant.)

Date_____

**Model** *Henry Herkimer Harlequin Halifax H H*

1

2

3

4

5

**Model** *Heather Hamilton H H H H H Harold*

1

2

3

4

5

**Model** *Harris Helena Hartford Hudson Holyoke*

1

2

3

4

5

168

# Copybook Practice Sheet (Set 1) Lesson 43

On each Set 1 sheet there are three model lines of writing and five blank lines beneath each model line. Carefully study the writing in the model lines. Using the model writing as a guide, write the same letters or words that appear on the model line on the five blank lines beneath it. Strive to make your handwriting look as much like the model writing as possible. (Remember: Diagonal lines are indicators of proper letter slant.)

Date_____

**Model** *Indiana Independence Inverness Illinois*

**1**

**2**

**3**

**4**

**5**

**Model** *Iowa Ireland IIIII Iroquois Irving*

**1**

**2**

**3**

**4**

**5**

**Model** *Idlewild Indonesia Impatiens Impala*

**1**

**2**

**3**

**4**

**5**

# Copybook Practice Sheet (Set 1) Lesson 44

On each Set 1 sheet there are three model lines of writing and five blank lines beneath each model line. Carefully study the writing in the model lines. Using the model writing as a guide, write the same letters or words that appear on the model line on the five blank lines beneath it. Strive to make your handwriting look as much like the model writing as possible. (Remember: Diagonal lines are indicators of proper letter slant.)

Date_____

**Model** *Jersey Jennifer Joseph Jackson Johnnie*

1

2

3

4

5

**Model** *Jeremiah J J J J J Juanita Jasper Jerry*

1

2

3

4

5

**Model** *Jackson Japan Jefferson Jupiter Jamaica*

1

2

3

4

5

# Copybook Practice Sheet (Set 1) Lesson 45

On each Set 1 sheet there are three model lines of writing and five blank lines beneath each model line. Carefully study the writing in the model lines. Using the model writing as a guide, write the same letters or words that appear on the model line on the five blank lines beneath it. Strive to make your handwriting look as much like the model writing as possible. (Remember: Diagonal lines are indicators of proper letter slant.)

Date_____

Model  *Kentucky Kingswood Kansas Kookaburra*

1

2

3

4

5

Model  *Killarney K K K K K Ketchikan Kodiak*

1

2

3

4

5

Model  *Kestrel Kathleen Koala Kenya Kristin*

1

2

3

4

5

# Copybook Practice Sheet (Set 1) Lesson 46

On each Set 1 sheet there are three model lines of writing and five blank lines beneath each model line. Carefully study the writing in the model lines. Using the model writing as a guide, write the same letters or words that appear on the model line on the five blank lines beneath it. Strive to make your handwriting look as much like the model writing as possible. (Remember: Diagonal lines are indicators of proper letter slant.)

Date_____

**Model** *Ladybug Lynx Leopard Loganberry Lion*

1

2

3

4

5

**Model** *Labrador L L L L L Lincoln Longfellow*

1

2

3

4

5

**Model** *Liszt Larkspur Lizard Lemur Lyrebird*

1

2

3

4

5

# Copybook Practice Sheet (Set 1) Lesson 47

On each Set 1 sheet there are three model lines of writing and five blank lines beneath each model line. Carefully study the writing in the model lines. Using the model writing as a guide, write the same letters or words that appear on the model line on the five blank lines beneath it. Strive to make your handwriting look as much like the model writing as possible. (Remember: Diagonal lines are indicators of proper letter slant.)

Date_____

**Model** *Maple Marigold Monaco Mesquite*

1

2

3

4

5

**Model** *McKinley Mercury M M M M M M M*

1

2

3

4

5

**Model** *Malaga Melbourne Mosquito Mongoose*

1

2

3

4

5

# Copybook Practice Sheet (Set 1) Lesson 48

On each Set 1 sheet there are three model lines of writing and five blank lines beneath each model line. Carefully study the writing in the model lines. Using the model writing as a guide, write the same letters or words that appear on the model line on the five blank lines beneath it. Strive to make your handwriting look as much like the model writing as possible. (Remember: Diagonal lines are indicators of proper letter slant.)

Date_____

**Model** *Nightingale Norway Niagara Narcissus*

1

2

3

4

5

**Model** *Nautilus N N N N N N N Nuthatch*

1

2

3

4

5

**Model** *Neptune Nairobi Nelson Neon Nightshade*

1

2

3

4

5

# Copybook Practice Sheet (Set 1) Lesson 49

On each Set 1 sheet there are three model lines of writing and five blank lines beneath each model line. Carefully study the writing in the model lines. Using the model writing as a guide, write the same letters or words that appear on the model line on the five blank lines beneath it. Strive to make your handwriting look as much like the model writing as possible. (Remember: Diagonal lines are indicators of proper letter slant.)

Date_____

Model *Olive Oleander Orange Orchid Oxalis O*

1

2

3

4

5

NOTICE THAT THE APOSTROPHE CAN BE PLACED WITHIN OR OUTSIDE THE BEGINNING LOOP OF THE NEXT CAPITAL LETTER.

Model *O'Hara O'Keefe O'Neil O O O O Osprey*

1

2

3

4

5

Model *Orion Octopus Opossum Oceania Ocelot*

1

2

3

4

5

175

# Copybook Practice Sheet (Set 1) Lesson 50

On each Set 1 sheet there are three model lines of writing and five blank lines beneath each model line. Carefully study the writing in the model lines. Using the model writing as a guide, write the same letters or words that appear on the model line on the five blank lines beneath it. Strive to make your handwriting look as much like the model writing as possible. (Remember: Diagonal lines are indicators of proper letter slant.)

Date_____

**Model** *Pansy Poppy Poppy Panda Panama Peach*

1

2

3

4

5

**Model** *Plymouth PPPPPPPP Philadelphia*

1

2

3

4

5

**Model** *Porcupine Pleiades Puffin Pronghorn Parsnip*

1

2

3

4

5

# Copybook Practice Sheet (Set 1) Lesson 51

On each Set 1 sheet there are three model lines of writing and five blank lines beneath each model line. Carefully study the writing in the model lines. Using the model writing as a guide, write the same letters or words that appear on the model line on the five blank lines beneath it. Strive to make your handwriting look as much like the model writing as possible. (Remember: Diagonal lines are indicators of proper letter slant.)

Date_____

# Copybook Practice Sheet (Set 1) Lesson 52

On each Set 1 sheet there are three model lines of writing and five blank lines beneath each model line. Carefully study the writing in the model lines. Using the model writing as a guide, write the same letters or words that appear on the model line on the five blank lines beneath it. Strive to make your handwriting look as much like the model writing as possible. (Remember: Diagonal lines are indicators of proper letter slant.)

Date_____

Model *Rhinoceros Reagan Rembrandt Rochester*

1

2

3

4

5

Model *Rhubarb R R R R R R R R Reindeer R*

1

2

3

4

5

Model *Robin Renaissance Raleigh Revere Rhesus*

1

2

3

4

5

# Copybook Practice Sheet (Set 1) Lesson 53

On each Set 1 sheet there are three model lines of writing and five blank lines beneath each model line. Carefully study the writing in the model lines. Using the model writing as a guide, write the same letters or words that appear on the model line on the five blank lines beneath it. Strive to make your handwriting look as much like the model writing as possible. (Remember: Diagonal lines are indicators of proper letter slant.)

Date_____

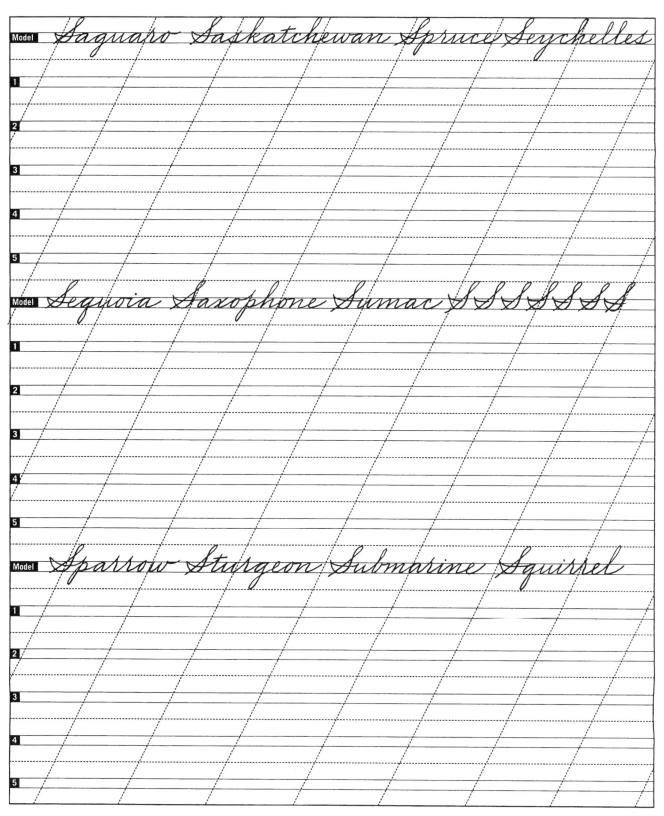

# Copybook Practice Sheet (Set 1) Lesson 54

On each Set 1 sheet there are three model lines of writing and five blank lines beneath each model line. Carefully study the writing in the model lines. Using the model writing as a guide, write the same letters or words that appear on the model line on the five blank lines beneath it. Strive to make your handwriting look as much like the model writing as possible. (Remember: Diagonal lines are indicators of proper letter slant.)

Date_____

**Model** *Truman Thoreau Toledo Thailand Texas*

1

2

3

4

5

**Model** *Tennessee Tulip Tonganoxie Triceratops*

1

2

3

4

5

**Model** *T T T T T Thistle Towhee Tecumseh*

1

2

3

4

5

180

# Copybook Practice Sheet (Set 1) Lesson 55

On each Set 1 sheet there are three model lines of writing and five blank lines beneath each model line. Carefully study the writing in the model lines. Using the model writing as a guide, write the same letters or words that appear on the model line on the five blank lines beneath it. Strive to make your handwriting look as much like the model writing as possible. (Remember: Diagonal lines are indicators of proper letter slant.)

Date_____

**Model** *Uganda Ukulele Uruguay Urbandale*

1

2

3

4

5

**Model** *Umbrella U U U U U Ulysses Uriah*

1

2

3

4

5

**Model** *Uranium Uranus Utrecht Ulexite U*

1

2

3

4

5

# Copybook Practice Sheet (Set 1) Lesson 56

On each Set 1 sheet there are three model lines of writing and five blank lines beneath each model line. Carefully study the writing in the model lines. Using the model writing as a guide, write the same letters or words that appear on the model line on the five blank lines beneath it. Strive to make your handwriting look as much like the model writing as possible. (Remember: Diagonal lines are indicators of proper letter slant.)

Date_____

**Model** *Virginia Valdez Vladivostok Vesuvius Violet*

**1**

**2**

**3**

**4**

**5**

**Model** *Voltaire V V V V V V Venezuela Victoria*

**1**

**2**

**3**

**4**

**5**

**Model** *Vireo Vespucci Vanilla Venetian Valentine*

**1**

**2**

**3**

**4**

**5**

# Copybook Practice Sheet (Set 1) Lesson 57

On each Set 1 sheet there are three model lines of writing and five blank lines beneath each model line. Carefully study the writing in the model lines. Using the model writing as a guide, write the same letters or words that appear on the model line on the five blank lines beneath it. Strive to make your handwriting look as much like the model writing as possible. (Remember: Diagonal lines are indicators of proper letter slant.)

Date_____

**Model** *Winchester Woodrow Wilson Washington W*

1

2

3

4

5

**Model** *Whippet Wichita W W W W W W W W W W*

1

2

3

4

5

**Model** *Winnipeg Webster Warbler Wolf Wisteria*

1

2

3

4

5

# Copybook Practice Sheet (Set 1) Lesson 58

On each Set 1 sheet there are three model lines of writing and five blank lines beneath each model line. Carefully study the writing in the model lines. Using the model writing as a guide, write the same letters or words that appear on the model line on the five blank lines beneath it. Strive to make your handwriting look as much like the model writing as possible. (Remember: Diagonal lines are indicators of proper letter slant.)

Date_____

**Model**

*y y y y y y C C C C C C X X X*

1

2

3

4

5

**Model**

*X X X Xenia Xylem Xavier Xylophone*

1

2

3

4

5

**Model**

*Xerophyte Xanthophyll Xenon Xinxiang*

1

2

3

4

5

# Copybook Practice Sheet (Set 1) Lesson 59

On each Set 1 sheet there are three model lines of writing and five blank lines beneath each model line. Carefully study the writing in the model lines. Using the model writing as a guide, write the same letters or words that appear on the model line on the five blank lines beneath it. Strive to make your handwriting look as much like the model writing as possible. (Remember: Diagonal lines are indicators of proper letter slant.)

Date_____

**Model** *Yakima Yucatan Yellowstone Yonkers*

1

2

3

4

5

**Model** *Youngstown Y Y Y Y Y Y Yogurt Y*

1

2

3

4

5

**Model** *Yuma Yangtze Yukon Yo-Yo Yucca Yew*

1

2

3

4

5

185

# Copybook Practice Sheet (Set 1) Lesson 60

On each Set 1 sheet there are three model lines of writing and five blank lines beneath each model line. Carefully study the writing in the model lines. Using the model writing as a guide, write the same letters or words that appear on the model line on the five blank lines beneath it. Strive to make your handwriting look as much like the model writing as possible. (Remember: Diagonal lines are indicators of proper letter slant.)

Date_____

**Model** *Zachary Zucchini Zinnia Zirconium Zither*

1

2

3

4

5

**Model** *Zoology Z Z Z Z Z Z Zurich Zodiac Zephyr*

1

2

3

4

5

**Model** *Zebra Zanesville Zoysia Zuider Zee Zambezi*

1

2

3

4

5

186

# Copybook Practice Sheet (Set 2) Lesson 61

This practice sheet is to be used after the student has completed all pages of the Copybook Practice Sheet (Set 1). Carefully study the writing on each model line. Then, using the model writing as a guide, write the same words that appear on the model line on the six blank lines beneath it. Strive to make your handwriting look like the model writing. Do your best to make your letter spacing and letter heights consistent and graceful. The height of the small letters on this sheet is shorter than the small letter height shown on Copybook Practice Sheet (Set 1). This is done to guide the student into the habit of writing at the size traditionally recommended for ease and speed of writing. It takes more time and effort to write larger letters. (Remember: Diagonal lines are indicators of proper letter slant.)

Date_____

*George expects to harvest his soybeans next month.*

*Marianne's jelly won First Place at the County Fair.*

*Frank invited us over this weekend for a hot dog cookout.*

187

# Copybook Practice Sheet (Set 2) Lesson 62

This practice sheet is to be used after the student has completed all pages of the Copybook Practice Sheet (Set 1). Carefully study the writing on each model line. Then, using the model writing as a guide, write the same words that appear on the model line on the six blank lines beneath it. Strive to make your handwriting look like the model writing. Do your best to make your letter spacing and letter heights consistent and graceful. The height of the small letters on this sheet is shorter than the small letter height shown on Copybook Practice Sheet (Set 1). This is done to guide the student into the habit of writing at the size traditionally recommended for ease and speed of writing. It takes more time and effort to write larger letters. (Remember: Diagonal lines are indicators of proper letter slant.)

Date_____

Model: *Always endeavor to make a good first impression.*

Model: *Severe thunderstorms brought rain, wind, and large hail.*

Model: *Last month a tornado roared through our neighborhood.*

# Copybook Practice Sheet (Set 2) Lesson 63

This practice sheet is to be used after the student has completed all pages of the Copybook Practice Sheet (Set 1). Carefully study the writing on each model line. Then, using the model writing as a guide, write the same words that appear on the model line on the six blank lines beneath it. Strive to make your handwriting look like the model writing. Do your best to make your letter spacing and letter heights consistent and graceful. The height of the small letters on this sheet is shorter than the small letter height shown on Copybook Practice Sheet (Set 1). This is done to guide the student into the habit of writing at the size traditionally recommended for ease and speed of writing. It takes more time and effort to write larger letters. (Remember: Diagonal lines are indicators of proper letter slant.)

Date_____

Model    *Xavier and Zachary were best friends in their childhood.*

Model    *Debbie's cats are playful and sometimes mischievous.*

Model    *It's fun to play my old albums on the turntable.*

189

# Copybook Practice Sheet (Set 2) Lesson 64

This practice sheet is to be used after the student has completed all pages of the Copybook Practice Sheet (Set 1). Carefully study the writing on each model line. Then, using the model writing as a guide, write the same words that appear on the model line on the six blank lines beneath it. Strive to make your handwriting look like the model writing. Do your best to make your letter spacing and letter heights consistent and graceful. The height of the small letters on this sheet is shorter than the small letter height shown on Copybook Practice Sheet (Set 1). This is done to guide the student into the habit of writing at the size traditionally recommended for ease and speed of writing. It takes more time and effort to write larger letters. (Remember: Diagonal lines are indicators of proper letter slant.)

Date_____

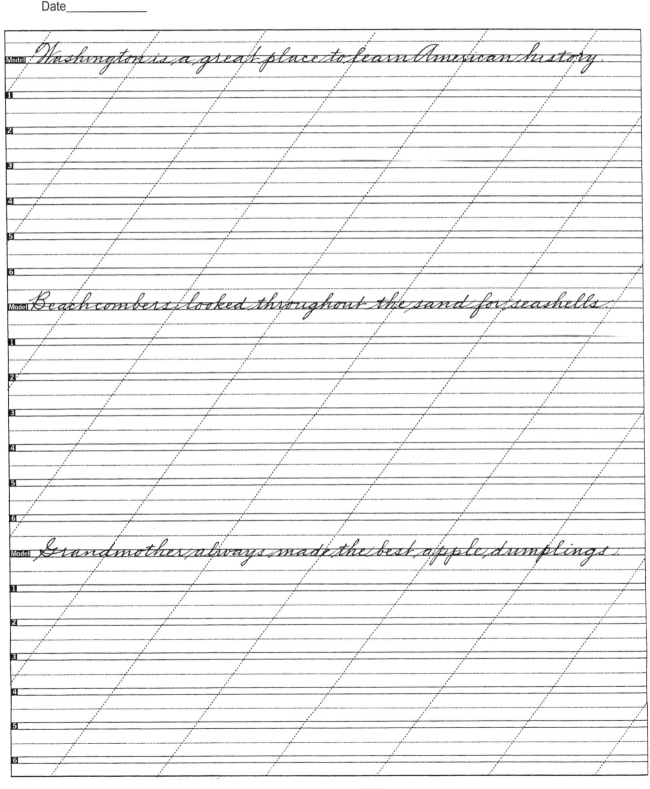

Model: *Washington is a great place to learn American history.*

Model: *Beachcombers looked throughout the sand for seashells.*

Model: *Grandmother always made the best apple dumplings.*

# Copybook Practice Sheet (Set 2) Lesson 65

This practice sheet is to be used after the student has completed all pages of the Copybook Practice Sheet (Set 1). Carefully study the writing on each model line. Then, using the model writing as a guide, write the same words that appear on the model line on the six blank lines beneath it. Strive to make your handwriting look like the model writing. Do your best to make your letter spacing and letter heights consistent and graceful. The height of the small letters on this sheet is shorter than the small letter height shown on Copybook Practice Sheet (Set 1). This is done to guide the student into the habit of writing at the size traditionally recommended for ease and speed of writing. It takes more time and effort to write larger letters. (Remember: Diagonal lines are indicators of proper letter slant.)

Date_____

Model: *Yesterday a group of students toured the theater.*

Model: *Two postlights illuminate the sidewalk at night.*

Model: *Our car had new brakes installed at the repair shop.*

# Copybook Practice Sheet (Set 2) Lesson 66

This practice sheet is to be used after the student has completed all pages of the Copybook Practice Sheet (Set 1). Carefully study the writing on each model line. Then, using the model writing as a guide, write the same words that appear on the model line on the six blank lines beneath it. Strive to make your handwriting look like the model writing. Do your best to make your letter spacing and letter heights consistent and graceful. The height of the small letters on this sheet is shorter than the small letter height shown on Copybook Practice Sheet (Set 1). This is done to guide the student into the habit of writing at the size traditionally recommended for ease and speed of writing. It takes more time and effort to write larger letters. (Remember: Diagonal lines are indicators of proper letter slant.)

Date_____

Model *Basil, Sage, Rosemary and Thyme are used in cooking.*

Model *I spent many hours at the library working on my project.*

Model *Roasted lamb and baked potatoes make a choice meal.*

# Copybook Practice Sheet (Set 2) Lesson 67

This practice sheet is to be used after the student has completed all pages of the Copybook Practice Sheet (Set 1). Carefully study the writing on each model line. Then, using the model writing as a guide, write the same words that appear on the model line on the six blank lines beneath it. Strive to make your handwriting look like the model writing. Do your best to make your letter spacing and letter heights consistent and graceful. The height of the small letters on this sheet is shorter than the small letter height shown on Copybook Practice Sheet (Set 1). This is done to guide the student into the habit of writing at the size traditionally recommended for ease and speed of writing. It takes more time and effort to write larger letters. (Remember: Diagonal lines are indicators of proper letter slant.)

Date_____

Model *Lettuce, tomatoes and cucumbers were in the garden salad.*

Model *Victoria made tuna fish sandwiches for our family picnic.*

Model *Oatmeal with cinnamon and raisins is a good breakfast.*

# Copybook Practice Sheet (Set 2) Lesson 68

This practice sheet is to be used after the student has completed all pages of the Copybook Practice Sheet (Set 1). Carefully study the writing on each model line. Then, using the model writing as a guide, write the same words that appear on the model line on the six blank lines beneath it. Strive to make your handwriting look like the model writing. Do your best to make your letter spacing and letter heights consistent and graceful. The height of the small letters on this sheet is shorter than the small letter height shown on Copybook Practice Sheet (Set 1). This is done to guide the student into the habit of writing at the size traditionally recommended for ease and speed of writing. It takes more time and effort to write larger letters. (Remember: Diagonal lines are indicators of proper letter slant.)

Date_____

Model *Fresh melon, strawberries and apples is a healthy dessert.*

Model *Mother made her special lasagna for tonight's supper.*

Model *Holiday meals and family dinners are memorable times.*

# Copybook Practice Sheet (Set 3) Lesson 69

This practice sheet is to be used after the student has completed all pages of the Copybook Practice Sheet (Set 2). Carefully study the writing on each model line. Then, using the model writing as a guide, write the same words that appear on the model line on the six blank lines beneath it. Strive to make your handwriting look like the model writing. Do your best to make your letter spacing and letter heights consistent and graceful. The height of the small letters on this sheet is shorter than the small letter height shown on Copybook Practice Sheet (Set 1) to guide the student into the habit of writing at the size traditionally recommended for ease and speed of writing. It takes more time and effort to write larger letters. (Remember: Diagonal lines are indicators of proper letter slant.)

Date_____

*Mount Saint Helens is a volcano in Washington State.*

*Robert E. Peary was a Naval officer and Arctic explorer.*

*Edward R. Murrow was a famous American news journalist.*

# Copybook Practice Sheet (Set 3) Lesson 70

This practice sheet is to be used after the student has completed all pages of the Copybook Practice Sheet (Set 2). Carefully study the writing on each model line. Then, using the model writing as a guide, write the same words that appear on the model line on the six blank lines beneath it. Strive to make your handwriting look like the model writing. Do your best to make your letter spacing and letter heights consistent and graceful. The height of the small letters on this sheet is shorter than the small letter height shown on Copybook Practice Sheet (Set 1) to guide the student into the habit of writing at the size traditionally recommended for ease and speed of writing. It takes more time and effort to write larger letters. (Remember: Diagonal lines are indicators of proper letter slant.)

Date_____

Model *Henry David Thoreau wrote "Civil Disobedience" and "Walden."*

Model *Sir Arthur Conan Doyle created Mr. Sherlock Holmes.*

Model *Sojourner Truth was an early leader of Civil Rights.*

# Copybook Practice Sheet (Set 3) Lesson 71

This practice sheet is to be used after the student has completed all pages of the Copybook Practice Sheet (Set 2). Carefully study the writing on each model line. Then, using the model writing as a guide, write the same words that appear on the model line on the six blank lines beneath it. Strive to make your handwriting look like the model writing. Do your best to make your letter spacing and letter heights consistent and graceful. The height of the small letters on this sheet is shorter than the small letter height shown on Copybook Practice Sheet (Set 1) to guide the student into the habit of writing at the size traditionally recommended for ease and speed of writing. It takes more time and effort to write larger letters. (Remember: Diagonal lines are indicators of proper letter slant.)

Date_____

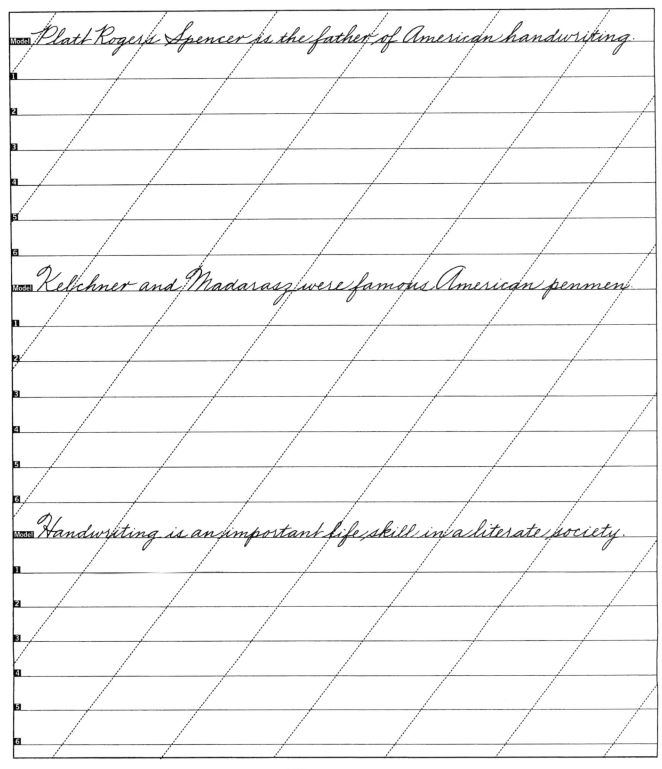

Platt Rogers Spencer is the father of American handwriting.

Kelchner and Madarasz were famous American penmen.

Handwriting is an important life skill in a literate society.

# Copybook Practice Sheet (Set 3) Lesson 72

This practice sheet is to be used after the student has completed all pages of the Copybook Practice Sheet (Set 2). Carefully study the writing on each model line. Then, using the model writing as a guide, write the same words that appear on the model line on the six blank lines beneath it. Strive to make your handwriting look like the model writing. Do your best to make your letter spacing and letter heights consistent and graceful. The height of the small letters on this sheet is shorter than the small letter height shown on Copybook Practice Sheet (Set 1) to guide the student into the habit of writing at the size traditionally recommended for ease and speed of writing. It takes more time and effort to write larger letters. (Remember: Diagonal lines are indicators of proper letter slant.)

Date_____

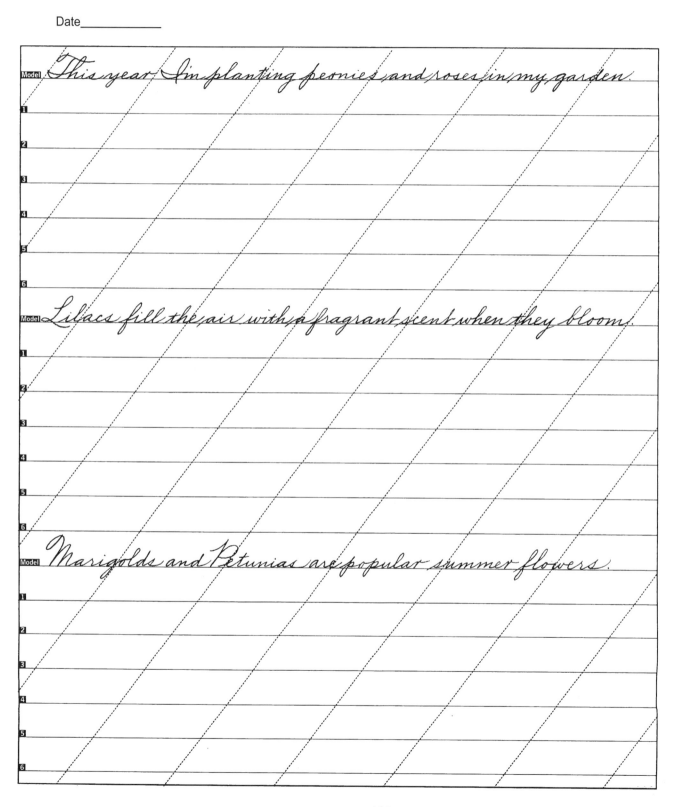

Model: This year I'm planting peonies and roses in my garden.

Model: Lilacs fill the air with a fragrant scent when they bloom.

Model: Marigolds and Petunias are popular summer flowers.

# Copybook Practice Sheet (Set 3) Lesson 73

This practice sheet is to be used after the student has completed all pages of the Copybook Practice Sheet (Set 2). Carefully study the writing on each model line. Then, using the model writing as a guide, write the same words that appear on the model line on the six blank lines beneath it. Strive to make your handwriting look like the model writing. Do your best to make your letter spacing and letter heights consistent and graceful. The height of the small letters on this sheet is shorter than the small letter height shown on Copybook Practice Sheet (Set 1) to guide the student into the habit of writing at the size traditionally recommended for ease and speed of writing. It takes more time and effort to write larger letters. (Remember: Diagonal lines are indicators of proper letter slant.)

Date_____

Model *We look forward to receiving our garden catalogs in Spring.*

Model *Numismatics is the sturdy of money, coins and currency.*

Model *The Aurora Borealis is a colorful sight in northern latitudes.*

# Copybook Practice Sheet (Set 3) Lesson 74

This practice sheet is to be used after the student has completed all pages of the Copybook Practice Sheet (Set 2). Carefully study the writing on each model line. Then, using the model writing as a guide, write the same words that appear on the model line on the six blank lines beneath it. Strive to make your handwriting look like the model writing. Do your best to make your letter spacing and letter heights consistent and graceful. The height of the small letters on this sheet is shorter than the small letter height shown on Copybook Practice Sheet (Set 1) to guide the student into the habit of writing at the size traditionally recommended for ease and speed of writing. It takes more time and effort to write larger letters. (Remember: Diagonal lines are indicators of proper letter slant.)

Date_____

Model   Our family always tries to celebrate Thanksgiving together.

Model   The Holiday Season is a joyous time of year for children.

Model   John Hancock's birthday is National Handwriting Day.

# Copybook Practice Sheet (Set 3) Lesson 75

This practice sheet is to be used after the student has completed all pages of the Copybook Practice Sheet (Set 2). Carefully study the writing on each model line. Then, using the model writing as a guide, write the same words that appear on the model line on the six blank lines beneath it. Strive to make your handwriting look like the model writing. Do your best to make your letter spacing and letter heights consistent and graceful. The height of the small letters on this sheet is shorter than the small letter height shown on Copybook Practice Sheet (Set 1) to guide the student into the habit of writing at the size traditionally recommended for ease and speed of writing. It takes more time and effort to write larger letters. (Remember: Diagonal lines are indicators of proper letter slant.)

Date_____

# Copybook Practice Sheet (Set 3) Lesson 76

This practice sheet is to be used after the student has completed all pages of the Copybook Practice Sheet (Set 2). Carefully study the writing on each model line. Then, using the model writing as a guide, write the same words that appear on the model line on the six blank lines beneath it. Strive to make your handwriting look like the model writing. Do your best to make your letter spacing and letter heights consistent and graceful. The height of the small letters on this sheet is shorter than the small letter height shown on Copybook Practice Sheet (Set 1) to guide the student into the habit of writing at the size traditionally recommended for ease and speed of writing. It takes more time and effort to write larger letters. (Remember: Diagonal lines are indicators of proper letter slant.)

Date_____

California landscape varies from mountain to desert to sea.

The best way to practice penmanship is to write to a friend.

Continue your efforts in handwriting every day of your life.

# Plan for Lessons 77-86

## Advanced (Small Scale) Writing

The purpose of the Advanced (Small Scale) Practice Sheets is to give you practice in writing multiple lines of text. There are no single-line models on these sheets. You are advised to study the writing presented on each sheet and then rewrite the entire text on a copy of the blank Advanced (Small Scale) Practice Sheet in Appendix 1. In this way, the entire page of writing serves the purpose of a "model line."

First practice a warm-up exercise of your choice. Then write eight to ten lines using any selection of literature, quotations, or poetry. Use a copy of the blank Advanced (Small Scale) Practice Sheet located in Appendix 1 for this practice. Finally, complete the appropriate Practice Sheet. Do at least one lesson per day.

Practicing single lines of writing on the previous Copybook Practice Sheets is an excellent method to gain skill in letterform, letterspacing, and movement of the hand while writing. However, it is extremely beneficial to have a mental image of what this penmanship looks like when it occupies several lines of text, a verse or more of poetry, a paragraph, or a quotation of at least a few sentences. There is a distinct appearance to such "blocks" of handwritten copy; it is flowing, graceful, and easy to read. This signature appearance of handwriting—that is, *the way it looks*, is what the student should strive for, so that his or her own writing will similarly look as flowing, graceful, and easy to read. The best way to achieve this is to study carefully the American Cursive handwriting Samples at the beginning of the book and to practice diligently every day.

As you write, not all letters will be perfect, but try your best. Don't worry about minor inconsistencies, such as if one letter is a little taller or shorter than another similar letter. There will be slight variations among your letters as you write, and this is normal. The overall "look" or "appearance" is what you should strive for: a combination of good letterform, consistent letterspacing (so your letters and words don't look cramped), and a graceful flow. Write at a speed that is comfortable; don't try to slowly draw each letter or to race across the page.

## Continue Your Daily Practice

After you have completed all of the lessons in this course, your next and final step is to continue your daily practice. Chapter 8 provides samples that you may wish to use for this handwriting practice. In addition to these, feel free to choose portions from quotations, verse, or literature that are particularly meaningful to you.

At your desk or table, always write on a single sheet of paper with a cushion sheet underneath. Use standard lined paper, the blank practice sheets provided with this program, or a piece of stationery paper. Never write on top of a pad or tablet.

You will notice that some papers are smoother to write on than others. I encourage you to try different varieties and select several you like. Also, find a particular writing tool you enjoy, one that is comfortable to hold and writes smoothly with a nice even ink flow.

Once you have done these things, then for the rest of your life you will possess not only a most useful skill, but you will also have that wonderful feeling known as the *joy of handwriting*.

# ADVANCED (Small Scale) Practice Sheet Lesson 77

This practice sheet is to be used when completing 8-10 lines from any of the quotations and selections from literature and poetry provided. Strive to make your letter spacing and letter heights consistent and graceful. Hold your pencil or pen comfortably and not too tightly. Remember to shift the paper every 2 to 3 inches as described in the Cross-Drill exercise instructions. Make it your goal for your penmanship to be a joy to write and beautiful to read! (Remember: Diagonal lines are indicators of proper letter slant.)

Date_____

Handwriting

... that action, of emotion, of thought and decision that has recorded the history of mankind, revealed the genius of invention, and disclosed the inmost depths of the soulful heart. Giving ideas tangible form through symbols and signs, it has forged a bond across millennia and generations that not only ties us to the thoughts and deeds of our forbears, but serves as an irrevocable link to our humanity as well. Neither machines nor technology can replace the significance or continuing importance of this portable skill, so necessary in every age, and as vital to the enduring saga of civilization as our very next breath.

-Michael R. Sull

# ADVANCED (Small Scale) Practice Sheet Lesson 78

This practice sheet is to be used when completing 8-10 lines from any of the quotations and selections from literature and poetry provided. Strive to make your letter spacing and letter heights consistent and graceful. Hold your pencil or pen comfortably and not too tightly. Remember to shift the paper every 2 to 3 inches as described in the Cross-Drill exercise instructions. Make it your goal for your penmanship to be a joy to write and beautiful to read! (Remember: Diagonal lines are indicators of proper letter slant.)

Date_____

*One Day at a Time*
*Finish every day and be done with it. You have done what you could. Some blunders and absurdities no doubt crept in; forget them as soon as you can. Tomorrow is a new day; begin it well and serenely and with too high a spirit to be cumbered with your old nonsense. This day is all that is good and fair. It is too dear, with its hopes and invitations, to waste a moment on all the yesterdays that have come before.*
*Ralph Waldo Emerson*

*Make Big Plans*
*Make no little plans; they have no magic to stir the soul. Make big plans; aim high in hope and work, remembering that a noble, logical diagram once recorded will never die, and that long after we are gone it will remain, a living thing for generations.*
*- Daniel Burnham*

# ADVANCED (Small Scale) Practice Sheet Lesson 79

This practice sheet is to be used when completing 8-10 lines from any of the quotations and selections from literature and poetry provided. Strive to make your letter spacing and letter heights consistent and graceful. Hold your pencil or pen comfortably and not too tightly. Remember to shift the paper every 2 to 3 inches as described in the Cross-Drill exercise instructions. Make it your goal for your penmanship to be a joy to write and beautiful to read! (Remember: Diagonal lines are indicators of proper letter slant.)

Date_____

When I Heard The Learned Astronomer

When I heard the learned astronomer,
When the proofs, the figures were ranged in
    columns before me,
When I was shown the charts and diagrams,
    to add, divide, and measure them,
When I sitting heard the astronomer where he
    lectured with much applause in the lecture room,
How soon unaccountable I became tired and sick,
Till rising and gliding out I wandered off
    by myself,
In the mystical moist night-air, and from time
    to time,
Looked up in perfect silence at the stars.
                    - Walt Whitman

207

# ADVANCED (Small Scale) Practice Sheet Lesson 80

This practice sheet is to be used when completing 8-10 lines from any of the quotations and selections from literature and poetry provided. Strive to make your letter spacing and letter heights consistent and graceful. Hold your pencil or pen comfortably and not too tightly. Remember to shift the paper every 2 to 3 inches as described in the Cross-Drill exercise instructions. Make it your goal for your penmanship to be a joy to write and beautiful to read! (Remember: Diagonal lines are indicators of proper letter slant.)

Date_____

*Lesson of the Bumblebee*
According to the theory of aerodynamics, and as may be readily demonstrated through wind tunnel experiments, the bumblebee is unable to fly. This is because the weight, size, and shape of his body in relation to the total wingspread makes flying impossible. But the Bumblebee, being ignorant of these scientific truths, goes ahead and flies anyway, and makes a little honey every day.

— Anonymous

*The Walloping Window-Blind*
~ A capital ship for an ocean trip
was the Walloping Window-Blind!
No wind that blew dismayed her crew
or troubled the Captain's mind.
The man at the wheel was made to feel
contempt for the wildest blow,
Tho' it often appeared when the gale had cleared
that he'd been in his bunk below.

— Charles E. Carryl

# ADVANCED (Small Scale) Practice Sheet Lesson 81

This practice sheet is to be used when completing 8-10 lines from any of the quotations and selections from literature and poetry provided. Strive to make your letter spacing and letter heights consistent and graceful. Hold your pencil or pen comfortably and not too tightly. Remember to shift the paper every 2 to 3 inches as described in the Cross-Drill exercise instructions. Make it your goal for your penmanship to be a joy to write and beautiful to read! (Remember: Diagonal lines are indicators of proper letter slant.)

Date_____

*Wise Wasting of Days*

To awaken each morning with a smile on my face, to greet the day with reverence, for the opportunities it contains; to approach my work with a clean mind; to hold ever before me, even in the doing of little things, the ultimate purpose toward which I am working; to meet men and women with laughter on my lips, and love in my heart, to be gentle, kind and courteous through all the hours; to approach the night with weariness that ever woos sleep, and the joy that comes from work well done – this is truly how I desire to waste wisely the days of my life.

Thomas Dekker

# ADVANCED (Small Scale) Practice Sheet Lesson 82

This practice sheet is to be used when completing 8-10 lines from any of the quotations and selections from literature and poetry provided. Strive to make your letter spacing and letter heights consistent and graceful. Hold your pencil or pen comfortably and not too tightly. Remember to shift the paper every 2 to 3 inches as described in the Cross-Drill exercise instructions. Make it your goal for your penmanship to be a joy to write and beautiful to read! (Remember: Diagonal lines are indicators of proper letter slant.)

Date_____

*Music and Poetry*

*If I had my life to live over again, I would have made a rule to read some poetry and listen to some music at least once a week; for perhaps the parts of my brain now atrophied would thus have kept active through use. The loss of these tastes is a loss of happiness, and may possibly be injurious to the intellect, and more probably the moral character, by enfeebling the emotional part of our nature.*

*- Charles Darwin*

*Sail, Don't Drift*

*I find the greatest thing in this world is not so much where we stand, but is rather in what direction we are moving. To reach the port of Heaven, we must sail sometimes with the wind, and sometimes against it; but we sail and not drift, nor do we live at anchor.*

*- Oliver Wendell Holmes, M.D.*

# ADVANCED (Small Scale) Practice Sheet Lesson 83

This practice sheet is to be used when completing 8-10 lines from any of the quotations and selections from literature and poetry provided. Strive to make your letter spacing and letter heights consistent and graceful. Hold your pencil or pen comfortably and not too tightly. Remember to shift the paper every 2 to 3 inches as described in the Cross-Drill exercise instructions. Make it your goal for your penmanship to be a joy to write and beautiful to read! (Remember: Diagonal lines are indicators of proper letter slant.)

Date_____

Ideals are like stars; you will not
succeed in touching them with your
hands. But like the seafaring sailor
on the desert of waters, you choose
them as your guides, and following
them, you will reach your destiny.
                    - Carl Schurz

                Count that day lost
        Whose low, descending sun
        Views, at thy hand
        No worthy action done.
                    - Longfellow

I have a little shadow that goes in and out with me,
And what can be the use of him is more than I can see.
He is very, very like me from the heels up to his head,
And I see him jump before me when I jump into my bed.
                    - Robert Louis Stevenson

211

# ADVANCED (Small Scale) Practice Sheet Lesson 84

This practice sheet is to be used when completing 8-10 lines from any of the quotations and selections from literature and poetry provided. Strive to make your letter spacing and letter heights consistent and graceful. Hold your pencil or pen comfortably and not too tightly. Remember to shift the paper every 2 to 3 inches as described in the Cross-Drill exercise instructions. Make it your goal for your penmanship to be a joy to write and beautiful to read! (Remember: Diagonal lines are indicators of proper letter slant.)

Date_____

*Dream and Reality*

If one advances confidently in the direction of his dreams, and endeavors to live the life which he imagined, he will meet with a success unexpected in common hours. . . In proportion as he simplifies his life, the laws of the universe will appear less complex, and solitude will not be solitude, nor poverty poverty, nor weakness weakness. If you have built castles in the air, your work need not be lost; that is where they should be. Now put foundations under them.

Henry David Thoreau

*My Penmanship*

My penmanship has been my companion and friend, with me constantly, ever ready to respond instantly whenever thought, inspiration, or necessity have impelled its presence and assistance. It has never failed me.

- William Henning

# ADVANCED (Small Scale) Practice Sheet Lesson 85

This practice sheet is to be used when completing 8-10 lines from any of the quotations and selections from literature and poetry provided. Strive to make your letter spacing and letter heights consistent and graceful. Hold your pencil or pen comfortably and not too tightly. Remember to shift the paper every 2 to 3 inches as described in the Cross-Drill exercise instructions. Make it your goal for your penmanship to be a joy to write and beautiful to read! (Remember: Diagonal lines are indicators of proper letter slant.)

Date_____

Crossing The Bar

Sunset and Evening Star,
and one clear call for me!
And may there be no moaning of the bar
when I put out to sea.
But such a tide as moving seems asleep,
too full for sound and foam,
When that which drew from out the boundless deep
turns again home.
Twilight and Evening Bell,
and after that the dark!
And may there be no sadness of farewell
when I embark;
For tho' from out our bourne of Time and Place
the flood may bear me far,
I hope to see my Pilot face to face
when I have crossed the bar.

- Alfred, Lord Tennyson

213

# ADVANCED (Small Scale) Practice Sheet Lesson 86

This practice sheet is to be used when completing 8-10 lines from any of the quotations and selections from literature and poetry provided. Strive to make your letter spacing and letter heights consistent and graceful. Hold your pencil or pen comfortably and not too tightly. Remember to shift the paper every 2 to 3 inches as described in the Cross-Drill exercise instructions. Make it your goal for your penmanship to be a joy to write and beautiful to read! (Remember: Diagonal lines are indicators of proper letter slant.)

Date_____

Sometimes

Across the fields of yesterday
he sometimes comes to me,
A little lad just back from play –
the lad I used to be.
And yet he smiles so wistfully
once he has crept within;
I wonder if he hopes to see
the man I might have been.
- Thomas S. Jones, Jr.

The Cry of a Dreamer

I am tired of planning and toiling
in the crowded hives of men;
Heart-weary of building and spoiling,
and spoiling and building again.
And I long for the dear old river
where I dreamed my youth away;
For a dreamer lives forever,
and a toiler dies in a day.
- John Boyle O'Reilly

214

# Chapter 8: Quotations and Selections from Literature and Poetry for Practice

**Sometimes**

Across the fields of yesterday
he sometimes comes to me,
a little lad just back from play
the lad I used to be.

And yet he smiles so wistfully
once he has crept within,
I wonder if he hopes to see
the man I might have been.

   – Thomas S. Jones, Jr.

&#8766;

**Mike O'Day**

This is the grave of Mike O'Day
Who died maintaining his right of way.
His right was clear, his will was strong,
But he's just as dead as if he'd been wrong.

   – Anonymous

&#8766;

**Requiem**

Under the wide and starry sky,
dig a grave and let me lie.
Glad did I live and gladly die,
and I laid me down with a will.

This be the verse you 'grave for me:
here he lies where he longed to be;
home is the sailor, home from the sea,
and the hunter home from the hill.

   – Robert Louis Stevenson

One step and then another
and the longest walk is ended,
one stitch and then another
and the widest tear is mended.
One flake and then another
and the deepest snow is laid,
one brick and then another
and the highest wall is made.

   – Anonymous

&#8766;

The pen, the pen, the brave old pen
which stamped our thoughts of yore,
through its bold tracings oft again
our thoughts still freshly pour.

   – Platt Rogers Spencer

&#8766;

Ideals are like stars; you will not succeed in touching them with your hands. But like the seafaring sailor on the desert of waters, you choose them as your guides, and following them you will reach your destiny.

   – Carl Schurz

&#8766;

Kind hearts are gardens.
Kind thoughts are roots.
Kind words are flowers.
Kind deeds are fruits.

   – Henry Wadsworth Longfellow

Consider the subtleness of the sea; how its most dreaded creatures glide under water, unapparent for the most part, and treacherous hidden beneath the loveliest tints of azure. Consider also the devilish brilliance and beauty of many of its most remorseless tribes, as the dainty embellished shape of many species of sharks. Consider, once more, the universal cannibalism of the sea; all whose creatures prey upon one another, carrying on eternal war since the world began.

Consider all this; and then turn to this green, gentle and most docile earth; consider them both, the sea and the land; and do you not find a strange analogy to something in yourself. For as this appalling ocean, surrounds the verdant land, so in the soul of many there lies one insular Tahiti, full of peace and joy, but encompassed by all the horrors of the half known life....Push not off from that isle, thou canst never return!

> – from *Moby Dick*
> by Herman Melville

~

Lost! No words in any human language can depict my utter despair. I was literally buried alive; with no other expectation before me but to die in all the slow horrible torture of hunger and thirst.

Mechanically I crawled about, feeling the dry and arid rock. Never to my fancy had I ever felt anything so dry.

But, I frantically asked myself, how had I lost the course of the flowing stream? There could be no doubt it had ceased to flow in the gallery in which I now was. Now I began to understand the cause of the strange silence which prevailed when last I tried if any appeal from my companions might perchance reach my ear.

It so happened that when I first took an imprudent step in the wrong direction, I did not perceive the absence of the all important stream.

It was now quite evident that when we halted, another tunnel must have received the waters of the little torrent, and that I had unconsciously entered a different gallery. To what unknown depths had my companions gone? Where was I?

How to get back! Clue or landmark there was absolutely none! My feet left no signs on the granite and shingle. My brain throbbed with agony as I tried to discover the solution of this terrible problem. My situation, after all sophistry and reflection, had finally to be summed up in three awful words –

Lost! Lost!! Lost!!!

> – from *Journey to the Center of the Earth*, (Chapter 24) by Jules Verne

**Sea-Fever**

I must go down to the seas again, to the lonely sea and the sky,
And all I ask is a tall ship and a star to steer her by,
And the wheel's kick and the wind's song and the white sail's shaking,
And a gray mist on the sea's face and a gray dawn breaking.

I must go down to the seas again, for the call of the running tide
Is a wild call and a clear call that may not be denied;
And all I ask is a windy day with the white clouds flying,
And the flung spray and the blown spume, and the sea-gulls crying.

I must go down to the seas again, to the vagrant gypsy life,
To the gull's way and the whale's way, where the wind's like a whetted knife;
And all I ask is a merry yarn from a laughing fellow-rover,
And quiet sleep and a sweet dream when the long trick's over.

– John Masefield

<div align="center">❧</div>

**My Shadow**

I have a little shadow that goes in and out with me,
and what can be the use of him is more than I can see.
He is very, very like me from the heels up to the head;
and I see him jump before me, when I jump into my bed.

The funniest thing about him is the way he likes to grow –
not at all like proper children, which is always very slow;
for he sometimes shoots up taller like an India-rubber ball,
and he sometimes gets so little that there's none of him at all.

He hasn't got a notion of how children ought to play,
and can only make a fool of me in every sort of way.
He stays so close beside me, he's a coward you can see;
I'd think shame to stick to nursie as that shadow sticks to me!

One morning, very early, before the sun was up,
I rose and found the shining dew on every buttercup;
but my lazy little shadow, like an errant sleepy-head,
had stayed at home behind me and was fast asleep in bed.

– from *A Child's Garden of Verses*
by Robert Louis Stevenson

**Trust Thyself**

Trust thyself: every heart vibrates to that iron string…Whoso would be a man, must be a nonconformist. He who would gather immortal palms must not be hindered by the name of goodness, but must explore if it be goodness…

Insist on yourself; never imitate. Your own gift you can present every moment with the cumulative force of a whole life's cultivation; but of the adopted talent of another you have only an extemporaneous half possession. That which each can do best, none but his Maker can teach him. No man yet knows what it is, nor can, till that person has exhibited it…

Nothing can bring you peace but yourself. Nothing can bring you peace but the triumph of principles.

 – Ralph Waldo Emerson

ॐ

**Books**

Books delight us when prosperity smiles upon us; they comfort us inseparably when stormy fortune frowns on us. They lend validity to human compacts, and no serious judgments are propounded without their help. Arts and sciences, all the advantages of which no mind can enumerate, consist in books. How highly must we estimate the wondrous power of books, since through them we survey the utmost bounds of the world and time, and contemplate the things that are as well as those that are not, as it were in the mirror of eternity. In books we climb mountains and scan the deepest gulfs of the abyss; in books we behold the finny tribes that may not exist outside their native waters, distinguish the properties of streams and springs and of various lands; from books we dig out gems and metals and the materials of every kind of mineral, and learn the virtues of herbs and trees and plants, and survey at will the whole progeny of Neptune, Ceres, and Pluto.

Books are masters who instruct us without words of anger, without bread or money. If you approach them they are not asleep. If you seek them, they do not hide, if you blunder they do not scold, if you are ignorant, they do not laugh at you.

 – Richard de Bury

**Standing Alone on a Hill**

To persons standing alone on a hill during a clear mid night such as this, the roll of the world eastward is almost a palpable movement. The sensation may be caused by the panoramic glide of the stars past earthly objects, which is perceptible in a few minutes of stillness, or by the better outlook upon space a hill affords, or by the wind, or by the solitude; but whatever be its origin, the impression of riding along is vivid and abiding. The poetry of motion is a phrase much in use, and to enjoy the epic form of that gratification it is necessary to stand on a hill at a small hour of the night, and, having first expanded with a sense of difference from the mass of civilized mankind, who are dreamwrapt and disregardful of all such proceedings at this time, long and quietly watch your stately progress through the stars. After such a nocturnal reconnoitre it is hard to get back to earth, and to believe that the consciousness of such majestic speeding is derived from a tiny human frame.

– from *Far from the Madding Crowd* by Thomas Hardy

ॐ

**Lesson of the Bumblebee**

According to the theory of aerodynamics and as may be readily demonstrated through wind tunnel experiments, the bumblebee is unable to fly. This is because the weight, size and shape of his body in relation to the total wingspread makes flying impossible.

But the bumblebee, being ignorant of these scientific truths, goes ahead and flies anyway—and makes a little honey every day.

– Anonymous

ॐ

**McCaffery's Law of Mechanics**

If the Finnegan Pin is connected to the Whatchamacallit after it has been carefully threaded to the Darned-if-I-know housing, the fulcrum will clearly be shifted to the right wall of center on the left side of the top compartment. The initial inertia thus obtained will be of significant metaphysical proportions to create a resultant change in the Flywheel Vector, thereby producing a positive advance in the engine's Giddyup.

## The Cry of the Dreamer

I am tired of planning and toiling
In the crowded hives of men;
Heart weary of building and spoiling,
And spoiling and building again.
And I long for the dear old river,
Where I dreamed my youth away;
For a dreamer lives forever,
And a toiler dies in a day.

I am sick of the showy seeming,
of a life that is half a lie;
of the faces lined with scheming
In the throng that hurries by.
From the sleepless thought's endeavour,
I would go where the children play;
For a dreamer lives forever,
And a thinker dies in a day.

I can feel no pride, but pity
For the burdens the rich endure;
There is nothing sweet in the city
But the patient lives of the poor.
Oh, the little hands too skillful
And the child mind choked with weeds!
The daughter's heart grown willful,
And the father's heart that bleeds!

No, no! from the street's rude bustle,
From the trophies of mart and stage,
I would fly to the woods' low rustle
And the meadow's kindly page.
Let me dream as of old by the river,
And be loved for the dream always;
For a dreamer lives forever,
And a toiler dies in a day.

– John Boyle O'Reilly

## Colors of Autumn

The colors of Autumn appear in the breeze,
A sigh to summer; a gift from the trees.
Like dreams in the making they tumble on down;
Yellow and crimson, burgundy, brown.
Memories of Summer, of sunshine and rain,
But windows to Winter and Hope, once again.

– M. Sull

❧

## Crossing the Bar

Sunset and evening star,
And one clear call for me!
And may there be no moaning of the bar,
When I put out to sea.

But such a tide as moving seems asleep,
Too full for sound and foam,
When that which drew from out the boundless deep
Turns again home.

Twilight and evening bell,
And after that the dark!
And may there be no sadness of farewell,
When I embark;

For tho' from out our bourne of Time and Place
The flood may bear me far,
I hope to see my Pilot face to face
When I have crossed the bar.

– Alfred, Lord Tennyson

**The Day Is Done**

The day is done, and the darkness
    Falls from the wings of Night,
As a feather is wafted downward
    From an eagle in his flight.

I see the lights of the village
    Gleam through the rain and the mist,
And a feeling of sadness comes o'er me
    That my soul cannot resist:

A feeling of sadness and longing,
    That is not akin to pain,
And resembles sorrow only
    As the mist resembles the rain.
Come, read to me some poem,
    Some simple and heartfelt lay,
That shall soothe this restless feeling,
    And banish the thoughts of day.

Not from the grand old masters,
    Not from the bards sublime,
Whose distant footsteps echo
    Through the corridors of Time,

For, like strains of martial music,
    Their mighty thoughts suggest
Life's endless toil and endeavor;
    And tonight I long for rest.

Read from same humbler poet,
    Whose songs gushed from his heart,
As showers from the clouds of summer,
    or tears from the eyelids start;

Who, through long days of labor,
    And nights devoid of ease,
Still heard in his soul the music
    Of wonderful melodies.

Such songs have power to quiet
    The restless pulse of care,
And come like the benediction
    That follows after prayer.

Then read from the treasured volume
    The poem of thy choice,
And lend to the rhyme of the poet
    The beauty of thy voice.

And the night shall be filled with music,
    And the cares, that infest the day,
Shall fold their tents, like the Arabs,
    And as silently steal away.

    – Henry Wadsworth Longfellow

**The Declaration of Independence**

When in the Course of human Events, it becomes necessary for one People to dissolve the Political Bands which have connected them with another, and to assume among the Powers of the Earth, the separate and equal Station to which the Laws of Nature and of Nature's God entitle them, a decent Respect to the Opinions of Mankind requires that they should declare the causes which impel them to the Separation.

We hold these Truths to be self evident, that all Men are created equal, that they are endowed by their Creator with certain unalienable Rights, that among these are Life, Liberty, and the Pursuit of Happiness—That to secure these Rights, Governments are instituted among Men, deriving their just Powers from the Consent of the Governed, that whenever any Form of Government becomes destructive of these Ends, it is the Right of the People to alter or to abolish it, and to institute new Government, laying its Foundation on such Principles, and organizing its Powers in such Form, as to them shall seem most likely to effect their Safety and Happiness. Prudence, indeed, will dictate that Governments long established should not be changed for light and transient Causes; and accordingly all Experience hath shewn, that Mankind are more disposed to suffer, while Evils are sufferable, than to right themselves by abolishing the Forms to which they are accustomed. But when a long Train of Abuses and Usurpations, pursuing invariably the same Object, evinces a Design to reduce them under absolute Despotism, it is their Right, it is their Duty, to throw off such Government, and to provide new Guards for their future Security. Such has been the patient Sufferance of these Colonies; and such is now the Necessity which constrains them to alter their former Systems of Government...

❧

**History Repeats**

It was the best of times, it was the worst of times, it was the age of wisdom, it was the age of foolishness, it was the epoch of belief, it was the epoch of incredulity, it was the season of Light, it was the season of Darkness, it was the spring of hope, it was the winter of despair, we had everything before us, we had nothing before us, we were all going direct to Heaven, we were all going direct the other way—in short, the period was so far like the present period, that some of its noisiest authorities insisted on its being received, for good or for evil, in the superlative degree of comparison only.

– from *A Tale of Two Cities*
by Charles Dickens

We had now reached the summit of the loftiest crag. For some minutes the old man seemed too much exhausted to speak.

"Not long ago," said he at length, "and I could have guided you on this route as well as the youngest of my sons; but, about three years past, there happened to me an event such as never happened before to mortal man—or at least such as no man ever survived to tell of—and the six hours of deadly terror which I then endured have broken me up body and soul. You suppose me a very old man—but I am not. It took less than a single day to change these hairs from a jetty black to white, to weaken my limbs, and to unstring my nerves, so that I tremble at the least exertion, and am frightened at a shadow. Do you know I can scarcely look over this little cliff without getting giddy?"

> – from  "A Descent into the Maelstrom"
>   by Edgar Allan Poe

❧

## Nature

It seems as if the day was not wholly profane, in which we have given heed to some natural object. The fall of snowflakes in a still air, preserving to each crystal its perfect form; the blowing of sleet over a wide sheet of water, and over plains, the waving rye-field, the mimic waving acres of houstonia, whose innumerable florets whiten and ripple before the eye; the reflections of trees and flowers in glassy lakes; the musical steaming odorous south wind, which converts all trees to windharps; the crackling and spurting of hemlock in the flames; or of pine logs, which yield glory to the walls and faces in the sitting room,—these are the music and pictures of the most ancient religion.

> – from *Essays: Second Series*
>   by Ralph Waldo Emerson

❧

## Criticism

Criticism is a study by which men grow important and formidable at very small expense. The power of invention has been conferred by nature upon few, and the labor of learning those sciences which may, by mere labor, be obtained is too great to be willingly endured; but every man can exert such judgment as he has upon the works of others; and he whom nature has made weak, and idleness keeps ignorant, may yet support his vanity by the name of Critic....

> – Samuel Johnson

Sunset and Evening Star,
And one Clear Call for Me!
And may there be No
Moaning of the Bar
When I put out to Sea.
But such a Tide, as moving Seems Asleep,
Too Full for Sound and Foam,
When that which drew From Out
The Boundless Deep
Turns Again Home.

-from Alfred, Lord Tennyson; Crossing the Bar

# Chapter 9: Artistic Penmanship

At this point, much of what has been covered in this book focuses on the *fundamentals* of handwriting. These basics of cursive penmanship are essential, but there is also great enjoyment to be found in creating "extras" to ornament your writing. The following techniques are not difficult to master and can be very effective in adding emphasis to the content of your text, personalization to the recipient, and individuality to your own style of penmanship. In short, they're fun and serve to animate your writing in the same way that your voice and facial expressions add context to words when you speak.

## 1. Embellish Capital Letters

The purpose of capital letters can be summed up in one word: "Emphasis." More specifically, when capitals are used (most often as the first letter in a word), they infer a sense of respect, identity, importance, and recognition to the word itself, and to the *meaning* of the word as well. I like to think of capitals as a sort of "automatic device" to add significance to any word. And, although we normally use capitals only to begin a sentence or to identify a proper noun such as a name, there is no law or rule that states we are limited to these two options. So, in the same fashion as when a person raises his or her voice to emphasize various words in speech, I capitalize any word that I wish to emphasize in my penmanship. The use of additional capitals not only gives more visual importance to the words and sentences, but they can make your normal handwriting appear more ornate and elegant.

Another easy way to use capitals is to make them more decorative or larger than normal. You shouldn't do this to all your capitals; if you did, then all the capitals would be competing for attention to the reader's eye. Choose the words carefully—capitalization is a powerful tool, and too many capitals can cancel out the image of any word as being special. Another idea is that any capital letter can be made to look fancier by adding one or more large ovals as an entrance or exit stroke in a fashion similar to 19th century Spencerian script. Again, you must be cautious not to overdo this technique or your letters will become a hodge-podge of lines and curves that look like spaghetti. Note the examples on page 225. This is by no means a complete list, but there are plenty here to get you started.

Note: The capitals are shown with a lowercase "a" following them to indicate where the lowercase letters should begin when writing the rest of a word. Also, many capitals share similar elements of form with other letters, such as P, B, R; U, V Y; M, N; O, QU; F, T; among others. Thus, various beginning and ending curves can be used for many capitals of such similar form.

## 2. Flourish Lowercase Letters

Add flourishes to lowercase ascenders and descenders of the "loop letters," such as b,d,f,g,h,j,k,l,p,q,y, and z. Also, add "ending flourishes" to the last letter of the last word of a sentence or paragraph. This type of flourishing is quick and easy; you simply extend the ending stroke of the last letter into a curved oval. Again—be careful not to overdo it! The ending strokes can be quite short or of a greater length. The rule of thumb here is that the flourish itself should not be longer, taller, or wider than the word it originates from.

*ending. evermore. forever.*
*tomorrow. garden. beautiful.*
*adventure. singing. sincerely.*
*future. again. rest.*

## In Conclusion

Handwriting can be so personal, so intimate or commanding, and so very much fun. The words written by your hand give you an almost physical presence to the recipient as they are being read. Your penmanship can make distances disappear between two people, and bring the shared thoughts together as if they were whispered in each other's ear. Treasure your ability to write and write well; it is as much a part of you as your own voice. And like your voice, your handwriting will be an identity of who you are.

# Appendix 1
# Blank Practice Sheets

Photocopy these sheets in quantity for your use.

- Movement Exercise Practice Sheet
- Cross-Drill Exercise Practice Sheet
- Blank Practice Sheet: Standard Scale (Set 1)
- Blank Practice Sheet: Small Scale (Set 2 and Set 3)
- Blank Practice Sheet: Advanced (Small Scale)

# Movement Exercise Practice Sheet

ARROWS INDICATE DIRECTION OF MOVEMENT

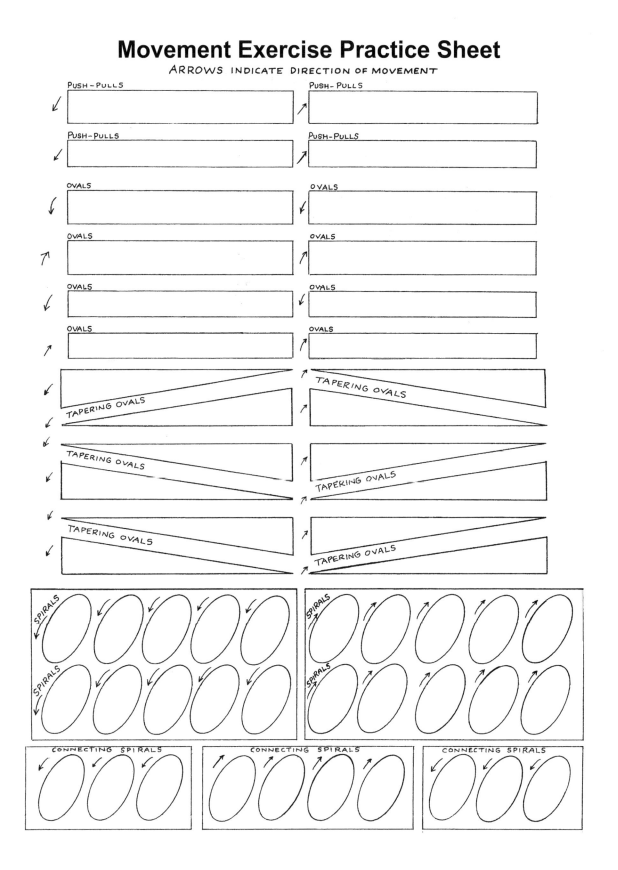

# Cross-Drill Exercise Practice Sheet

HORIZONTAL FORMAT

HORIZONTAL FORMAT

VERTICAL FORMAT

231

# Practice Sheet (Set 1)

Since no model lines of writing have been printed, it is recommend that you use this sheet to write letters and words of your own choosing. Strive to make your letter spacing and letter heights consistent and graceful. Hold your pencil or pen comfortably and not too tightly. Remember to shift the paper every 2 to 3 inches as described in the Cross-Drill exercise instructions. Make it a goal for your penmanship to be a joy to write and beautiful to read! (Remember: Diagonal lines are indicators of proper letter slant.)

Date_____

# (Small Scale) Practice Sheet  (Set 2 and Set 3)

This practice sheet is to be used when completing 8-10 lines from any of the quotations and selections from literature and poetry provided. Strive to make your letter spacing and letter heights consistent and graceful. Hold your pencil or pen comfortably and not too tightly. Remember to shift the paper every 2 to 3 inches as described in the Cross-Drill exercise instructions. Make it a goal for your penmanship to be a joy to write and beautiful to read! (Remember: Diagonal lines are indicators of proper letter slant.)

Date_____

233

# ADVANCED (Small Scale) Practice Sheet

This practice sheet is to be used when completing 8-10 lines from any of the quotations and selections from literature and poetry provided. Strive to make your letter spacing and letter heights consistent and graceful. Hold your pencil or pen comfortably and not too tightly. Remember to shift the paper every 2 to 3 inches as described in the Cross-Drill exercise instructions. Make it your goal for your penmanship to be a joy to write and beautiful to read! (Remember: Diagonal lines are indicators of proper letter slant.)

Date_____

# Appendix 2
# Using a Fountain Pen

This section is provided purely as a source of information to the reader. A person does not *need* a fountain pen to produce their handwriting; any of the previously mentioned instruments will work well for penmanship. These include ballpoint pens, rollerballs, gel-writers, and writing markers. Pencils, though satisfactory for practice work, do not fall into the category of an instrument recommended for social or business writing. The softness of the pencil lead produces lines of indistinct thickness and varying appearance. Because of this, and also because regular graphite pencil lines can easily become smudged or be erased, pencils are not considered to be good tools for correspondence or any permanent writing.

All that is required for handwriting to have a crisp appearance is a handheld instrument that is comfortable to grasp, has a fairly sharp point, and produces a line of consistent thickness. However, just as there are luxury models available for many products such as automobiles, boats, photography, and entertainment equipment, in the field of tools of handwriting, the elite item of choice is generally recognized to be a fountain pen.

Now, to be sure, there are high-end models of ballpoint pens available, many costing several hundred dollars. Much of the lofty price of these is because of the recognition factor of the manufacturer's name-brand on the market and/or the materials used in the construction of the pen body, such as silver, gold, and hand-applied lacquers. The actual working mechanism of ballpoints is fairly similar across the price spectrum. Nearly all of them use a system of a thin tube filled with an oil-based ink that terminates in a smooth metal ball. As this ball is set in a rolling motion when it contacts the paper, it leaves a thin residue of ink it its path.

A product of World War II technology, the ballpoint pen is extremely convenient, available in every price range, and quite reliable. However, it is sometimes considered to be a rather "impersonal" writing instrument. This is because the rolling ball moves so smoothly that it is often difficult for the person using the pen to actually feel the physical sensation of the pen forming the letters and words as it writes. Truthfully speaking, this may be a harsh and unfair judgment, since many people are passionately fond of their favorite ballpoint pens for many reasons. Yet, as a general statement of fact, when a person wants to experience the tactile sense of producing language on paper to visually express their thoughts, no other modern writing tool can compare to a fountain pen.

Fountain pens are tools with a vintage heritage all their own, boasting an original manufacture date going back well over a century. Also, during the years of the 20th century prior to World War II (and therefore before the emergence of ballpoint pens), there existed a marvelous age of fountain pen production and use, with numerous models featuring innovative filling systems and colorful materials in their construction, including precious metals. Often a particular fountain pen would become a favorite lifelong writing tool of a family member, and this pen would subsequently be handed down to a son or daughter as the years and generations passed. For these reasons, there is an aura of

nostalgia about fountain pens that is unique among all writing instruments. There is as much of a market for vintage-era fountain pens as there is for new, contemporary models, and there are ample sources for a person to obtain both of these styles.

It should be mentioned, however, that a fountain pen is not as convenient as a ballpoint pen. Fountain pens must be filled with ink on a regular basis, they should be cleaned ever so often (I clean mine once a month), and they tend to be more fragile in their construction than ballpoints. And yet—ahhh!—for people who love to correspond by hand, to sit down with a fresh sheet of stationery in front of you and a favorite fountain pen in your grasp is a joyful moment of anticipation that's difficult to describe. The action of the pen transferring your heartfelt thoughts into legible language and the feeling of the penpoint gliding upon the page, leaving a ribbon of glistening ink in its wake, are intimate sensations indeed. It is like having the person to whom you are writing actually sitting there next to you and conversing with them in person. And for true fountain pen aficionados, the extra attention that is part of the instrument's "care and feeding" simply endears the tool to its owner, and thereby makes the pen more special.

Thinking about my own love of writing with fountain pens, as I considered sharing these ideas with you, it soon became apparent that few readily available texts exist by which people can be introduced to the most basic information about fountain pens. With this in mind, I offer the following material as general guidelines.

### Selecting a Fountain Pen

Selecting a fountain pen is a very personal matter, but there are a few thoughts to keep in mind. You should have a pen that feels comfortable in your hand (not too small or large and not unbalanced or too heavy) and writes smoothly, producing a consistent flow of ink as you write. The ink should come off of the penpoint easily as the point glides upon the paper surface.

The best method to select a fountain pen that feels right to you and works well is to go to a reputable pen store, ask a knowledgeable salesperson for suggestions and advice, and try writing with several models before you make your purchase. If you are not able to do this, contact a pen store by telephone, speak to a salesperson, and, similarly, ask for their advice.

There are many major fountain pen brands of good quality, and on the whole, they're quite reliable and easy to use. Learning about fountain pens is advisable and will make you more knowledgeable about the characteristics of the pens and their availability and cost. For this purpose, I encourage you to check out the sources listed at the end of this section. Whenever possible, try writing with a pen before you make the purchase. If you see a fountain pen and are attracted by the way it looks—its shape, size, or color—you probably won't enjoy writing with it if it doesn't feel comfortable in your hand or if it writes poorly.

## Cost

Fountain pens are available in a wide range of prices, from less than ten dollars to special edition collector models costing as much as a small car! Just because a fountain pen is fairly inexpensive does not mean it is of poor quality. Usually even the low-end models will write well and are reliable. However, there are differences between high-end and low-end pens. Inexpensive pens have points made of steel; pens costing $100 or more usually have points made of gold or other precious metal. But even this is misleading, because the very tip of the point in nearly all but the cheapest pens is not made of steel or gold at all. The tip that actually touches the paper as you write is made of a hard metal called *iridium*. This little ball of iridium is welded onto the rest of the pen point. In well-made, expensive pens, this tip is finely polished and the gold "body" of the point flexes as you write—responding to the subtle flexing of your finger muscles during the process of writing.

My recommendation is to select several models in your price range that appeal to you. Then, if possible, try them out and see how they feel. If you take care of your pen, it will last for many years—often a lifetime. Buy one that you really like, and it will become an old friend through the years. Many people start with less costly pens and purchase more costly pens as their experience with fountain pen handwriting and their finances improve. Basically, just consider your budget and use common sense.

## Is Any Brand of Pen Better than Others?

As a general rule of thumb, all of the reputable brands of fountain pens are reliable and can be counted on to serve the writer well. The question of whether one brand is better than another is a personal decision. People who enjoy using fountain pens will invariably have their favorite choices for many reasons other than the quality of the pen itself. Nostalgia, previous ownership (the pen used to be their father's), and circumstance (the pen was a gift, perhaps given to recognize a special event, like a birthday or a graduation) often influence the preference an individual has for a particular brand or another. I love writing with pens made by Waterman, Sheaffer, Cross, and Parker equally well; one of my dearest friends would not part with his Pelikans for all the tea in China. Again, it's a personal choice. You will make the decision based on your own preferences as you gain experience using a variety of pens.

## What Size Point Should I Use?

Generally, the points of fountain pens come in four sizes: broad, medium, fine, and extra-fine. Some specialty points, such as italic calligraphy points, are also available on a limited basis. The majority of inexpensive pens come with a medium point as a standard item. If you purchase such an inexpensive pen, you may have no other point option. There's no problem with this at all.

My only suggestion is this: For general handwriting, I find that medium and fine points work best. The key is that the point should be small enough so that when you write small letters such as **a**, **e**, and **o**, the enclosed areas will not fill with ink. While broad points do add a touch of character to the appearance of handwriting, nearly all of the enclosed areas of your small letters will tend to close up and no longer look like letters. This detracts greatly from the legibility of your handwriting. Writing with an extra-fine

point usually requires a more delicate touch; you have to be more careful not to be heavy-handed as you write because the metal tip that comes in contact with the paper is extremely small. If you inadvertently press too hard on the pen while writing, you can seriously damage the point.

## Which Ink Should I Use?

Most of the major manufacturers of fountain pens also sell their own brand of ink and recommend that ink to their customers. This is good advice, but once again, fountain pen enthusiasts will have their own favorites. I like Pelikan, Sheaffer, and Waterman inks, but I make a habit of keeping the same brand of ink in a particular pen. In other words, I don't fill my Sheaffer with Sheaffer ink today and then fill it with Pelikan ink next week. You don't need to fill a pen with ink of the same manufacturer; I habitually fill my Sheaffer with Pelikan ink. Inks of different brands do have subtle differences in viscosity (thickness of the liquid), so I simply find it prudent to keep the pen working with the same ink consistency by using the same brand of ink within a pen. Thus, I "devote" my pens to a brand of ink I like. Currently I use Sheaffer ink in two pens, Waterman in two pens, and Pelikan in three pens. These are my favorites; again, it's a personal choice.

## How Do I Fill My Pen?

There are primarily three methods by which fountain pens can be filled with ink. These are known as: 1) Bottle-fill, 2) Cartridge, and 3) Converter. Most pens that are at the very low end of the price scale use only cartridges. The vast majority of fountain pens costing $50 and up accept either cartridges or converters, while a number of special high-end pens (usually priced above $250) are made to be "bottle-filled" only. Each of these filling methods works well and is reliable. Here are some broad descriptions:

| Cartridge: | The most convenient and widely used method for keeping pens filled with ink. A sealed plastic capsule containing ink is inserted into the pen body behind the point. The end of the cartridge is pushed against a sharpened tube, causing the tube to pierce the cartridge. The ink can then fill the tube and flow within the pen until it reaches the end of the penpoint. Once the ink in the cartridge is used up, the individual simply removes and discards the empty cartridge and inserts a new cartridge. |
|---|---|
| Converter: | A type of empty cartridge that fits onto the sharpened tube inside the pen body. A special mechanism built into this cartridge allows you to fill the pen with ink by immersing the entire penpoint in a bottle of ink and moving the mechanism with your fingers. It is called a converter because it "converts" a cartridge pen into a bottle-fill pen and offers the pen owner the option of using a much wider variety of ink brands than may be available only in cartridge form. Several different mechanisms for filling converters are manufactured; they all work fairly well. I prefer piston-mechanism cartridges in my pens, but converters that use a thin rubber tube (called a "bladder") are also reliable. |

| **Bottle-Fill:** | In this kind of pen, the body itself has a mechanism—usually a small section at the end of the pen body—which you turn with the fingers while the penpoint is immersed in ink. As your fingers rotate this section, a piston within the ink chamber of the pen creates a vacuum, thereby drawing the ink by means of suction from the ink bottle into the pen. Some other internal filling mechanisms exist, but the piston method is most common and works extremely well. Pens that fill in this manner, where the filling mechanism is actually part of the pen's construction, cannot be filled in any other way. |
|---|---|

## Cleaning Your Fountain Pen

It is wise to make a habit of cleaning your fountain pens on a regular basis. I faithfully clean my pens once a month. If your pens contain ink (as they should) and you do not clean them, over time (several weeks or more, depending on the quality of your pen), the ink that rests inside the pen point will tend to evaporate. This can leave a dry residue of ink in the fine tube and other areas of the point where the ink must flow for your pen to work properly. If this happens, the next time you try to use your pen, not only will it fail to write, but even after you refill it, this minute crust of dried ink may cause the pen to work inconsistently, producing ragged or scratchy lines of writing. In extreme cases, the residue can actually plug the ink feeding tube leading from the pen's ink chamber to the pen point. When this happens, the pen will not write at all.

A little routine effort on your part can easily prevent this from happening. Here's what I suggest:

Once a month refill your pen. Refilling flushes out old ink and draws new ink into the pen, thereby ensuring that the internal ink system of the tool is moist and loaded with the writing fluid. If your pen uses a cartridge, hold the whole penpoint under a stream of warm water for a minute or so. The water should flush out any dried residue on the point. Then blot the point several times with a paper towel. After this step, test the pen by writing on a scrap of paper for a few moments to see how the pen works. It won't hurt converter-filled or bottle-fill pens for you to rinse their points under the faucet each month, either. I would suggest, however, that you always rinse them *before* you refill them with ink. Remember also to blot the point prior to refilling. That's all there is to it.

## Sources for Additional Information

If you would like more information about fountain pens, I heartily recommend the following sources. They will lead you into a wonderful world of quality writing instruments, fascinating knowledge about the history of pens, product availability, and contact information for reputable repair services.

## Anderson Pens

With over forty years combined pen/ink/paper experience, Brian and Lisa Anderson have quality pen shops in Appleton, Wisconsin, Chicago, Illinois, and an online superstore at andersonpens.com. Stocking more than 2,000 writing instruments and 1,000 ink colors and a huge assortment of excellent paper, Anderson Pens can help with all of your writing needs.

**Store Address:**

Anderson Pens
10 E. College Ave, Suite 112A
Appleton, Wisconsin 54911

**Ordering Information:**

Telephone: 920-997-8220
Website: www.andersonpens.com

## Classic Fountain Pens

Classic Fountain Pens offers a full range of nib customizations for fine penmanship and calligraphy originated by owner John Mottishaw. Each pen or nib purchased on the nibs.com website also receives complimentary nib tuning services to optimize the writing instrument for each writer's specific preferences. As an authorized retailer for pen manufacturers from around the world, Classic Fountains Pens offers a finely curated selection of unique and high-quality writing instruments.

**Store Address:**

Classic Fountain Pens, Pens
717 N. Highland Avenue, Loft 27
Los Angeles, California 90038

**Ordering Information:**

Telephone: 323-655-2641
Email: info@nibs.com
Website: www.nibs.com

## Fahrney's Pens

This is one of the most reputable and respected pen companies in America. Founded in 1929, Fahrney's has a store in the Washington, D.C. area, a phenomenal website, and an excellent free color catalog. Their staff members are courteous, professional, and friendly. I find the catalog particularly helpful because it not only shows a fine selection of writing instruments, but also lists all the various refill items, accessories, and service telephone numbers for the majority of pen manufacturers. It is an excellent resource to keep at your fingertips.

**Catalog Address:**
>Catalog Department
>8329 Old Marlboro Pike, B13
>Upper Marlboro, MD 20772

**Store Address:**
>1317 F Street NW
>Washington, D.C. 20005
>(across from the National Press Building and near the White House)

**Ordering Information:**
>Telephone: 1-800-624-7367 or 301-568-1755
>Fax: 301-736-2926
>Customer Service: 1-800-336-4775
>Website: www.Fahrneyspens.com

## Fountain Pen Hospital

The Fountain Pen Hospital, another excellent source, has a well-deserved reputation for the high quality of their products and service. Boasting an expansive line of writing instruments in every category, they are also internationally known for their superb repair service of all makes, both vintage and contemporary.

**Store Address:**
>10 Warren Street
>New York, NY 10007

**Ordering Information:**
>Telephone: 800-253-PENS or 212-964-0580
>Fax: 212-227-5916
>E-mail: info@fountainpenhospital.com
>Website: www.fountainpenhospital.com

## Pen Place

Located in the prestigious Crown Center Shops in Kansas City, Missouri, the Pen Place features a wide selection of writing instruments in every price range, representing numerous manufacturers from around the world. A knowledgeable, friendly sales staff is always willing to offer suggestions and advice to customers.

**Store Address:**

Crown Center Shops
2450 Grand Boulevard, Suite 111
Kansas City, MO 64108

**Ordering Information:**

Telephone: 816-474-7500
Fax: 816-474-4147
Website: www.penplace.com

## Pen World

This bimonthly magazine is a pen lover's dream. It is a publication of the highest order, featuring full-color coverage of writing instruments (particularly fountain pens) and accessories. Each issue is packed with a wealth of information about all aspects of pens. Believe me—just glancing through the pages is an exciting experience. Each issue also features a section of resource information that is very helpful indeed.

**Store Address:**

P.O. Box 550246
Houston, Texas 77255-0246

**Ordering Information:**

Telephone: 713-869-9997
Fax: 713-869-9993
Website: www.penworld.com

## Inkpen Vintage Fountain Pen

Inkpen is a highly reputable company specializing in vintage fountain pen repair and sales. They also are authorized sales representatives for Pelikan and Visconti fountain pens. Their booklet, *Collecting Fountain Pens... A Primer for Newer Collectors*, provides information about acquiring, using, and maintaining fountain pens. The owners of Inkpen are Joel Hamilton and Sherrell Tyree; they frequently provide pen repair workshops and seminars at fountain pen shows.

**Store Address:**

Inkpen Vintage Fountain Pens
1602 Arizona Avenue
Alamogordo, NM 88310

**Telephone:**

Joel Hamilton: 575-491-3025
Sherrell Tyree: 913-642-3216

**Email:**

Joel Hamilton: inkpen5326@gmail.com
Sherrell Tyree: st3836@swbell.net

**Website:**

www.ink-pen.com

## Sources for Related Supplies

The following companies are excellent sources for books, art materials, instructional publications and advice on handwriting, calligraphy, illustration, gilding, and bookbinding, among other subjects in the field of art. Contact them for a free catalog. Their staff personnel will be happy to answer any questions you might have.

### John Neal Bookseller

**Store Address:**

1833 Spring Garden Street, First Floor
Greensboro, North Carolina 27403

**Ordering Information:**

Telephone: 1-800-369-9598
Telephone: 336-272-6139
Website: www.JohnNealBooks.com

### Paper & Ink Arts

**Store Address:**

240 Great Circle Road
Suite 328
Nashville, Tennessee 37228

**Ordering Information:**

Telephone: 1-800-736-7772
Website: www.paperinkarts.com

# Appendix 3
# The Essentials of Correspondence:
# How to Write a Personal Letter

By the time you have reached this section, your ability to write in American Cursive should be progressing well. Now that you have this important skill, wonderful opportunities await you in all the various ways you can use your penmanship. Like an athlete who trains with discipline and finally begins to enjoy their sport with confidence, you can now enjoy the action of handwriting with a new sense of accomplishment, achievement, purpose, and success.

However, any athlete knows that their training never stops; to enjoy their participation in the sport for many years, they must continue to train. In doing so, the training itself becomes an enjoyable part of their involvement in the sport. So it is with handwriting—your skill and the enjoyment you experience when you write will both increase if you continue to write as often as possible. The most fulfilling and satisfying way you can accomplish this is through the action of corresponding with other people. In other words—writing a personal letter.

## Thoughts to Consider

There are many reasons why people continue to handwrite letters in this 21st century, despite the wide use of e-mail and computer-generated communication. It is undeniably true that when you take the time to write someone a letter, you are saying that this person is special to you, and upon receiving your letter, the person whom you addressed will feel special as well.

The activity of writing a letter involves more, however, than just your skill in penmanship. Remember that in the action of writing a letter, you are communicating your thoughts, feelings, and ideas through the use of language. For this reason, your command of proper spelling, grammar, punctuation, and sentence structure is essential in making your letters interesting, easy to understand, and pleasing to read. Unfortunately, when people write personal e-mails today, many seem to show a lack of care or concern about the proper use of our language.

Handwriting your letters gives you the time to consider what you want to say; arrange your thoughts in a clear, understandable manner; carefully select your words; and check your spelling. Many people who frequently write letters make a habit of keeping a dictionary nearby to check on spelling, verb tense, and definition before they put pen to paper. A thesaurus—an invaluable book of synonyms and antonyms that can help you expand your vocabulary—is also a good item to have within reach. I recommend that you consult both of these resources frequently.

When you write to someone, you are truly speaking to them as if they were visiting with you. If your letter conveys your thoughts with good use of the basic elements of language, it will be easy for the recipient to understand what you are saying, and they won't have to guess or try to interpret what you mean. And of course, a well-written letter says a lot about you, too—that you care enough about the recipient that you took the time to compose the letter and write it properly.

## Format of a Personal Letter

Writing personal letters is not complicated at all. Anyone can write them—with the help of parents or older friends, even younger primary-grade children can write a brief letter of their own. The basic components of a personal letter are:

1. *Your return address.* You may not think this is necessary, but it is important. Your address is helpful to the recipient of the letter; it gives him or her an instant reference to where they can write back to you. They don't have to try to remember where you live or search elsewhere to find your address. Do not include your name here; just your street address, city, state, and ZIP code. If you are writing from outside the United States, you should include the address information that is pertinent to your geographic location. The address should either be centered at the top of the page or placed in the upper right-hand corner of the paper.

2. *Date.* Write the date about ¼ inch below the last line of your address. Write out the date in full; do not abbreviate.

   **This:** February 13, 2009     **Not this:** Feb. 13, '09     **Or this:** 2/13/09

3. *Salutation*: Personal letters to individuals usually begin with the word "Dear." The name that follows can be personalized as you wish: Dear Grandma, Dear Uncle Bill and Aunt Sarah, etc. During the 18th, 19th, and early 20th centuries, longer, more personal greetings were frequently used for salutations, such as: "Mary, my dearest Friend and Love"; "Beloved Mother"; "My very dear Parents"; "Dear Classmate and Friend," etc. Today, it remains true that you should feel free to personalize your salutation as you wish. After all, you're using your personal letter to speak to your special person. The salutation is placed at the left-hand margin of the paper a line or two below the date.

4. *Body*: The body refers to the text that you write. It is the primary reason you took the time to write the letter in the first place, for it is the message that you wish to share with the person to whom you are writing. The body of a letter can be any length at all, from only a single sentence, question, or exclamation to several full pages of text. Basically, you just say what you wish to say, but as mentioned earlier, you should always strive to use proper spelling, grammar, and sentence structure.

   Begin writing the body of your letter two lines below the salutation; it is much easier for the addressee to read your letter if all the components of the letter are not jammed up against each other. The first word of your first line should be indented, with the remaining lines of the first paragraph extending approximately 1/2 inch

further to the left, thus forming the left-hand margin of the text. The remaining paragraphs of the text should be formatted the same way, leaving one blank line before each new paragraph.

As far as the right-hand margin of the body is concerned, it is normal for the right side of your text to be uneven or "ragged" in appearance. It generally looks best if you try to end the last letter of the last word of a line no closer than ¾ inch from the right edge of the paper.

If your text takes more space than a single sheet of paper, your last line of writing on the first page should be no lower than two lines—approximately ¾ inch—from the bottom of the sheet. Also, if you use more than one sheet of paper, the pages following the first page should be numbered, starting with the number 2 on the second page. Typically the page number is centered approximately ¼ - ½ inch from the bottom of the page. The first page does not need to be numbered since it contains the salutation and date.

5. **Closing.** The closing is actually a greeting of farewell, and again, you can be as casual or personal as you wish. In centuries past, it was common in some cultures for writers to close their letters with long, descriptive phrases, such as: "Your faithful and obedient servant"; "Your devoted and loving son"; "I remain your sincere and loyal friend"; "With my cordial wishes for you in the new year," etc. You may choose such descriptive closings as you feel appropriate for your own letter. Most often, however, closings used today are brief. Below are some examples of commonly used closings.

| | | |
|---|---|---|
| Best wishes, | Truly, | As ever, |
| My best wishes, | Yours truly, | Missing you, |
| Best wishes always, | Truly yours, | Fraternally, |
| With best wishes, | Very truly yours, | Love, |
| Sincerely, | Respectfully, | Much love, |
| Sincerely yours, | Respectfully yours, | My love, |
| Most sincerely, | Most respectfully, | With love, |
| Very sincerely, | Always, | With my love, |
| Sincere regards, | Your friend, | Love always, |
| Regards, | In friendship, | Fondly, |
| Warm regards, | Your friend always, | Affectionately, |
| Cordially, | Always your friend, | Affectionately yours, |
| Most cordially, | Always in friendship, | With affection, |
| Cordially yours, | Faithfully, | Warmly, |
| Yours most cordially, | Faithfully yours, | Lots of love, |

You can see that many of these closings are variations of one another, yet each example may serve as the perfect choice for someone writing a letter. Human nature, circumstance, and the relationship between the sender and receiver will invariably affect a person's decision as to which closing is the most appropriate. The closing is placed two lines below the last line of the body and can be centered, placed slightly to the right of center, or on the left margin.

6. ***Signature.*** Your signature should *never* be a haphazard, illegible scribble. Your signature represents you; you don't want yourself and everything you wrote about in your letter to be represented by a scrawl that is unattractive and difficult to read. It is fine to have a sense of creativity in your signature and make it artistic, but above all, it should be legible. The signature is placed several lines below the closing. If you wish to emphasize your name as John Hancock did on the Declaration of Independence, you can write your signature at a slightly larger size than the penmanship you used to write your letter.

## In Summary

The personal letter that you write to someone is your chance to say what you want to say on paper. Some people simply touch their pen to the paper and continue from there, thinking of what they want to say while they are writing. Such spontaneous letters will get your message across to the reader, but in most cases the letter will end up with the contents badly thought out and some words poorly spelled. There is a tendency for such hastily written letters to contain run-on sentences and repetitive words.

Letters that are well written, however, are carefully crafted and composed. They are planned out by the writer, who takes the time to consider the best words to use to convey the message. As the writer quickly drafts a rough copy of the letter, he selects the grammar, spelling, wording, and so on, perhaps revising and rewriting until he is pleased with the final result. Then, using the final revision as a guide, the writer pens the actual letter on the stationery that will be sent to the recipient.

Many books are available that provide detailed information on the use of language in correspondence. Among those that I recommend are *The Someone Cares Encyclopedia of Letter Writing, a Guideposts book,* and *The Elements of Correspondence*, by Mary A. De Vries. Another good reference is *A Dash of Style—The Art and Mastery of Punctuation,* by Noah Lukeman. Information on these books is included in the Sources for Additional Information, Appendix 3.

The following illustration shows a sample layout of a typical one-page personal letter.

# Personal Letter Format

(Your address) _____

_____

(Date) _____

(Salutation or Greeting)

Dear _____ ,

(Body)

_____

_____

_____

_____

_____

_____

_____

_____

_____

_____

_____

_____

_____

(Closing)

With best wishes,

(Signature)

_____

# Appendix 4
# Glossary

| | |
|---|---|
| **Alternate Letters** | Variations in the shapes of standard letterforms that the student may use at his/her discretion. |
| **American Cursive** | A traditional form of cursive handwriting based on the modified form of Spencerian used in the 20th century; similar to Palmer Penmanship or the Hausam System of Plain Penmanship. |
| **Baseline** | The horizontal line upon which all letters and numbers are written. It can be imaginary, as when writing on a blank sheet of paper, or printed, as when writing on a lined tablet. |
| **Compound Curve** | A curve that changes direction throughout its length. |
| **Copybook Practice Sheet** | Instruction sheet that contains printed letters, words, and/or sentences that serve as models for the student to practice. |
| **Cross-Drill Exercise** | Traditional practice exercise used to develop the combination finger and wrist/arm movement necessary to move the hand from letter to letter while writing from the left to the right side of the paper. |
| **Cross Writing** | A form of writing practice wherein after several lines are written, the paper is turned 90 degrees and additional lines of writing are completed over the previously written lines. Also known as cross-drill exercises. |
| **Curve** | In American Cursive Handwriting, any portion of an oval. |
| **Cushion Sheet** | A soft piece of paper (e.g., blotter paper) placed under the writing sheet that serves as a resilient surface, enabling the pen to move more smoothly in the process of writing. |
| **Letter Slant** | The angle at which all letters and numbers lean to the right, approximately 35° from the vertical in American Cursive Handwriting. |
| **Model Letters** | Correctly written samples that show proper shape and size of letters. |
| **Model Numbers** | Correctly written samples that show proper shape and size of numbers. |
| **Movement Exercise** | Traditional practice exercise involving the writing of ovals, lines, and curves used to help the student develop a spontaneous and graceful motion of the hand when writing. See **Cross-Drill Exercise** for a specific kind of movement exercise. |
| **Oval** | A continuous enclosed curved shape that is approximately twice as long as it is wide. |

| | |
|---|---|
| **Over-curve** | A convex line that is the left side and top portion of an oval. |
| **Palmer, Austin N.** | American penman (1860-1927) who modified Spencerian penmanship, credited with introducing "combination muscular movement" in handwriting instruction. His Palmer Penmanship succeeded Spencerian as the nationally adopted style of handwriting taught in American public schools at the beginning of the 20th century. |
| **Posture (good)** | The correct position of the body when writing that allows the muscles of the arms, back, shoulders, neck, torso, and legs to work most efficiently. |
| **Practice Sheet** | A sheet with preprinted lines (baseline, letter slant, and at times, letter height) and no model lines of writing (unlike a Copybook Practice Sheet). For students to practice writing words of their own choosing. |
| **Scale of Writing** | The height at which the letters are written. Students in grades 2-4 use primary scale, ranging from approximately 1/2 inch to 1/4 inch; students in grades 5 through adult use standard scale of writing (1/8 inch) to small scale (1/16 inch). |
| **Slant Line** | The imaginary line that indicates the angle at which all letters and numbers lean toward the right. |
| **Spencer, Platt Rogers** | American penman (1800-1864) who developed the first style of penmanship that was taught nationally in schools throughout the United States. He is known as the Father of American Handwriting. |
| **Spencerian Penmanship** | Style of handwriting developed by Platt Rogers Spencer that was taught in America during the 19th century. The handwriting features shaded and unshaded letters, capitals with large curves, and many flourished strokes. |
| **Straight Line** | A line that does not change direction throughout its length. |
| **Under-curve** | A concave line that is the right side and bottom portion of an oval. |
| **Writing Zone** | The area located on the desk or table where the hand naturally rests when the body is in the proper position to write. This is usually a 4- to 6-inch circular area on the table surface in front of the body. It is the most comfortable location to write while maintaining good posture. |

# About the Author

A native of Buffalo, New York, Michael Sull is an American Master Penman whose work in the field of traditional handwriting has extended over a thirty-five-year career. He is internationally recognized as the most significant American Penman of the past fifty years for his penmanship skills, authorship, and teaching efforts. A devoted chirographer, Michael's activities have been innovative and instrumental in bringing back our handwriting heritage. He is widely regarded as the individual responsible for ushering in the new interest in American handwriting and reintroducing today's generation of students to Spencerian penmanship.

Michael's interest in calligraphy began shortly after he completed his service in the US Navy in 1973. He founded the Tidewater Calligraphy Guild in 1978 in Virginia Beach, Virginia and subsequently met veteran Master Penmen Isaac Weldon Bullock, David Fairbanks, and Paul O'Hara. At age ninety, Mr. O'Hara at that time was one of the last living Master Penman from America's Golden Age of Penmanship (1850–1925). These individuals became Michael's mentors, and over the next few years they encouraged him to share his new knowledge and skills with others so that America's history of Penmanship would not remain forgotten. To this end, Michael has dedicated his career.

His achievements over the next several decades have been unprecedented and substantial: 1981–1986 staff lettering artist, Hallmark Cards; founder and director, Spencerian Saga Workshop Program, 1987–2012; president, International Association of Master Penman, Engrossers and Teachers of Handwriting (IAMPETH), 2001; founder and director, IAMPETH Master Penman Program, 2001–2015; personal calligrapher to former president Ronald Reagan, 1990–2003; founder, the Spencerian Monument for American Handwriting, 2012; author: *Spencerian Script and Ornamental Penmanship*, *Learning to Write Spencerian Script*, *Spencerian Practice Set*, *Penmanship Poetry: Tales and Legends from a Lost Era*, and *American Cursive Handwriting*; Zaner-Bloser corporate master penman, academic director, The Ink Academy; featured contributor and subject, *Pen World* international magazine, and associate producer, documentary film *With Pen in Hand: The Journey of American Handwriting* (in progress).

Michael's teaching efforts have been extensive. Since 1985 he has taught American Penmanship in over forty states and twelve foreign countries; more than any other person in our country's history. He is also known for his handmade oblique penholders, personally crafting more than six thousand of these special writing instruments in the past twenty-five years. His writing skills are highly sought after as private commissions, and examples of his Spencerian and Ornamental Penmanship can be found in personal collections around the world.

A renowned Penman respected for his teaching ability and writing skill, Michael Sull is a singular figure in today's renaissance of interest in American Penmanship. With *The Art of Cursive Penmanship*, he focuses his attention on improving handwriting skills for the adult community.

# Acknowledgments

*The Art of Cursive Penmanship* is a project brought to life through the combined efforts of numerous individuals who taught, inspired, and assisted me throughout my career. Foremost of these has been, and remains, my devoted wife, Debra Sull. For more than twenty years, she has been my strength through projects and programs, states and countries, continents and adventures around the world. Helping me in countless ways, I am forever grateful and very proud to dedicate this book to her. Thank you for everything, my Bubbe.

To my beloved mother, Esther Sull (1919–2012), I owe so very much. Always encouraging me, it was her beautiful handwriting that awakened my interest in penmanship. Thank you, mom!

I always extend my sincere gratitude and respect to my own teachers of the handwriting arts: Paul H. O'Hara (1889–1990), David P. Fairbanks (1913–2004), and Isaac Weldon Bullock (1915–1992). Without their generosity and belief in me, I most probably would never have been inspired—or trained—to become a penman. Their kindness is inscribed in my heart.

In addition, I wish to recognize my brothers, Errol and Chuck, my sister, Evonne, and my many students who have encouraged and supported me for more than forty years. I am indebted to you more than I can say. You have shared your hearts, homes, and all manner of resources with me that I would have been lost without. Thank you so very, very much!

And most certainly, I wish to thank Julia Citrin, my editor Nicole Mele, and Skyhorse Publishing for giving me this amazing opportunity.

# Index